SECRET
CANTERBURY

Geoff and Fran Doel

AMBERLEY

First published 2018

Amberley Publishing
The Hill, Stroud
Gloucestershire, GL5 4EP

www.amberley-books.com

Copyright © Geoff and Fran Doel, 2018

The right of Geoff and Fran Doel to be identified
as the Authors of this work has been asserted in
accordance with the Copyrights, Designs and Patents
Act 1988.

ISBN 978 1 4456 6912 0 (print)
ISBN 978 1 4456 6913 7 (ebook)

British Library Cataloguing in Publication Data.
A catalogue record for this book is available from the
British Library.

Origination by Amberley Publishing.
Printed in Great Britain.

Contents

Early Historical Introduction

Canterbury is located on the River Stour, rising at Lenham and forking outside the city with one branch running through and the other round the walls. The two rivers reunite at Fordwich, Canterbury's early port. Canterbury became the tribal capital of the Celtic tribe the Cantiaci and a spectacularly large mound – Dane John – of possible religious significance dates from this time, adjacent to an ancient trackway.

The incoming Romans occupied Canterbury, calling it Durovernum Cantiacorum, 'the fort of the Cantiaci by the alder grove'. There was a huge amphitheatre complex near St Margaret's Street, which partly survived until the Middle Ages and whose circular shape can still be seen impacting on the street pattern; the stage was excavated near the Three Tuns Inn. Evidence of mansions, baths, temples and mosaic floors have been found throughout the city. Watling Street, connecting London and St Albans to the Roman

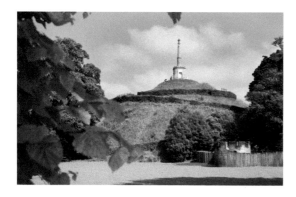

Dane John.

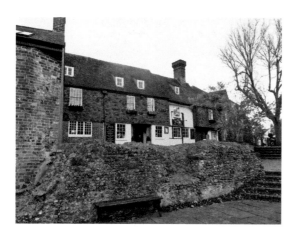

Roman wall at St Radigunds.

ports of Dover ('Dubris') and Richborough ('Rutupiae') passed through Canterbury; a fine hoard of late Roman silver was buried outside the city wall to the west.

There is evidence for a considerable decay in Roman Canterbury in the early fifth century, but the excavation of nearly thirty huts with sunken floors (grubenhauser) from this period shows the presence of Germanic settlers. By the late sixth century, King Ethelbert was living in Canterbury, married to a Christian Frankish princess, Bertha, who journeyed from Ethelbert's 'palace' (probably sited in the cathedral area) to worship at St Martin's, through the surviving Queningate. Ethelbert was probably concerned that his Frankish in-laws might use Christian conversion as an excuse for invasion and co-operated with Augustine's mission from the papacy to convert Kent. Augustine initially used St Martin's Church for worship and then created two abbeys, Christ Church, which became the cathedral, and St Peter and St Paul's Church (later renamed St Augustine's). The remains of the church of St Pancras (incorporated in the latter) has substantial Roman tiles and, according to legend, was Ethelbert's 'Idol House'.

Several early Anglo-Saxon churches in Canterbury are founded on earlier buildings. Excavations at St Martin's have located a rectangular Roman building beneath the chancel, which tallies with Bede's account of the allocation of a derelict Roman church for the use of the Frankish Christian Queen Bertha when she married Ethelred. St Peter's and

Queningate.

St Martin's Church
south wall.

St Dunstan's may also be on the site of Roman buildings, the latter being near a Roman cemetery outside the walls and which has a late Anglo-Saxon tower. St Mildreds, by the southern walls, has Anglo-Saxon work in the south and west walls of the nave, reusing Roman tiles and oolite quoins.

The Vikings attacked Kent in the ninth century and 'great slaughter' was recorded at Canterbury in 842 and in 851, when King Athelstan scattered the Viking fleet off Sandwich. Further, virtually annual raids occurred from 991 to 1011, when the citizens defended Canterbury for twenty days before the Vikings broke in and captured Archbishop Alphege, who opposed his ransom and was murdered at Greenwich, becoming the first Archbishop of Canterbury martyr. Chaos reigned until Canute became king in 1016, after which prosperity returned to England and Canterbury, both protected by a strong king who had been transformed by the Church from thug into model Christian king.

Kent did an ethically questionable deal with Duke William in 1066 to remain technical 'invictus', and William was allowed to travel through Canterbury unmolested to London. He ordered the construction of a motte and wooden castle and the existing Dane John mound (whose name is a corruption from the Norman *donjon*) was used. The Domesday Book, referring to the end of Edward the Confessor's reign, shows that Canterbury had 187 urban properties and 451 freemen burgesses and a portreeve, who oversaw the markets, except for Longport and Westgate on the archbishop's land. The substantial cathedral burnt down in 1067 and an even larger Norman cathedral replaced it; a stone castle was later built by the Normans on a site near the South Gate. Some dozen goldsmiths were working in Canterbury between 1149 and 1200, and the city had eight mints, second only to London in this and in the quantity of coin produced. The thriving Norman city was focused on the primary archbishopric of England and its administration.

Above: Interior of south wall of
St Martin's Church.

Right: Ruins of St Pancras Church.

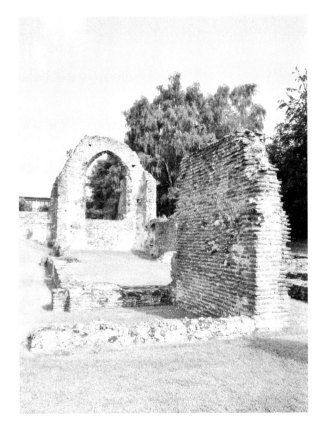

1. Secrets of the Cathedral

Walter Cozens, a Victorian master builder who lived in Canterbury and loved its old buildings, once said that each old building is full of secrets that will never be told. This must be true of Christ Church Cathedral.

This great cathedral was of course built as a house of God and also as a Benedictine monastic church. It was designed to impress and is on a huge scale. The soaring nave was designed primarily as a space for the theatrical rituals and processions so beloved of the Benedictines, in addition to being a place in which pilgrims and lay people including women could gather and hear Mass. 'Hear' Mass is important – they did not have to *see* the Mass enacted. The choir that rose beyond with its great altar was its most important religious space. In this area the community of monks, screened off from the body of the church and enclosed within the high walls of the choir, recited the night office round about midnight and afterwards the Divine Office or *Opus Dei,* the seven official set of prayers, lessons and psalms throughout the day; the services were enriched by chants and other glorious music.

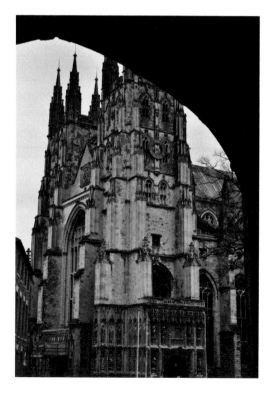

Christ Church Cathedral.

Today the walls are not emblazoned with ornamentation as they were in the Middle Ages. Everything then, walls and windows alike, told a story in pictures – they were 'the Bible of the Poor'.

A Puritan sympathiser and iconoclast in the seventeenth century gleefully recorded that the complex iconography of the windows was so carefully recorded in a register of the cathedral's treasures that this enabled him and others to use it 'as a card and compasse to sail by, in that Cathedral's ocean of images; (so that) by it many a Popish picture was discovered, and demolished'.

In theory the monks' lives were marked by self-abnegation and organised ascetic practices, and their life circumscribed by their precinct wall. The Rule of St Benedict, composed in sixth-century Italy, was kept fresh in their minds by select daily readings in the chapter.

With the meteoric rise of the Canterbury pilgrimage in the Middle Ages, the cathedral became the Lourdes of its day. Pilgrims poured into the city from all over Europe and Britain, with many of them seeking cures as Thomas Becket was regarded as one of the greatest of all the Church's many healing saints. The cures he affected were carefully recorded. Chaucer, in *The Canterbury Tales*, tells us that his contemporaries regularly prayed to St Thomas Becket when they were sick and that he would generously 'hem ... holpen whan that they were sicke'. Certainly no other medieval shrine had a greater collection of miracle stories than that of Thomas Becket, the murdered archbishop of Canterbury.

In 1220 a new dramatic religious space was created within the cathedral: the Trinity Chapel. In its centre was Becket's new gold shrine, carefully sited so that pilgrims could circulate round it and pray on their knees underneath it. A series of densely coloured windows – the Miracle Windows – later formed a backdrop to the shrine floor and a new round chapel, the Corona, was built where a silver gilt bust of the murdered archbishop was set on an altar – the portion of his skull that had been sliced off was inset into its head.

The cathedral's conflux of visitors was a constant and powerful influence on the monks' daily monastic life. They were obliged to organise and control the daily flow of thousands of pilgrims, as well as deal with their monetary contributions and votive offerings – a considerable part of the cathedral's finances. As votive offerings in the form of jewels began to flood in – diamonds, pearls, sapphires, rubies – the best of these were displayed in a gilded wire mesh over Becket's shrine. Security became a vexing problem. A watching chamber was set over the shrine where a security watch kept their eyes fixed on the treasures night and day. Erasmus, the sixteenth-century Dutch humanist, when he visited the cathedral noted with some interest that it was patrolled by monks with bandogs. These dogs were lethal; they were normally bred for hunting and bull-baiting. During the Crusades they were employed as war dogs (special armour was created for them) and they were encouraged to attack the legs or tear out the underbelly of the enemy's horses. A description of the bandog survives in a sixteenth-century work by John Caius in his *Of Englishe Dogges*: 'This kind of Dogge Called a mastyve or Bandogge is vaste, huge, stubborn, ougly and large, of a hevy and burthenous body and therefore of little swiftnesse, terrible and frightful to behold.'

The monks with their fierce bandogs and their relics and jewel encrusted gold shrine are long gone. The walls have largely been stripped of their colourful frescoes and only a portion of the early windows remain. What we have left is this wonderful ancient building.

Today's pilgrims and visitors approach the cathedral via the Buttermarket, which marks the centre of the city.

Christ Church Gate is our entry point to the cathedral. It was set up in 1501 and was the gift of Henry VII to the abbey. It is ornate, imposing and functional in that all tourists must filter past the barriers beneath and pay the required dues (£12.50 adults, £11.50 concessions and Canterbury citizens go free), which gives them the right to enter both the cathedral and its precincts.

Numerous coats of arms are displayed above the stout wooden door. Boldly displayed among the Tudor arms are those of Arthur, eldest son and heir apparent of the monarch, and those of his new young wife Katherine of Aragon, daughter of the King and Queen of Spain. Two stone heads, thought to be portraits of the newlyweds can be found on the inside of the gate to the right. This gate celebrates a great prince's illustrious marriage. Had he lived, Prince Arthur should have become King Arthur I of England – the other and better known Arthur after whom he was named is believed to have been a *Dux Bellorum* (war lord) as well as a creation of myth, legend and literature. The sixteen-year-old prince died only a year after his marriage, whereupon his bride married his younger brother Henry after a delay of a few years. The pope gave his approval.

Passing through the gate into the precinct and the first thing that strikes us about the cathedral, apart from the glory of its architecture, is the splendour of the stone. This came from quarries in France: one near Caen, the other near Poitiers. When stone is required for conservation work today, it is brought from the same two quarries in great blocks weighing up to 5 tons. Lorries take them to a huge industrial unit on the edge of the

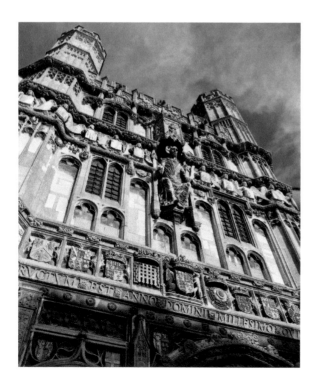

Christ Church Gate.

Stone heads of Prince Arthur and Katherine of Aragon.

city and there 'they are cut by diamond tipped saws into smaller manageable sections and worked by hand to templates by a team of masons before being transferred to the cathedral'. The cathedral has twenty-five stonemasons on its books and that includes four apprentices. Two of those apprenticeships are funded by the Freemasons.

Before entering the cathedral detour along the south side of the building in order to see an unusual, small box-like stone structure protruding from the outer east wall of St Michael's Chapel (also known as the Warriors' Chapel). Unbelievably, these contain the feet of the once eminent Archbishop Stephen Langton (1150–1228). When he died in Sussex his body was sent to Canterbury for burial and he was duly interred in the cemetery close to the apsidal Chapel of St Michael. This chapel was subsequently enlarged and his tomb became incorporated – all except the feet, which were allowed to poke out of the exterior wall.

To add insult to injury, in 1439 an illustrious lady (Lady Margaret Holland, the granddaughter of the Fair Maid of Kent) had her own wonderful high alabaster monument with its representations of herself and her two dead husbands thrown over the archbishop's grave slab within the chapel, eclipsing the archbishop's own modest memorial.

It is hard not to be sorry for this long dead archbishop. He was highly influential in the drawing up and signing of the Magna Carta, and we also have to thank him for dividing the Bible into chapters and verses.

Once in the great nave a flight of steps rise dramatically to the east to meet the monks' choir, hidden behind their screen. Underneath these stairs is a little door on the south side, which opens into the pilgrims' 'secret' passage. This runs south to north, bringing the tourist pilgrim straight into the place of martyrdom – the scene of Becket's brutal murder in 1170. From this spot the pilgrims were taken into the crypt where Becket's miracle-working body lay for fifty years before being transferred to its new resting place in the Trinity Chapel in 1220. This passage very effectively got the visitors into a manageable single file and also prevented the monks from being disturbed in their important work in the choir above.

The secret passageway leads you 'slap bang' in front of Archbishop Warham's tomb in the Chapel of the Martyrdom. Archbishop Warham was Henry VIII's archbishop. His court portrait by Hans Holbein the Younger reflects a beleaguered and perhaps

Left: Archbishop Langton's feet.

Below: Maquette of Archbishop Langton.
(Used with permission of Beaney Museum)

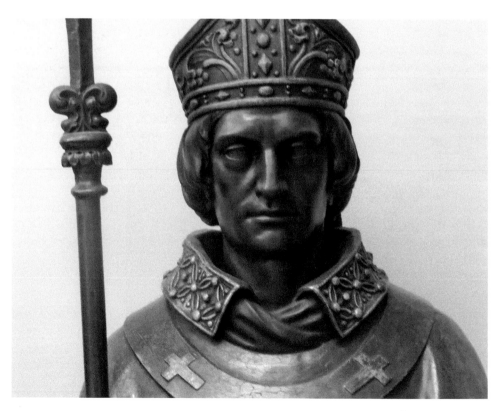

The Pilgrims' Passage.

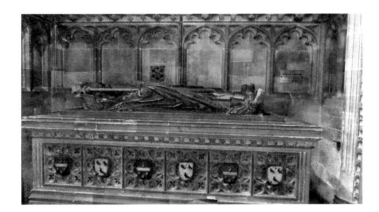

Tomb of Archbishop
Warham.

weak old man; his effigy in the cathedral is a little more flattering. Warham had initially rejoiced over the young Henry VIII's piety and allegiance to the Church as we know from a letter he wrote to Cardinal Wolsey. He happily presided over the marriage ceremony and then the coronation of Henry VIII and Katherine of Aragon. But twenty-four years later when he was confronted with the 'king's great matter' – i.e. his need for a divorce, the now elderly and somewhat confused archbishop was ordered to reinvestigate the validity of the marriage, deal with the pope's concerns and finally – and very half-heartedly – to give support to Katherine in her trial. In his last years he muttered continuously '*ira principis mores est*' – to annoy the king is death.

The Miracle Windows
The twelve Miracle Windows that ring round the Trinity Chapel are an amazing survival and a perpetual joy. They illustrate Becket's life and death as well as some of the more astonishing cures claimed at his shrine, such as the growing back of severed limbs and the bringing back from the dead – the monks' ideas of a cure were flexible to say the least, and some miracles are simply finding lost property.

In the base of the first Miracle Window, at the western end of the north aisle, is a portrait of Becket vested as archbishop raising his right hand in blessing. For years experts debated how it was that this unique and authentic medieval representation of the martyred archbishop had come to survive Henry VIII's, Edward IV's and seventeenth-century Puritan iconoclastic intervention. It became an icon in Canterbury – until it was discovered that it was not, in fact, either original or authentic. In the early twentieth century the then master of medieval glass in the cathedral had, unbeknown to anyone, created the image himself using shards of smashed medieval glass – mystery solved!

There is a secret among these superb stained-glass windows and it is the missing window representing the Trinity and the Life of the Virgin. Every physical scrap of this window is missing. But an account written during the English Civil War in the year 1644 by Richard Culmer in his *Cathedral Newes from Canterbury* tells us that it was formerly sited 'on the left hand as you goe up into the Quire'. Richard Culmer is well known to Canterbury historians as a truly 'fanatical divine': one of a number of fervent iconoclasts who had been appointed by Parliament in 1643 to 'detect and demolish' offensive vestiges of Roman Catholicism in the cathedral. Culmer describes the lost window with the utmost relish. There was 'the prime cathedral Saint-Archbishop Thomas Becket ... rarely [i.e. exquisitely] pictured ... in full proportion, with Cope, Rochet, Miter, and all his Pontificalibus along with the picture of God the Father, and Christ besides a large Crucifix, and the Holy Ghost in the form of a Dove. There were the 12 Apostles and seven large pictures of the Virgin Marie, in seven several glorious appearances, as the Angels lifting her into heaven, and the Sun, Moon and Stars under her feet, and every picture had an inscription over it, beginning with *gaude Maria*'.

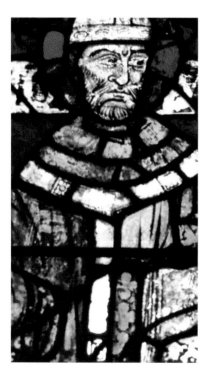

Archbishop Thomas Becket depicted in the Miracle Windows.

He adds something to break any medieval art historian's heart. That *this* particular window had been 'the superstitious glory of that cathedral ... and is now 'more defaced that *any* window' for Culmer himself had ascended a ladder 'near 60 steps high ... with a whole pike in his hand' and rattled down proud Becket's glassy bones'. With intense enjoyment he records how he and his helpers had turned deaf ears to pleas to spare the window and even bribes of 'many thousands of pounds'.

Archbishop Thomas Becket is himself the cathedral's greatest secret. Was Becket, considered by just about everyone including his own monks, as a worldly and haughty man, indeed a saint? Three master theologians of Paris disputed the point soon after his death. They concurred that Becket 'was a martyr for the liberty of the church', but only after long debate did they come to the conclusion that Christ himself had solved the problem 'by the manifold and great signs with which he has glorified him' – the 'manifold and great signs' being Becket's miracle-working relics added to his subsequent quick canonisation on 12 March 1173, both of which raised not just his reputation but his cult to the dizziest of heights and made of Canterbury the greatest centre of pilgrimage in Europe for the next several hundred years.

Various kings chose not to see Thomas as a saint. The Icelandic *Thomas Saga Erkibyskups* (written in the fourteenth century, but based on earlier sources) claims that Henry's rancour and bitter hostility towards Becket persisted even after the archbishop's death and that the Canterbury monks were for a long time terrified of reprisal as 'the highest lords of the land forbade under peril of life and limbs, any one to call archbishop Thomas a holy man or even a martyr'. Almost the same sentiments were echoed by Henry VIII, who came across a portrayal of Henry II doing penance at Thomas's shrine and was enraged that a monarch could be so debased by churchmen. He declared Thomas a rebel and a traitor and declared that 'notwithstanding the sayde canonization, there appeareth nothing in his life whereby he should be called a saynct' and ordered that 'from hence forth the sayde Thomas Becket shall not be esteemed, named, reputed nor called a saynct'. He saw to it that Becket's shrine was dismantled and all representations of him defaced.

Henry VIII was assured that nothing whatsoever remained of Becket's shrine, but the Beaney Museum, however, thinks differently. It claims to have a secret survival: fragments of the rose-coloured pillars that once supported the saint's miracle-working shrine. They had been smashed up before being thrown into the River Stour.

And there are other survivals. Thanks to a Miss Hales, St Thomas's Catholic Church Canterbury now has two authenticated relics of St Thomas Becket. Miss Hales was from an old Catholic family in Canterbury and had been a nun. The relics came from Gubbio in Umbria, Italy. One is a tiny piece of material cut from the episcopal robe Becket was wearing when he was reinterred and the other is a tiny piece of the saint's finger bone. These had been acquired from Canterbury during the saint's 'translation'. They are on display in the south chapel in a special reliquary above the side altar. The church is always open and welcomes visitors.

Back in the cathedral and near to the great altar is the chapel of St Anselm (1033–1109). His tomb lies in a striking Romanesque, much-restored chapel in the south side of the choir's south aisle. Though a Lombard, he had trained and been schooled in the prestigious Bec Abbey in Normandy, where the great Lanfranc had been his mentor and he himself a

Beaney Museum: rose marble pillar fragments.

Reliquary of St Thomas Becket,
St Thomas's Church, Canterbury.

star pupil. Anselm was the first of Canterbury's archbishops to consistently style himself Primate of Great Britain and Ireland and Vicar of the Pope. He was invited to become archbishop in 1093 by the Conqueror's successor William II of England. Anselm accepted reluctantly as William's evil reputation had preceded him.

This early archbishop deserves to be better known, for as a spiritual leader he helped eradicate chattel slavery in England, regulated clerical dress in Britain and Ireland and

brought in clearly badly needed monastic reforms to enforce celibacy and good behavior – by 'prohibiting marriage, concubinage, drunkenness, sodomy and simony for all in holy orders!' Canterbury Cathedral also profited from his love of his church for (thanks to his priors, Enulf and Conrad) he 'doubled the size of the cathedral'.

As he no doubt anticipated, his years as archbishop were fraught: he came under pressure from the two kings he served, William Rufus and Henry I, both of them ruthless and venal men who were determined to assert royal authority over the Church; twice he was forced into exile. William Rufus famously said of his clever archbishop, 'I hated him before, I hate him now, and I shall hate him still more hereafter.'

Perhaps we should thank William Rufus. Exile gave Anselm the peace to reflect and to write for he was at heart an ascetic and scholar. A modern window in the Anselm Chapel shows him holding his book *Cur Deus Homo?* (Why did God become Man?), a treatise on the Incarnation that he completed in exile. This work, which explores the humanity rather than the divinity of Christ, along with his other works on the nature and existence of God, had an immense impact on succeeding generations of believers. The idea of Christ's humanity and the Passion came to dominate late medieval spirituality, particularly among fourteenth-century English mystics who 'approached the Divine through 'empathic experience of Christ's humanity'

An unexpected small but vividly coloured fresco depicting St Paul and the Viper (28:3) can be seen high up on the wall in Anselm's Chapel. It dates to 1160, but its presence was a secret for over 700 years; it only came to light when the Victorians were restoring the chapel

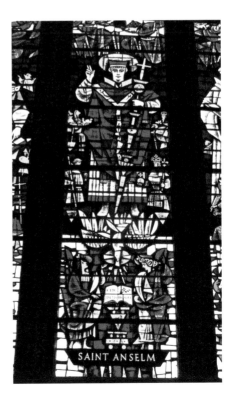

St Anselm Window, St Anselm's Chapel.

in 1888. This tiny fragment had obviously also escaped the 1644 Ordinance of Parliament for the demolishing of monuments of idolatry. We are told by Culmer, the Anglican clergyman with Puritan sympathies, just how colourful the walls were and that the 'Cathedral men would not execute that Ordinance themselves, they loved their Cathedral Jezebel, the better because she was painted, which painted Cathedral Jezebel ... [they call] the Mother Church'.

Anselm died in 1109 at the age of seventy-six with an unrivalled European reputation as a philosophical and religious thinker.

DID YOU KNOW?
The Bayeux Tapestry (actually an embroidered cloth more than 70 metres long) is thought to have been made in Canterbury c. 1070 within a few years of the Norman defeat of the English and while Canterbury Cathedral was being built. It was probably made for Bishop Odo, the half-brother of the 'Conqueror', William Duke of Normandy. Odo later became Earl of Kent. The scenes may have been adapted from images in manuscripts illuminated in Canterbury.

A Walk Round the Cloister

Few visitors look closely at the stone benches in the cloister. If they did they would be intrigued by the amount of graffiti on the surface of the stone – as well as its nature. There are numerous representations of relatively small shoes and hands, incised presumably with penknives, as well as numbers of round holes that have been gouged out of the stone in a variety of patterns. The thinking is that these were done by King's Scholars during recreation time in the cloisters (perhaps when the weather was bad and presumably when their supervisors' backs were turned); some of the carvings date back to the sixteenth century. It is likely that the holes were made for their games of marbles.

Queen Bertha's Walk

This walk is marked out by fourteen bronze plaques inserted into the ground. It is amazing how many Canterbury residents have never noticed them and yet pass over them nearly every day. The walk starts in the cathedral precincts and follows the presumed route taken by Queen Bertha when she left her husband's palace in order to worship daily at St Martin's Church. It was devised in 1997 to mark the 1,400th anniversary of the arrival of St Augustine from Rome in AD 597. It takes you past the cathedral and by St Augustine's Abbey. Without visits this walk would take you half an hour. If you add a visit to the cathedral add another two hours, and similarly with the abbey. An information leaflet is usually available from the Beaney Institute.

Cozens in his *Old Canterbury* tells us that there is an 'outer strip immediately behind the city wall ... known as Queeningate Lane '*which few people see* and gives access from Northgate to Burgate'. This path still exists but will continue to be a secret as it is firmly closed to the public.

Bronze plaque,
Queen Bertha's
Walk.

The Cathedral Water Conduit

Although washing the body was generally discouraged in the Benedictine Order (except for those ill and near death in the infirmary), the Benedictine rule followed at Canterbury Cathedral (as at St Augustine's Abbey) did order a ritual and routine washing of hands and face at the start of each day and before meals and had a foot-washing ceremony on Fridays. This required a regular water supply to the *lavatorium* where fresh towels were always made available and water was also taken to other buildings in the monastery. One of the cathedral's freshwater sources can be easily visited as it is only ten minutes away from St Martin's Church. There is something a little incongruous about the site of this twelfth-century conduit, set deep into the steep hillside but now circled round with a few 1970s estate houses. In the past it was enclosed in a circular building with one entrance, and steps that led down into the spring. The exterior may have been plastered and painted white and it had a red conical timber roof. Today it is maintained by English Heritage and there is a display board giving information about its history.

Oliver Postgate's Secret

Oliver Postgate delighted children and adults alike in the 1980s with his immensely popular *Noggin the Nog, Ivor the Engine, Bagpuss, The Clangers* and other television programmes . He lived and worked in a village just outside Canterbury and he was commissioned to paint a huge work – *Canterbury Chronicle* – which has hung in Eliot College University refectory since 1992. In the bottom right-hand corner is his name in a cartouche being carried away by two little mice.

The work has a charming childlike quality with lots of movement and no respect for the rules of perspective. Busy little cartoon-like figures in a variety of historic clothing scuttle about the canvass in the manner of a medieval tapestry, and are involved in multiple narrative scenes representing Canterbury's long history – and all within one frame.

Central to it all is the great cathedral. The side opened like a giant doll's house so that we see its interior rooms and the tragic killing of a man being enacted within. And outside, a figure larger than all the rest is Henry VIII. The year is obviously 1538 and he is supervising the enormous quantity of gold and jewels robbed from the cathedral – the treasure was said to have filled twenty-six carts – that is being trundled away and into his coffers.

We love Postgate's vision of modern-day Canterbury on the far right, with Canterbury's ring road showing a typical scene of congestion at rush hour and drab shops replacing the picturesque medieval buildings.

Postgate's painting was discovered to have a secret: it was actually a triptych and only discovered to be so by the present master, Stephen Burke, when he ordered the painting to be cleaned. No one had suspected that there were two hinged side panels that closed inwards, turning the painting into a medieval-style triptych depicting Thomas Becket on the left and Henry II on the right – the two men that put Canterbury onto the world map.

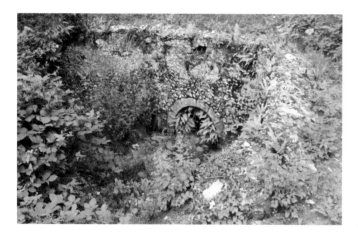

Cathedral water conduit, King's Park.

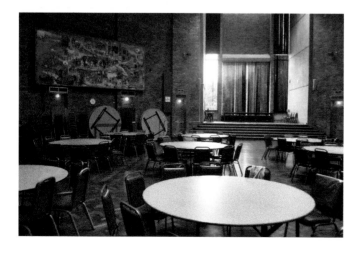

Eliot College Refectory, with the Oliver Postgate painting on the left.

2. Medieval Hospitals and Friaries

Canterbury has substantial surviving buildings from four medieval hospitals. Another, St Laurence near Oaten Hill, has fragmentary remains, while the Priory of St Jacob in Wincheap has been totally destroyed. Parts of two friaries survive, but a third, Whitefriars, succumbed to wartime bombing and redevelopment.

The Hospitals

Eastbridge Hospital

In 1190 Edward FitzOdbold founded a hospital to accommodate pilgrims on the bridge in the High Street and Becket's nephew Ralph was probably its first master. Archbishop Stratford refounded it in 1342. After the Reformation it housed a school for twenty boys from 1569 to the 1880s. Archbishop Whitgift's reforms of 1584 provided accommodation for ten poor people of Canterbury and a dole of food for ten more. Today the almshouses are occupied by older persons connected with Canterbury.

St Nicholas Hospital Harbledown

St Nicholas was founded by Archbishop Lanfranc in the 1080s well outside the city walls as a lazar hospital, the floor of the church being prominently sloped to aid cleaning. It was endowed with money from two manors, later supplemented with regular donations from archbishops, who provided and revised statutes for the hospitals. Henry II visited

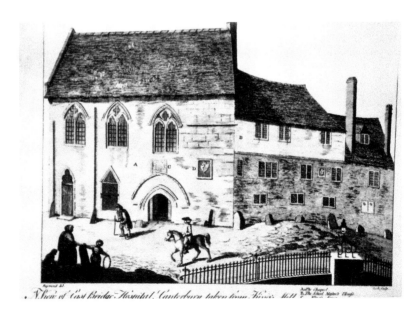

Eastbridge
Hospital.

A View of East Bridge Hospital, Canterbury, taken from Thine. 11.11

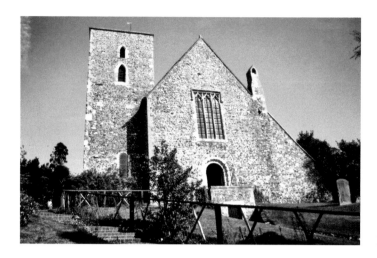

St Nicholas',
Harbledown.

Harbledown on his way to do penance at Becket's shrine and granted it 20 marks in rent 'for the love of St Thomas'.

In 1343, after the demise of leprosy, Harbledown was united with Eastbridge Hospital. Later a perpetual chantry was established there, which was abolished at the Reformation. The site is now used for sheltered accommodation. St Nicholas's Church is a gem – open on request – and originated in the late eleventh century as a small chancel and nave and tower, with a surviving Norman west doorway. A north aisle was added in the twelfth century with an arcade of three semicircular arches. There are interesting wall paintings and floor tiles.

Harbledown was on the pilgrim route from London to Canterbury and is mentioned by Chaucer in *The Canterbury Tales*, where he calls it by the delightful name of 'Bobbe-up-and-down', referring to the fluctuating gradients.

Erasmus visited Harbledown after visiting Becket's shrine in 1510 and wrote an interesting account, commenting that St Nicholas has sixty brothers and sisters, some of which live in the community with houses and some living outside with a financial allowance. The Archbishop of Canterbury is the patron and there is a chaplain.

St John' Hospital, Northgate

St John's was also founded by Lanfranc for 'the lame, weak and infirm', with an endowment of £70 per year. It had a master, reader, eighteen in-brothers (one of whom was annually chosen as prior), twenty in-sisters, and the like number of out-brothers and out-sisters. Part of the original chapel and a Norman doorway survive, though much altered and modernised, but the kitchen and hall are thought to date from just after the Reformation. Visits can be made on request of the warden.

The Poor Priests Hospital

The site was a tannery and a minter's house on the banks of the Stour in the twelfth century, which were converted into almshouses in the name of the Virgin Mary for elderly and poor priests by the minter's son, Alexander. The priests used the house as a

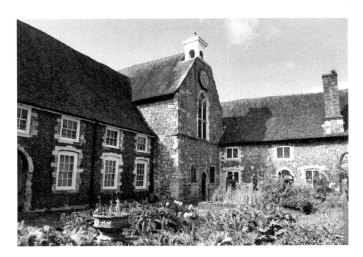

Poor Priests Hospital.

hall, sleeping round a central fire; a solar and undercroft were added in 1373. The Crown got possession at the Reformation and in 1574 Queen Elizabeth granted it to the city for the lodging of poor boys and a house of correction. Subsequently it had various uses, including workhouse and police station. In 1987 it opened as an excellent heritage museum after restoration had highlighted the crown post roof. Problems with funding, charges and partial opening led to decline of use. The Marlowe Theatre took it over in 2017, with help from the Marlowe Society, as 'The Marlowe Kit'. The Marlowe and Conrad collections will continue to be held there.

The Priory of St Jacob

This was at Wincheap, just outside the city walls, and was probably called the Priory or Hospital of St James – 'Jacobus' is the Latin for James. The hospital was founded by a doctor called Feramin or Fermin, who attended the monks of Christ Church. He asked the abbey in 1188 to 'take the hospital into their protection'. The abbey agreed to maintain three priests and one clerk 'for the services of religion and twenty five leprous women'. This was why the hospital was outside of the city: for fear of contagion. It had become a house for six poor women by 1546, with a chapel and a hall. It was surrendered to the Crown in 1552 and went into private ownership. The only trace of it now is in street names.

The Hospital of St Laurence

This was on the Old Dover Road, founded by Hugh the Abbot of St Augustine's Abbey in 1137. He granted it 21 acres of Canterbury land as well as land in Chislet and Sturry to finance its maintenance. According to eighteenth-century documents it was a hospital both for the relief of leprous monks and the poor parents or relations of monks of St Augustine's Abbey and the warden was always chosen from one of the monks. Part of a wall survives on the Old Dover Road and a gateway on which could still be seen (in 1838) a 'half obliterated representation of St Lawrence's gridiron (on which he was martyred) attended by two men'.

The Friaries

Greyfriars (Franciscan)

Canterbury was a natural starting point for the orders of friars seeking to establish themselves in the larger English towns, where they could best live off charity and preach and minster to the poor and sick, notably at Eastbridge Hospital. After an inauspicious start at Dover, where five friars were nearly hung, five Franciscans arrived in Canterbury in September 1224 – during the lifetime of the founder of the order, St Francis.

The master of the Poor Priests Hospital helped the friars and gave them part of the hospital gardens, where they built their original buildings. This site was inside the city walls on a small island on the River Stour, thus well sited for water. In 1267 one of the city aldermen, John Digge, gave land on the far side of the Stour, where the friars built a church. By 1498 the friary covered 18 acres of land, including gardens and orchards, and there were thirty-five friars. Only one building survives, astride a branch of the river on two pairs of arches; this is an attractive, restored two-storey dwelling of stone, flint and bricks. Its original purpose is unknown; possibilities are a hospitium, infirmary or warden's residence.

Blackfriars (Dominican)

The order was founded by St Dominic in 1217 and arrived in England in 1221. They visited Canterbury three years before the Franciscans, but did not establish their friary on the Stour until 1236 on a 5-acre site. All that remains is the flint refectory of 1260 and the hospitium for guests. The former has a projection out of its river-facing wall where a pulpit was located, from which one of the friars would read scriptural passages at mealtimes. After the dissolution, those structures not demolished were used by weavers as a cloth factory.

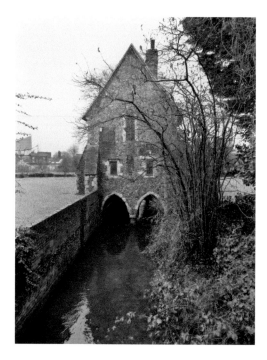

Greyfriars.

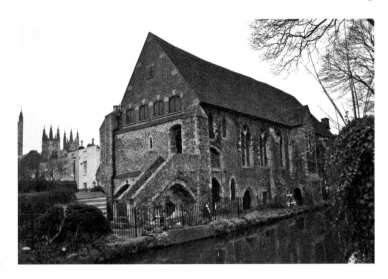

Blackfriars Refectory.

Whitefriars (Augustian)

The Whitefriars were founded 1324. The Augustinian friary in Canterbury had its main entrance in St George's Street, now marked in the pavement by an inscription. After the Reformation a house called Whitefriars developed from the religious foundation in which Mrs Knight, who adopted Jane Austen's brother, lived in the early nineteenth century – Jane frequently visited. A photograph survives online of the house before its destruction in the Blitz. Excavations of the friary ruins revealed the church, main cloister, infirmary cloister, kitchen, refectory and dormitory, with walls standing 2 metres high in places, plus superb fireplaces and beautifully carved stonework.

Other Vanished Ecclesiastical Buildings

The Nunnery of St Sepulchre

This was founded by Anselm in 1100 next to the Church of the Holy Sepulchre, near the junction of Oaten Hill and the Old Dover Road. It was a small Benedictine priory with a prioress and a handful of nuns.

St Gregory's Priory

This was founded by Archbishop Lanfranc in the late eleventh century opposite to St John's Hospital, originally under the administration of secular canons, replaced by Archbishop William (1123–36) by canons regular. It is mentioned in the Domesday survey and possessed several churches including St Dunstan's and Thanington. The priory church burnt down in July 1145 and it was damaged in 1241 during violent altercation with the chapter of Christ Church.

It was frequently investigated and punished in the fourteenth century for malpractices, including the access of women and failure to observe the rule of silence. It was dissolved in 1536, with the prior receiving an annual pension of 20 marks. Its later use included a pottery and a tobacco pipe manufactory. It seems to have been largely destroyed around 1848, although a drawing of it was published in 1879, presumably from memory.

3. Canterbury's Hermits and Anchorites

The first hermits in the Christian tradition were the Desert Fathers and Mothers who lived out their lives in the wastelands of Egypt, Palestine and Syria. In antiquity these early desert ascetics were famed for their austere religious practices, which included long periods of contemplation, rigorous fasting and mortification of the flesh. The most famous of these desert saints is Anthony of Egypt, who was the first to seek out the wilderness (AD 270); his biographer Athanasius of Alexandria recorded and made famous the stories of his many temptations.

Many may think that when Bertha came to marry the Anglo-Saxon King Ethelbert of Kent in AD 580 she was the first Christian in his kingdom to be given permission to follow the Christian faith, but this was not so. Though we do not know their numbers, there were native Britons living and practicing their faith in Kent (as indeed elsewhere throughout Britain and under Anglo-Saxon rule) whose families had converted to Christianity long before when the island was still a Roman colony.

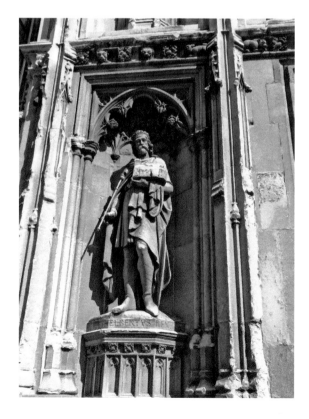

Statue of Ethelbert.

Canterbury's First Hermit

The first recorded hermit from Canterbury was a contemporary of St Augustine. His name is not recorded but because he has chosen to live his life 'in the wilderness' in the style of the Desert Fathers he is clearly working within a Christian tradition, and we are told that his local community had priests and bishops. However, British Christianity was obviously far less well organised than Augustine's for it had few or perhaps even no churches. Rome, on the other hand, even in the seventh century was well on the way to becoming a powerful, monolithic, centralised and well-ordered institution.

In 603 the British bishops are said to have sought out the hermit and asked his advice before their meeting with Augustine. Should they accept Augustine and the authority of the bishop of Rome over the British church in Kent? Their holy man rather disconcertingly suggested that they should judge Augustine's behavior as a man – presumably he was suggesting that this would reflect the kind of Christianity that Augustine represented. His words were: 'If he rises up to greet you, then accept him. If he remains seated, then he is arrogant and unfit to be your leader and you should reject him.'

The story did not have a happy ending for the Canterbury Christians as Augustine did not rise to greet them and quarrels followed. Soon after Ethelbert ordered all his subjects to present themselves for conversion to Rome. Saying 'no' was not an option.

The Early Canterbury Solitaries

Early references to Christian recluses term them hermits and/or anchorites. But in the Middle Ages the Church saw a clearer distinction between these two groups, while acknowledging that both were indeed solitaries whose needs and objectives was to retire (metaphorically) to a 'desert' of contemplative prayer and meditation.

From the eleventh century to the Reformation (at the end of the fifteenth century), a significant number of Canterbury men and women opted to withdraw from secular society in order to adopt an intense spiritual lifestyle. Most were content to enter into one of the four great orders of friars in the city or either of the two great abbeys, where they were subsumed into a monastic collective culture. A very small number in Canterbury chose to become hermits or anchorites in order to adopt a more isolated, penitential lifestyle. So far only two medieval hermitages are known in Canterbury and two anchor-holds.

English Episcopal records show that both hermit and anchorite were required to obtain an episcopal licence before they were admitted. Anyone wishing to become a recluse had first to obtain the consent of a priest known to him or her. Low birth and illiteracy was not a social issue: a candidate could come from any walk of life, and from either a lay or a religious background. The Church did not generally accept women as hermits for the latter were more often required to undertake hard physical work on behalf of the community such as the upkeep of roads, keeping wayside chapels in good repair, maintaining roads and bridges and carrying combustibles up towers for the lighting and maintaining of primitive beacons that were the warning systems for shipping on the coast. Anchorites could be of either sex, however. The men who applied were often retired priests or friars; many women were widows, 'spinsters' (that is, unmarried) or nuns that wished for a more reclusive lifestyle.

An interview would follow and the priest would contact the bishop (or archbishop) only if he considered that the candidate was suited to an isolated and what might seem to us unnatural lifestyle, somewhat reminiscent of solitary confinement and with a poor diet. What was obviously essential was that their sense of vocation had to be rock hard. Mental stability was a consideration – there were a number of suicides, bulimics, anorexics and self-harmers among the solitaries. Young candidates, men as well as women, were often asked to spend a year or more living the life of a novice within a more traditional convent in order to test and strengthen their vocation.

If accepted each candidate had to be provided with a dowry or had to be self-funding. The archbishop could himself contribute or draw on a network of patrons and generous benefactors, including rich convents. Whatever support was offered had to be for the solitary's lifetime factored into the equation was the fact that an anchorite enclosed in a cell had to be supported by a servant who would make and bring food to the recluse.

The most evident difference between the hermit and anchorite is probably location. The hermit was permitted to retain freedom of movement in the world and could change his location several times (with, of course, his director's permission). The hermitage could be a stone built cell, but it could also be a cave or makeshift shelter. The anchorite, on the other hand, lived out their religious life walled up or locked into a specially built cell (the anchorage or anchor-hold) appended to the wall of a church and which she or he never left alive.

In an attempt to channel and regulate the lifestyle of those who were to become solitaries, the Church, having accepted the candidate, provided them with a confessor and/or spiritual advisor to monitor and direct their physical and spiritual well-being.

Ceremonial induction rites were devised (for the hermit noticeably much simpler than those used by the anchorite or those in monastic institutions), which might indicate that the eremitical lifestyle had an appeal to men who had little or no education but were passionate in their desire to share the sufferings of Christ. Chaucer, in his persona of pilgrim in *The Canterbury Tales*, noted that the most fervent pilgrims in their group making their way to Canterbury were the poor priest and his brother a poor ploughman (the latter presumably illiterate). Both were on foot – an indication of serious penitential intent behind their pilgrimage and a mark of their humility.

During the ceremony the hermit made his vows of chastity, obedience and poverty, after which part of the 'Service of the Dead' was recited. For the anchorite, the ceremony was longer and more complicated. During Mass the candidate holding a candle made a profession of vows to their bishop or delegate promising to remain in the anchor-hold and to devote themselves to prayer and penance. Then came the singing of the litany of saints and after communion the 'Prayers of the Dying' were recited and the anchorite sprinkled with earth. At that point the bishop entered the anchor-hold and blessed it. An anchorite priest would have a small internal altar consecrated and blessed. Following that the anchorite took possession and the archbishop, bishop or his delegate gave orders that the door should be sealed.

There is no 'one rule' for either hermit or anchorite. Sometimes the priest or archbishop made a rule for incumbents or modified a rule book that had been written for other sets of recluses. Various rules for hermits survive, more often in English rather than Latin.

What both hermit and anchorite were required to do, and the rule helped them do, was to maintain a celibate lifestyle and a cycle of prayer – a simplified form of the Divine Office as those celebrated in monastic orders. Otherwise they did not change their name or adopt a distinctive costume that would mark them out in society. Priests, ex-friars monks and nuns retained their original habits.

Most anchorites were content to follow a quiet existence of contemplation, prayer and fasting. Too much contact with the community was frowned upon but anyone could ask them for spiritual advice and they may have provided a valuable service in the community. Rotha Mary Clay, in her influential book *Hermits and Anchorites*, found out that many female anchorites were making or repairing the clothes of the poor, and that all, charitably, were 'beadsmen' praying for all those who asked for their prayers.

DID YOU KNOW?

Margery Kempe (b. 1373) – an eccentric 'wanna-be' saint who was the first woman to write her autobiography in English – visited Canterbury Cathedral with her husband. She obviously spent hours shrieking, swooning and weeping, as was her wont, in front of the numerous shrines and altars, creating a disturbance and annoying the monks and pilgrims round about. Her husband went back to their lodging but she remained. At dusk the beleaguered monks called on the senior monk to deal with her. Suspecting she might be a Lollard, he questioned her closely. Having assured himself that she was not a heretic he led her out of the cathedral and suggested (no doubt ironically) that she might do better as an anchorite. One monk suspected she was possessed of the Devil; the crowd of pilgrims that had gathered round about her suggested that she should be burnt. Margery left the cathedral precinct in a huff. And then she realised that she couldn't remember where her lodgings were.

The Hermitages

The first hermitage (in Canterbury) that we know of was said to have been a room or even a cupboard in the old Church of St Mary, which stood over the Northgate. The name of the hermit is not known and we do not know what jobs he would have been obliged to do. The church was contained in an upper chamber over the gate, which spanned the street below. The area round about this gate was always overcrowded and unpleasant with jerry-built buildings and narrow streets. Even in the twelfth century buildings were being constructed in the city ditch at this point.

All that is known about a second hermitage is that it was erected on a parcel of land that included the great Dane John mound. It was still known as a hermitage in 1446 when in August 'the land called the hermitage, with a part of the great Dungeon land was consigned by a William Benet to John Lynde and others' (*Canterbury in the Olden Days* by John Brent, 1879).

The Anchor-holds

At the moment we only know of two Canterbury anchorites. Much is known and has been written of the little houses that were constructed for anchorites and stood attached to churches. They were often flimsy constructions, with walls of wattle and daub and a roof of reed. They nearly always had three windows – the most important being the squint through which the solitary could see the enactment of transubstantiation on the altar. Windows were the anchorite's all-important contact with the outside world. It was important that he or she could be confessed, follow church ceremonies and receive holy communion – his or her spiritual food and support. There was always a second window on the ground floor and its usual measurements were 2 feet by 2½ feet. Here the anchorite's servant could pass in food and drink, take out slops, pass in firewood and take out ashes. This window was heavily shuttered and curtained normally with a black cloth. This was the only thing that gave him or her contact with secular society. A third window high up permitted a view of the heavens.

A female anchorite (variously called Lady Lora or Loretta or 'Loretti of Hackington') had her anchorage by Hackington Church close to the highway linking Canterbury with the London–Dover road. She was obviously useful to the community because she 'was glad to receive and pass on messages'. She died in 1266 and may be buried in the chancel. This is unusual as many anchorites were interred in their own anchor-holds. Sometimes the solitaries were told to prepare their own graves by removing a handful of earth every day in preparation for the coming event! Hackington church has a dedication to St Stephen the Martyr and during the time Loretti was there pilgrims could have visited her and also left offerings before the cult statue of the church's patron saint, which was apparently 'much resorted to by pilgrims for cures'.

In 1533 Christopher Warener was an anchorite in the friary church of the Dominican Order of Friars (the Black Friars) Canterbury. He must have been well regarded as he was asked to interrogate Elizabeth Barton, often known as the Holy Maid of Kent (she was then a nun in the Convent of St Sepulchre's, Canterbury). At this point no one knew whether she was a self-deluding hysteric or a genuine visionary who heard voices and saw visions of the Virgin Mary.

The interview must have taken place at his anchor-hold. Warener came down on her side. He wrote to Thomas Cromwell saying that after a consideration of Elizabeth's 'perfect life and virtue' he thought her ability to prophesise 'a thing supernatural' and did 'judge it to the best that it should come of God'.

Barton, who had been admitted to the nunnery on the recommendation of Archbishop Warham's early commission of enquiry, caught the interest of a Dr Bocking, who was connected to Christ Church. He declared her to be 'a person much in the favour of God and had special knowledge of Him in many things'. He began to meet and to counsel her regularly, as did two sympathetic Canterbury Franciscans and her parish priest. The girl began to get a great deal of attention from learned men.

It was at that point that the events of her life became entangled in the king's convoluted divorce proceedings. In the early 1530s she prophesied that 'if Henry divorced his wife Katherine he would cease to be a king and die a shameful death'. She was not afraid to make these pronouncements publically and even to Henry's face. It perhaps comes as

St Stephen's Church, Hackington.

no surprise that in March 1534 the Maid was being paraded before the good people of Canterbury in a penitential shift along with her five 'confederates', similarly humiliated. From 20 April 1534 we have a record of her death written up by one of the Canterbury Franciscans: 'This year was the Maid of Kent ... drawn to Tyburn [from the tower of London] an a hurdle and there hanged and headed.'

The most painful prolonged and humiliating death that could be devised for man was reserved for the men said to have schooled her in her 'prophesies'. After the grisly 'show' the Maid's head was parboiled and placed on London Bridge. The men's were displayed on various London gates.

A monk from St Augustine's smugly recorded that Elizabeth Barton had 'by marvelous hypocrisy mocked all Kent and almost all England'.

4. The Skull Behind the Iron Grill

The old grey flint church of St Dunstan with its Saxon tower seems to be feeling its age. It squats today, as it has for centuries, on a little prominence that overlooks a roundabout linking the old Roman London road to the road from Whitstable where fisher girls from time immemorial used to walk in with creels on their back bringing in fish to sell to the good people of Canterbury.

The Roper Gatehouse.

In 1524 one John Roper, a local rich Canterbury man with a great estate just outside Canterbury city walls and an equally prestigious property in Eltham, wrote in his will: 'my bodye to be buryed in the churche of Saincte Dunston without Westgate of Canterburye, in the chapel of Saincte Nycholas. in the same churche where I have made my burying place ... I bequethe to the making of an horse way, for the fysshe wyves, and other, in the highway from Whitstaple, to the entering of the street of Saincte Dunston, without the Westgate of Caunterbury ... one hundred markes.'

The Roper Chapel is still there – having been 'updated and beautified' (perhaps rather incongruously to modern eyes) by replacing its outer flint wall with Tudor red brick.

The Roper men – in particular John and his son William – were deemed to be hard, greedy, quarrelsome and intransigent, but when William married Margaret More (the highly intelligent and Latin-educated daughter of Thomas More, Chancellor of England) it was thought an excellent match. The young married couple did not live in Canterbury, but William saw to it that he inherited the valuable Roper estates in St Dunstan's, Canterbury, despite the terms of his father's will to the contrary. Thomas More, meanwhile, had built a great mansion in Chelsea in a pleasant location by the river and preferred to have his extended family round him. William Roper found no objection – as a lawyer and MP he could turn the contacts he made in this great house to advantage. A pious, even ascetic, man of his time, More had founded a private chantry chapel in the nearby Chelsea parish church near the chancel and hoped to be interred there in the family vault.

St Dunstan's Tudor Chantry Chapel.

Disaster for the More family came when Henry VIII, anxious to marry Anne Boleyn, became intent on disproving the validity of his marriage to Katherine of Aragon and began the break with Rome.

More declined on grounds of conscience to take the Oath of Supremacy, declaring the king to be the head of the Church of England, and resigned his chancellorship. He also made a bad move: he failed to attend Anne Boleyn's coronation, which was noted and enraged the new queen's family.

Within months he was a marked man; his career ended. His trial was a piece of staged theatre with perjured evidence and a jury that included members of the Boleyn family. Despite failed attempts to link him in with the Maid of Kent he was found guilty and sentenced to a traitor's death – to be hanged, drawn and quartered – but this was later commuted to beheading. He was taken to the Tower in 1534, where after several grim months he was beheaded. He managed to say on the scaffold that he died 'a good servant of the King, but God's first'.

His body disappeared – most likely thrown into a communal grave in the tower Chapel of St Peter ad Vincula. His head (presumably after parboiling and coating with tar) was exposed on London Bridge. Legend has it – and it does appear likely – that the head was collected by Margaret from the bridge master some weeks after his death and that she identified it by a missing tooth and took it back to the Roper's Chelsea home, where the need to keep it discreetly hidden soon became apparent. Henry had already decided, for example, that the family should be ousted from More's Chelsea estate and the property given to a favourite courtier.

And this is where the little church of St Dunstan's Canterbury comes into play. For at some point the Roper Chapel would acquire a secret relic – the head of Thomas More. The word 'relic' was not a word to be bandied about in a post-Catholic period.

Soon after acquiring her father's head, Margaret had found herself in a potentially dangerous situation: she was called before the privy council and interrogated as to what her reasons were for retrieving her father's head. She died a year or two later.

When William Roper made his will he had asked to be buried alongside Margaret (now among the More family dead in Chelsea) but for whatever reason, when the time came, permission was refused.

On his father's death, William and Margaret's son Thomas was charged with his father's burial and must have been devastated that the family could not lie together in the chapel his grandfather had so loved. Thomas had his mother dug up and had her bones (evidently along with his grandfather's skull) sent to the Roper vault in St Dunstan's Canterbury, and here his father was also interred.

All this – the story of the skull – was not known, or had conveniently been 'forgotten', because of the dangerous and often violent times in which these people lived. It only came to light in 1835 when by accident the roof of the Roper vault was broken and a grisly head was revealed 'seen to be enclosed in a leaden case with one side open; that stood in a niche protected by an iron grill'. The vault was investigated and later sealed; a tablet on the floor above now bears the inscription 'Beneath this floor is the vault of the Roper family in which is interred the head of Sir Thomas More of illustrious memory, sometime Lord Chancellor of England beheaded on Tower Hill.'

The St Nicholas Chapel is now full of display boards and information regarding the archeological findings and story of Thomas More's life and his literary works. Donated by the Roman Catholics are beautiful windows commemorating More and his fellow martyr Bishop of Rochester.

Do not look for the great estate that once belonged to the Roper family for it has entirely disappeared; all that remains today is a single doorway.

In 2000, Pope John Paul declared More to be the patron saint of statesmen and politicians. There is a plaque in the middle of Westminster Hall (part of the original Palace of Westminster) – a reminder that More was Speaker of the House of Commons before being appointed Lord Chancellor of England.

These days it is not possible to visit the vault, but the church is open daily.

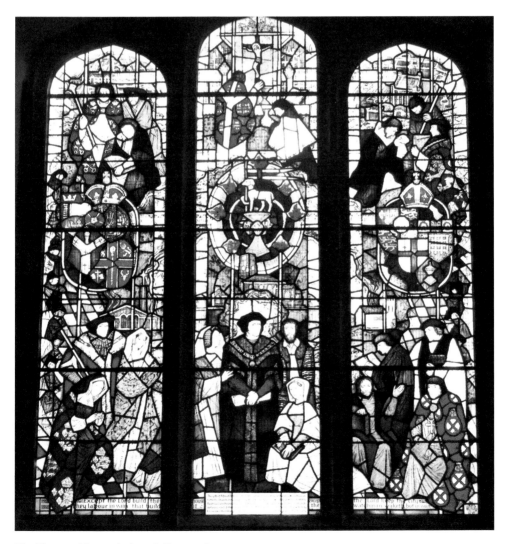

The Thomas More window, St Dunstan's.

5. Pageants, Plays and Customs

Mystery Plays

In many medieval cities the guilds sponsored cycles of mystery plays, often on Corpus Christi Day in July. Canterbury had such a cycle, but no texts survive. References to them are sparse, but indicate that performances were financed by the craft guilds and probably ceased around 1520. Ronald Hutton in *Stations of the Sun* suggests that the sparse references to mystery plays in Canterbury could well be because the civic emphasis swung behind the St Thomas Pageant, only a few days away in the calendar.

Five Pageants on the Feast of St Thomas

Pageants in the Middle Ages and Tudor periods were largely civic affairs organised through the guilds. As to be expected at Canterbury, there was a major celebratory processional pageant on the feast of St Thomas in early July, for which considerable details survive in the Canterbury Civic Archives. There were five pageant processions: the Salutation, St George, the Nativity, the Assumption and St Thomas, which probably started and ended at the old Guildhall. Constables of the various city gateways and soldiers accompanied the processions, with the mayor and aldermen following the St Thomas pageant. Giants featured and the St Thomas pageant used a horse-drawn cart with actors playing the four knights who killed St Thomas, who seems to have been represented by a puppet with detachable head and a bag of blood.

The Medieval Fête

Nowadays there is a July Medieval Fête with a procession starting from West Gate Gardens that wends its way to the cathedral. In it King Henry, harangued by his wife Eleanor of Aquitaine, tries to justify to the crowd his role in the killing of Becket and is led away to be whipped by young monks. The procession includes giants and the four knights on horseback.

The St Nicholas Parade

Another modern celebration, in December, which draws on medieval iconography and beliefs is the St Nicholas Parade. St Nicholas, children's saint and archetypal Father Christmas, travels from the Curzon Cinema to the cathedral where a service is followed by free hot chocolate.

Plays

The professional theatre developed in London in the latter part of the sixteenth century with companies grouped around the monarchy and leading aristocrats to protect themselves from vagrancy laws and the opposition of puritans, who became increasingly

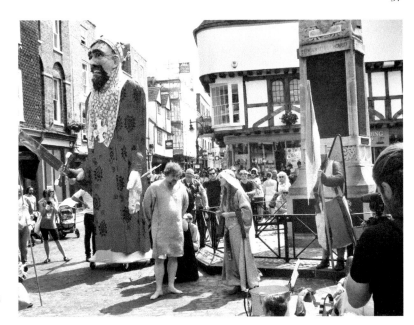

Canterbury
Medieval
Fete 2018 –
Eleanor berates
King Henry.

active in city and town councils. During the summer months and plague outbreaks, many of these companies toured the provinces and there are records of payments for performances in Canterbury. For example, in 1591 30s were paid to Lord Strange's Men for performing at the 'courte hall before Mr Leedes and other brethren'.

In the reign of James I, Shakespeare's company became 'The Kings Men'. After Shakespeare's death the company had a regular contract with Canterbury Council, which caused problems when the council's Puritanical leanings turned against public performances of plays. The council had, on several occasions, to pay the King's Men not to appear! In 1621, the council made a payment of 20s 'to William Daniell the cheife of the Kinges Players to ridd them out of the Cittie without acting'. And in 1622 in April, 'the kinges players' were given 22 shillings to 'depart the Cittie and not playe'. In March 1629, 'the kinges players' were paid 10s 'for there forbearing to play in the Citty'. In each case it is likely that the King's Men were on general tours in Kent.

Folk Customs
Morris Dancing
There are no records of early village Kent sides or of Kent dances, but touring groups of dancers frequently visited the county. Philip Edmonds, in an article 'Hoath and Herne', quotes the following references to Morris dancing in Canterbury in 1589 from the records of the quarter sessions in the Canterbury Cathedral Archives Library: 'And yesternyght being fryday they cam to Brydge...to the ale howse and ther laye and from thens cam to Canterbury and sayeth they were going to St Stephens to Mr Peter Manwood but that Mr Manwood dyd not request and they went of ther on myndes...they began at St George's Gate to daunse till they cam to the highe striate and ther they daunsed once or twyse agaynst Mr Mayers dore.'

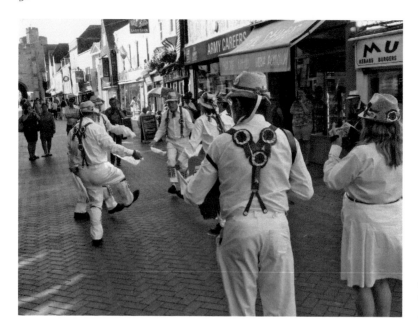

Hartley Morris dancing in Canterbury, 2018.

James Barley, aged twenty, was one of the company who 'dyd adresse themselves in the morrys dansis appere [apparel]'. Twelve-year-old Thomas Yong is described as 'being dressed in womans apparel for mayd Marryon, without any breeches and with breyded here'.

Morris dancers were male, but the six dancers were often aided by a fool and a Maid Marion – a boy dressed up as a woman.

Beating of the Bounds

Many seasonal folk customs are perambulatory, the most obvious being the Beating of the Bounds, a ceremony often enacted at Rogationtide, which precedes Ascension Day, when the parish boundaries were walked and the younger generation symbolically beaten or bumped to aid their territorial memories. This is one of our earliest documented folk customs and was regarded with suspicion by Puritans, but Elizabeth I reaffirmed permission for clergy, churchwardens and parishioners to process on Ascension Day to define parish boundaries and offer up prayers for fruitful crops.

The Canterbury city boundaries were formerly marked out by wooden crosses, later replaced by stones. In early times the bounds were beaten every seven years. A detailed route survives from 1761, which started from Westgate Bridge and followed the river to the bridge above Dean's Mill and then to Dean's Meadow, Barton Mill. Old Park Lands, the Mote, Paternoster Wood, Gutteridge Field (where there was a milestone by the Old Dover Road), Nackington Farmyard (where there was a boundary stone near Murton Farmhouse), Smith Forge at the corner of St Jacob's Hospital, Wincheap and Cock and Bull Lane. This regular beating of the bounds died out in the nineteenth century, but there were occasional revivals and a photo of 1910 shows 'The Beating of the Bounds Before the Crossing of the River Stour'; sometimes the Beating the Bounds was organised by parishes and a photo survives of the custom at St Stephens in 1903.

Beating of the Bounds in the parish of St Stephen, 1903.

The Hooden Horse

The derivation of the term 'hoodening' is a mystery. It may mean a disguise or covering (as in 'hooded') as it consists of a man representing a horse by crouching under sacking or a hop pocket and moving a wooden horse's head attached to a pole, with jaws that snap open and shut on stone teeth. It is a Christmas/New Year perambulation, bringing good luck, but there are no pre-eighteenth-century references; however, there are for analogous customs in other parts of the country and some scholars have linked its origins to horse worship.

The expert on this custom was Canterbury solicitor Percy Maylam, who researched it and produced his classic book *The Hooden Horse* in 1909. His research shows that Hooden Horse teams regularly visited the environs of Canterbury – at Blean; Mystole, Chartham; Broad Oak and Wingate Farm, Harbledown. The Lower Hardres Team visited Canterbury regularly between 1859 and 1892:

> They went round for a week or 10 days at Christmas time and must have covered a wide district, Petham and Waltham, Upper and Lower Hardres and Nackington, even going into Canterbury itself, where they entertained parties of soldiers in the public houses, but this was not altogether a success, the soldiers being too vigorous with their horseplay, quarrels and black eyes were the frequent result. Mr Edward Mount Collard recollects this party visiting Sextries, in the parish of Nackington, from 1870 to 1890. Mr Thomas Louis Collard tells me that in the early sixties [1860s] the hooden horse used to come at Christmas to the St Lawrence Farm House, Canterbury, which was then his home, he also tells me that the Lower Hardres horse visited Winter's Farm, Nackington [up to 1892].

James Frost and Geoff have recently founded the Canterbury Hoodeners, which performs annually in December at the New Inn and the Bell and Crown. The performance includes a play based on other British horse customs at midwinter, written by Geoff and Nick Miller of the Hartley Morris and also sometimes performed in Canterbury and environs by the Tonbridge Mummers and Hoodeners. Percy Maylam's great-nephew, Richard Maylam, lives at nearby Charing and supports the revivals.

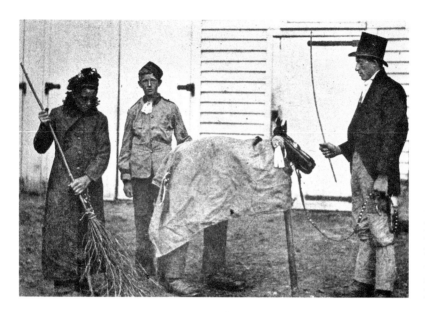

St Nicholas at Wade Hoodeners, 1905. (Courtesy of Percy Maylam)

The Canterbury Hoodeners at the New Inn, 2016.

6. The Canterbury 'Others'

The Quakers and their Cemetery

It is hard to imagine nowadays, but in seventeenth-century Canterbury the most persecuted and disliked of all the dissident communities within Canterbury's walls appears to have been the Quakers (i.e. members of the Religious Society of Friends). Records indicate that Quakers were being persecuted in Canterbury during the second half of the seventeenth century on a regular basis – vilified, locked up, fined or imprisoned. Sources also indicate that they were very vociferous, indignant and resentful about their social and political exclusion from society as dissidents and highly critical of Canterbury society generally.

Although George Fox (the founder of Quakerism) never visited Canterbury, a visit in 1655 of two Quaker missionaries – William Caton and John Stubbs – made a huge impact. The society grew in numbers and in 1687 the Canterbury Quakers set up a meeting house (they did not use the word church or chapel) in Canterbury Lane. This meeting house no longer exists but taxi drivers waiting for customers often lounge underneath a faded plaque that indicates where it once stood. The original building was destroyed during the Second World War June bombing raid in 1942.

All dissenters at this time, along with Roman Catholics, were regulated and discriminated against. By law, they were not allowed to become MPs and were excluded from the universities. An additional problem was that they were obliged to pay 'tithes' to the Church of England, despite the fact that they were not Anglican members. Many felt that they were being burdened financially and unfairly. Disputes – many acrimonious – were commonplace, and Canterbury's citizens began to regard the Quakers as troublemakers. They regularly went into a church and argued with the preacher in the middle of a service. Thomas Pollard disrupted a cathedral service by standing up and

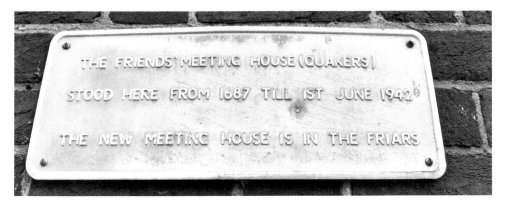

Friends former Meeting House.

shouting out that they were all in a 'Great Mad-House'. Another Friend refused point-blank to pay church taxes. His name was Martin Swarthing and he spent twelve months of his life locked up for the offence – they happened to be his last for he died in prison, leaving behind an impoverished widow and children.

High days and holy days in Canterbury began to be good fun for townsfolk after the Restoration of the Monarchy, but the Friends, whose worship was not Christocentric, did not recognise either Christmas or Easter and neither did they venerate the saints. In fact they thoroughly disapproved of holidays and claimed that 'so- called holy days' were just an excuse for over-indulgence, not to mention 'card playing, dicing, play-acting & reveling'. In 1685, one Canterbury shoemaker and cobbler Luke Howard, who had a Quaker wife, was persuaded by her to keep his shop open over the Christmas period. His neighbours promptly brought along hammers and nails and nailed up his front door. They probably wished him a Merry Christmas.

More problems arose when the Friends found that the Church of England denied them burial in consecrated ground in Canterbury. Under pre-Reformation canon law certain people (i.e. suicides, the excommunicated and the unbaptised) could be refused Christian burial. Quakers do not have clergy, or believe in sacramental rites or use holy water. Inevitably, the Church of England labeled them 'unbaptised'.

Eventually a space was found for the Friends' dead: outside the city walls, up on 'Forty Acres', next to the Jews' cemetery.

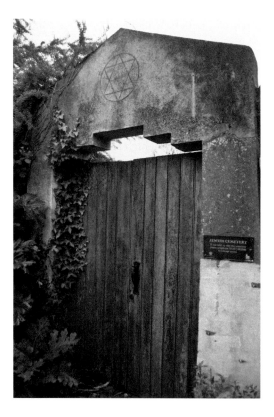

Formal entrance to Quaker's Burial Ground.

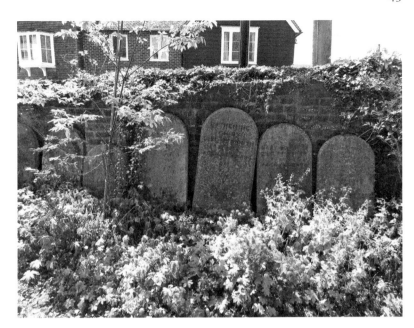

Saved Quaker
tombstones.

This was one of Canterbury's great secrets until 2016, for though it was possible to get access the burial ground was tucked away behind buildings, there was no car parking, one could only visit on certain days and phone calls had to be made in advance to arrange for the collection of the key. A further problem was that the burial ground had become neglected and overgrown over the years and the original gravestones were very eroded. Today only a few rescued headstones that stand in front of the perimeter wall of the present meeting house (built in 1956) are all that remains of this almost forgotten Quaker cemetery. And this is because the Church of Jesus Christ of the Latter Day Saints (the Mormons) bought the Quaker burial ground in 2015, bulldozed the burial ground and built their present meeting house over it. Only a section of one old wall remains to remind us where the walled-in plot used to be.

But we are assured by Quaker friends that for most Friends this is not a sadness: belief in the afterlife is not, apparently, a pre-requisite of their faith.

DID YOU KNOW?
Friends used to be known as Quakers or Shakers because they would tremble uncontrollably when standing to pray or talk when the spirit descended upon them. Dorothea Scott was a prominent Canterbury Quaker and preacher who lived in St Alphege Lane and was married to Major Daniel Gotherson, who had served in Cromwell's army. She left for America in 1680 to find religious freedom. She settled on Long Island, where her descendants still live and was a founder of the Singing Quaker Movement in America.

Canterbury's 'Strangers'

Parlez-vous français? If so, you might like to attend a service in French that is held every Sunday at 3 p.m. in the Black Prince's Chantry Chapel in the cathedral. The entrance is signposted on the lawn 10 metres from a door on the south side of the cathedral, near a sign that proclaims *'Eglise Protestante Française de Cantorbéry – fondée au XVm siècle d'origine Wallonnes et de remanance Hugeunote.'*

These two groups (Walloons and Huguenots) were also known as in Canterbury as the 'Strangers' – the Walloons being a congregation of Protestant refugees from Belgium and Holland, and the Huguenots a later influx of refugees from France. They arrived in successive waves and in considerable numbers at times, which did, on occasion, cause the locals some concern, but the Strangers from the first were 'self-sufficient, self-regulating concerning morals and behavior', generous in that they shared the secret of their craft with Canterbury's weavers and, as far as we can tell, were scrupulously polite towards their hosting city and its citizens. What is sure is that their considerable managerial and practical abilities (for they were highly skilled weavers with many master weavers among their numbers) helped to turn Canterbury into one of England's most prosperous and thriving manufacturing cities. The Walloons dealt predominately with woollen cloth, while the later Huguenots gained a phenomenal reputation for the production of silk. It was Elizabeth I who first allowed them the use of Canterbury Cathedral's crypt, and they made full use of it. Here they stored goods, used it as temporary lodgings when necessary, held secular meetings and also used it for their worship. In the seventeenth century, Archbishop Laud's dislike of the Protestant refugees in the realm is well documented; he demanded that the Strangers integrate into the community by becoming members of the established Anglican churches in Canterbury. The Canterbury refugees were non-confrontational. They acquiesced and were soon observed to be attending services in the many parish churches in Canterbury while continuing to worship in the crypt with their own ministers, and in their own language and using their own liturgy.

The Strangers' Presence in the Black Prince's Chantry Chapel

Notice the window that shows two hands clasped in friendship over a red beggar's purse on a green background? This represents the Walloon congregation; the beggar's purse may be a symbol of pilgrimage. John Bunyan, a Calvinist, famously used pilgrimage as a metaphor for one's life being a progress towards God in his work *A Pilgrim's Progress.*

The cross over a dove in the adjacent window represents the Huguenots. It was devised following the revocation of the edict of Nantes in 1688 as a symbol of their Protestant faith and is patterned after the Order of the Holy Spirit insignia worn by Henry IV of Navarre. The symbolism is complex: four triangles meet in the centre to form a cross, signifying the four gospels and their eight rounded tips signify the Beatitudes; the fleur-de-lys that link the four arms of the cross represent both the Trinity and purity; and the heart-shaped space between each fleur-de-lys and the cross signifies loyalty. Note also the cartouche near the doorway to the crypt. It has a quotation from Ecclesiastes 5:1: *'Quand tu entreras en la maison de Dieu, prends garde à ton pied et approches-toi pour ouïr'* – guard your step when you go to the house of God and approach to listen.

Above: Walloon Window.

Right: The Huguenot Cross.

The Ecclesiastes cartouche.

A Note About the Chantry Chapel

The cathedral took the chantry chapel back in 1895 but has made it available for worship by Canterbury's Huguenot community.

Chantry chapels were only set up by very rich Catholics. They are where services of the dead along with Masses and prayers were constantly said for the benefit of the donor after his death – such prayers were thought to help reduce the departed soul's time in Purgatory.

This chantry chapel dates back to the eleventh century, though the interior of this was updated and remodelled in the fourteenth century at the instigation of its founder, the Black Prince. The Black Prince (1330–76) was the eldest son of Edward III and his wife Philippa of Hainault. He had engaged in a number of successful military campaigns against the French, which gained him a reputation as a warrior prince, but he could also be viciously cruel.

The Back Prince may have been particularly concerned about the validity of his marriage. He had made a consanguineous marriage to his cousin Joan (known as the Fair Maid of Kent) for which they had obtained a dispensation from the pope. It is of little surprise then that one of the bosses is thought to represent his wife. It is not coloured – though it may well have been painted in the pre-Reformation period – and shows a woman with luxuriant hair bound in a net snood gazing steadily outwards.

The Black Prince's chantry chapel is open to the public on Saturdays (12–2 p.m.) with the entrance via the crypt. Check in advance for crypt closures.

Boss: The Fair Maid of Kent.

Canterbury's Jesuits

The Society of Jesus (the Jesuits) was founded in 1540 and its contact with England has always been sporadic and somewhat unfortunate. It was, for example, infamously implicated in plots to overthrow Elizabeth I and was also associated with the Gunpowder Plot, not to mention the Inquisition. From the year 1579, when the then pope set up a college for the training of English priests in Rome and put the Jesuits in charge, the Society has always been linked to education and entrusted to run prestigious schools, colleges and seminaries throughout Europe. And this is how the Jesuits came to be involved with Canterbury. For in 1880 a community of French Jesuits from Lyons (there being political persecutions in France at this time) bought Hales Place, a huge eighteenth-century mansion in St Stephen's parish on the outskirts of Canterbury for the sum of £24,000. This they turned into monastery and a public school for French boys and renamed The Jesuit College of St Mary. The boys dined in the elegant hall and worshipped in its beautiful chapel; there were dormitories for 300 male students and the park was full of beautiful sculptures, probably religious in nature. New buildings were added to the existing buildings, including state-of-the-art science labs. The college was popular with French aristocracy. They paid high fees, sent their sons to board and visited regularly. When the college closed in 1928 the buildings were demolished and the land sold on as building plots. A huge housing estate now covers the hillside. Where the great house once

stood was in the middle of what is now called The Terrace. Part of the once impressive avenue leading to the mansion became Hales Drive. Of the once great college all that remains is a small section of a wall, and a delightful little Jesuit chapel and cemetery in Tenterden Drive.

The Jesuit Chapel

This tiny chapel probably started off as a dovecote in 1776. In the twentieth century it was converted into a chapel by Miss Hales, the then owner of Hales Place and a former nun. When the Jesuits took over the estate they used it as their mortuary chapel. There are nineteen Jesuit burials in its grounds, plus one burial of a young student. Miss Hales and two others in her family were reburied here in 1928 when the Jesuits left.

It is a Grade II-listed building, circular and with a porch. The main building materials are attractive alternating bands of flint and red-brick strips 'bonded with stone and blocks of animal knucklebones'. The little porch has a round-headed arch topped by a cross made of animal bones. The slate roof has a lantern that is surmounted by a cross. As the building is kept permanently closed we did not see the interior, but are told that the walls and ceiling are plastered internally and painted blue with gold decoration. There is also a marble altar dated to 1875, and a funeral brass to Sir Edward Hales, 5th Baronet (d. 1802) that depicts him in medieval costume. This brass was formerly in a grander and larger chapel attached to Hales Place – now demolished.

The Jesuit Chapel.

This tiny chapel has enormous curiosity value and is also of historical interest, but is in a rather tragic state of neglect. The little cemetery is so overgrown that its few headstones are almost entirely hidden. It stands next to a bus pull-in and a rubbish collection point. When we first began this book we asked a friend who had lived in Canterbury for sixty years where the chapel was. 'Never heard of it,' he said. He lives less than half a mile away.

Canterbury's Jews

Cromwell readmitted Jews to England in 1654. By 1760 there was a considerable Jewish community living and working in Canterbury in the labyrinth of narrow streets inside the medieval walled town – and relations with the locals we are delighted to say were very good.

The Jews acquired a burial ground in St Dunstan parish, which became the burial ground for all Jews in East Kent and which they once shared with the Quakers. Today this is kept locked and anyone wishing to visit must ring 01227 862190 and find out where and when they can obtain the key. We have visited and found the site badly overgrown and difficult to access.

Their synagogue was built in St Dunstan Street in 1763. Unfortunately this building had to be demolished when in 1846 the South-Eastern Railway needed the land space for a level crossing. Compensation was duly paid. Land was eventually purchased in King Street in 1846 and a new synagogue built in the Egyptian style. The architect was a local man named Augustus Welby Pugin.

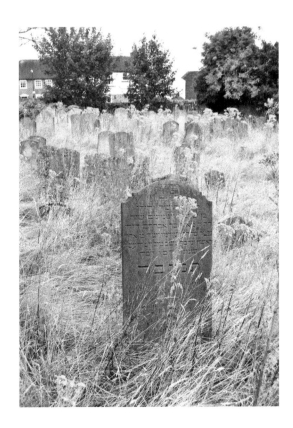

Jewish graves.

The synagogue.

The Canterbury Jewish Ritual Bath

Outside the synagogue just to the north is a little building. It is a *mikveh*, or ritual bath, built at the expense of the La Mert brothers in memory of their mother. It has in-branded brickwork in quasi-Egyptian style to match the synagogue. The date above the door is incorrect. It would have contained a changing room and a small bath with steps. There are windows on each side, which would have been shuttered or curtained, and the room was heated by means of a small fireplace.

A *mikveh* is a ritual bath for full-body immersion and is an important part of Jewish tradition. It is normally found near the synagogue and would have been considered a sacred site. The Canterbury immersion pool was known as the Women's Bath – there are instances of Jewish communities with pools for men and women elsewhere.

This form of ritual bathing or ablution in an immersion pool in freshwater is thought to be very ancient. We are told that two holy books, the Mishnah and the Talmud, refer to the practice. 'The cleansing of the physical body was never the object– its purpose was to achieve spiritual purity or renewal.' Ritual bathing is part of Jewish law.

An underground water supply brought water to the immersion pool.

The *mikveh* was used by women following menstruation or childbirth, but also by brides just before marriage. If they had no pool of their own men would use the *mikveh* to achieve purity following relations with their wives; bridegrooms bathed just before marriage. Gentiles who converted to Judaism used the pool as part of the rite

The *Mikveh*.

of conversion. Priests would use the bath 'in preparation of performing certain rites'. Bathing in a *mikveh* was also required after contact with a corpse.

In the past, for some Jewish communities all eating utensils and objects connected with food that had been used by a Gentile had to be cleansed in a *mikveh* before Jews were permitted to use them. Gentiles were not permitted in the *mikveh*.

In 1982 the synagogue and its *mikveh* were sold to the King's School. At that point the *mikveh* was converted into a room – the original fireplace is still there, though no longer used.

7. The Debtors

Westgate Towers was built over a branch of the River Stour and had its own drawbridge and huge double doors that were locked at Curfew. It is the only remaining example of eight gates to survive from Canterbury's medieval city and was built in 1380 by Archbishop Sudely on the site of an earlier structure. The architect was possibly the famous Henry Yevele, who had designed Christ Church Cathedral's nave. The gate is built of grey Kentish ragstone. Until 1829 it was used as the city prison.

Westgate Towers Museum was opened as a city museum in the first decade of the twentieth century. It is still a museum today and has to be entered through the Pound Cocktail Bar and Restaurant (the former gaol and police station).

The Debtor's Prison
The Westgate Towers has two circular towers. The lower turret rooms were used in the eighteenth century to hold the debtor prisoners.

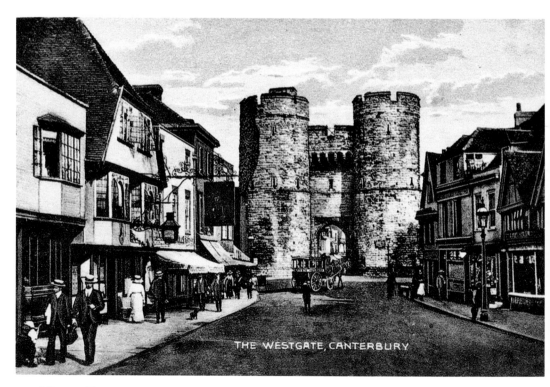

Westgate Towers.

In the eighteenth century, those who got into financial difficulties and became insolvent were regarded as cheats and dodgers. Their incarceration was to ensure that the bankrupt did not leave the city before their debts were cleared.

The gaolers initially decided to use the ground-floor rooms in the towers as day rooms for their debtors. They wanted them to be seen. The road passing under the Westgate was the main London–Dover road and a great number of travellers passed under the arch. A begging box was fixed to the wall under the archway next to the road in the hope that charitable wayfarers would give a donation. Because most debtors were local, their relatives (whom it was hoped might somehow find the money to clear the debt) could visit regularly. They did not have to gain access to the prison. It seems that they just brought extra food and drink and passed it through the medieval gun-loop windows to their loved ones. Debtors also were known to stick out their arms from the glass-free windows and beg from passers-by.

At some point in the mid-eighteenth-century security became a problem. A large circular iron cage was custom made and placed in one of the lower room in the Westgate and the debtors were kept in this during daylight hours. It was removed in 1775.

James Nield (1744–1841) was a prison reformer who had made a fortune in the city from his jeweller's shop in the fashionable St James Street, London. As a young man in 1762 he had been greatly moved when visiting a young fellow apprentice who had been confined in the King's Bench for debt. On his retirement and inspired by a great sermon from an Anglican cleric, Nield dedicated himself to prison reform and began to visit debtor's prisons everywhere and to report on the harsh treatment of men he considered 'unfortunate' rather than criminal.

He visited Canterbury's Westgate and left a damaging report. He mentions that the actual gaol is over the west gate and that there is only one common day room, but because it has been partitioned into five sleeping cells for criminals it is now 'a mere slip of a room with a fire place at one end and a stone sink in the other with an unenclosed and filthy sewer' (toilet), which because it is sluiced is not 'unbearably offensive'. Nield says how debtors 'mix indiscriminately throughout the day' with those committed for assault or bastardy. The room has not been whitewashed, which it should have been by law at least once a year and is in a 'nasty state'. Nield describes the sleeping arrangement for the debtors. They are given two sleeping rooms, one at each end of the tower, each 11 feet 6 inches and well ventilated, but with no toilet facilities except a bucket and no running water. There were no beds, just a rush mat laid on the floor for each debtor with two blankets and a rug. Neild complains that he only saw one mat in each cell and one old rag of a rug and a tattered blanket. He mentions that the rooms were bitterly cold in winter.

Nield pointed out that the debtors should have the right to walk about in the open air. He mentioned that the prison rules are not displayed. He noticed that their begging box was indeed fixed on the gate wall but was now 'so obscured now by rust and dirt as is not easily to be seen'. He recommended that the cells be washed out frequently with un-slaked lime and regularly fumigated with vinegar to freshen the air. He particularly wanted the toilet to be screened 'to separate the sexes where decency most requires it'.

Nield worked hard to raise funds for the release of debtors. After fifteen months of strenuous fund raising in August 1774, he managed to get 986 small debtors released from prisons up and down the country.

The pleas of reformers like Nield did have an effect. In 1829 in Canterbury the new purpose-built Westgate Gaol opened. Now there were clear instruction for the processing of prisoners and the staff were given written instructions regarding their duties. The gaol additionally had a visiting surgeon and a matron as well as a keeper. There were two common day rooms – one for each of the sexes. For night-time each debtor had a sleeping cell with a bed and blankets. There was also an outdoor platform for the debtors to take the air, part of which it overlooked Pound Lane. It kept the debtors in the public eye.

Here are some of the gaol's new rules:
- Anyone refusing to obey the prison rules was for 'the first offence to be kept on bread and water in close or solitary confinement' for any time 'not exceeding three days', though this could be extended to one month. A second offence merited the same punishment with the addition of whipping in the presence of the visiting justices and the other prisoners.
- Debtors who did not receive any allowances from the city and county were obliged to 'procure for themselves and receive at seasonable times' food, coal, bedding, linen and other necessities all of which had to be vetted by the keeper or matron.

Westgate Gaol.

No debtor was permitted more than one pint of wine or one quart of strong beer in twenty-four hours. If they were caught trying to defraud the officials they would 'forfeit their claim to all future indulgence'.

- Any debtors wishing to ply their trade had to apply to the keeper for permission and could send for tools and materials provided that the objects were not 'unsuitable for admission'.
- Debtors who were totally destitute of friends and incapable of supporting themselves would be eligible for the prison allowance.
- Debtors were locked up in their rooms until sunrise during the whole of the year. At 10 p.m. all fires and lights were extinguished. If a debtor or his visitor broke a pane of glass it had to be paid for.
- All visitors had to apply to the keeper before being admitted to the debtors' rooms (Sundays excepted) between 8 a.m. and 4 p.m., but not twice in one day. Debtors were not permitted to entertain more than two friends (or relations) at a time.
- If any of the debtors' friends acted improperly the keeper could order them out. If they refused to go he could compel them by force and refuse them admittance in future. They could of course appeal in which case they had first to obtain an order from the visiting justices or sheriff.
- If any debtor made 'any improper use of the water closet' or threw anything down it that was 'not in a liquid state' or left any kind of mark on the walls floors windows and doors he or she was confined to his or her room for any time up to three days at the keeper's discretion. For a second offence the confinement was doubled. This punishment had to be sanctioned by visiting justices and entered into the visiting justices book.
- Finally, if any debtor refused point-blank to obey the keeper's orders, he was to be immediately confined and reported to the visiting justices, who would 'award such punishments and privations' as the case merited.

One unfortunate debtor lost control and seems to have hit Mr Ruck, his keeper. He wrote a sad little poem, which was published in a newspaper on 10 July 1773. Here is part of it: -

Here felons lodge, and each poor debtor
who cannot pay for today better
To be in debt is sure curse
The fear it causes ten times worse
How many honest men now rot
in jails, for debts of trifling note?
Denied power to maintain
Their hapless wives and infant train
No pity's shown
perchance until the wretches die

8. The Secret Tunnel

The following account is by Jonathan Baker, a trustee of the Crab and Winkle Line.

THE SECRET TUNNEL UNDER THE HILL

One of Canterbury's best kept secrets is the disused Tyler Hill Tunnel, which ran underneath the Kent University. The tunnel was part of the pioneer Canterbury to Whitstable railway.

The Act of Parliament for the line was passed on 1825. The route was 6 miles long from North Lane in Canterbury directly over the Blean Plateau to Whitstable. The line used inclined planes to cross the high ground. This needed a tunnel of 842 yards to maintain the gradient of 1 in 56 through the hill to the present day university.

The tunnel was designed for rope haulage of the trains driven by two stationary winding engines, one at Tyler Hill and the second one at Clowes Wood. This meant the tunnel was constructed to mean dimension, 12 feet high x 12 feet wide for a single track. The railways was designed by George and Robert Stephenson .

The tunnel was started in 1825 and bored through the London clay at the northern end and the southern end was through running sand. The two gangs boring the tunnel through in 1827 and was less than 1" out of alignment. A good result using pick and

Crab & Winkle Line signpost.

shovel and wheelbarrow under light of candles! The tunnel was lined with approximately 2.5 million hand-made soft red bricks and lime mortar. The northern 465 metres was a horse shoe in cross section with a brick invert below and the southern remaining length was vertical walls with a barrel vaulted roof with brick footings.

The railway opened on 3 May 1830 with much civic celebration, as this was the first railway tunnel to carry passengers in the world. Passenger trains were open trucks being pulled up hill and free-wheeled on the downhill gradients.

The South Eastern Railway took over the line in 1846 when a new line from Ashford to Sandgate opened. Modifications to the tunnel were carried out. This included the formation of 10 tunnel refuges on the East side only, to shelter platelayers in the tunnel. Major works were required at the North portal by adding buttress wing walls as the portal was in danger from collapse.

The line was repaired and converted for steam locomotive operation which in the tunnel created problems for the future as specially cut back chimneys, bocher mountains and vans were required in order to fit into the tunnel.

Passenger coaches and good wagons also had to be modified to fit in the tunnel.

The line was merged to form the South eastern and Chatham Railway in 1899.

The tunnel had no air shafts and locomotives worked 'bunker first' to travel to Whitstable. The locomotive crews were almost suffocated as there was little clearance between the chimney and the crown. They must have been glad to exit the tunnel for fresh air!

In 1923 the South Eastern and Chatham Railway became the Southern Railway which wasted no time to nationalise the line. The Southern invested in shares in the east Kent Road car Company which enticed the passengers to travel by bus despite a slower journey. The train took 18 minutes, a journey time that cannot be achieved today.

Passenger services were withdrawn on January 1 1991, as more modern stock could not be use due to tunnel. Freight services continued until withdrawn by British Railways on 29 November 1952. This should have been an end but nature has other ideas. In January 1953 came the East Coast floods when the main line from Faversham was severed by the sea. This meant the Crab and Winkle Line was re-opened to deliver essential supplies to Whitstable until March 1953 and the line was finally closed. The track was soon torn up and the land sold.

The tunnel lay abandoned and open throughout until 1955 when a three quarter section at the South end was sold to the Archbishop's School and was subsequently blocked with cross walls and a door. The remainder of the tunnel was sold to British Rail for a princely sum of £70, to the Kent University. This sale included the tracked North of the tunnel to Tyler Hill Road.

Both British Rail and the university inspected the tunnel every five years and noted the inner ring of bricks was scaling badly. The North portal was blocked and fitted with a steel door and air bricks to ventilate the tunnel.

I have walked through the tunnel in 1970 and noted the tunnel was dry and sound.

In 1973 the university carried out a major survey and found some sections of the tunnel needed early attention to prevent collapse. They noted that the section below Cornwallis building had deteriorated with local failure of the brick lining and recommended that the tunnel be trained with finite sprayed concrete.

The Postgate Banner.

As tenders were being evaluated the tunnel below Cornwallis collapsed, severely damaging the building above, in July 1974.

Emergency tunnel filling was carried out from the North portal to just South of Rutherford College 500 metres from the North portal. The tunnel was filled with fly ash and a weak cement mixture poured through boreholes above the tunnel.

A ventilation borehole was provided to ventilate the unfilled section leading to the South portal. A further section was filled leading to a block wall at 690 metres with a second vent borehole.

The tunnel has been listed as a Grade 2 listed building in recognition of its history. As a result both portals have been restored.

The Tunnel's Secret Bats

The tunnel is a perfect home for bats and has a new life as a roosting area for the tiny Natterer's bats, which live in the open brickwork joints as the tunnel is cool and moist – ideal for hibernating bats. Shirley Thomson of the Kent Bat Group led the 2018 visit to the bat colony in the tunnel. For details of Canterbury's secret bats go to the Kent Bat Group website.

9. Canterbury's Statues and Monuments

Canterbury has wonderful figurative statues commemorating men and women associated with Canterbury's history, such as *Ethelbert and his wife Queen Bertha* by Stephen Melton (2006) in Lady Wootton's Green, and the monumental bronze *Chaucer in Canterbury* by Samantha Holland and Lynne O'Dowd (2016) at the junction of Best Lane and High Street. In the last, commissioned by the Canterbury Commemoration Society, the figure and plinth are separate creations; the base represents characters found in *The Canterbury Tales* and remodeled on people with Canterbury connections.

The Bull by Stephen Portchmouth (2006) in Tannery Field, Westgate Park, has a highly symbolic content that may not readily be understood by those not acquainted with Canterbury's more recent past. The statue is made out of ripped up old railway track found on-site and was once used by the tanneries.

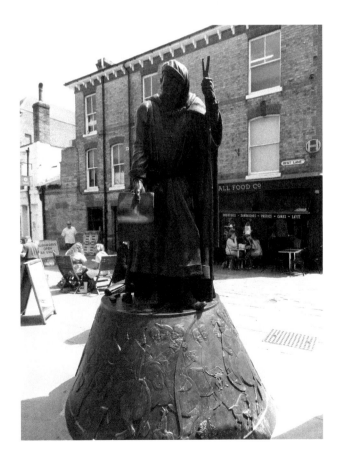

Chaucer.

Canterbury's tannery business started over 200 years ago and only closed in 2002. Tanneries use freshly slaughtered animals and have to divest the hides of any remnants of blood, dung, hooves and horn. The trimmed skins then have to be degreased, desalted and soaked over a process of days. It is the last process that is notoriously noxious – the stink over the city is still remembered. Normally tanneries were sited away from city centres, but this one was not. Its absence is not mourned.

Tannery Fields is now part of Westgate Park and the setting is green and delightful, a far cry from the Bosch-like reality of what the field looked like when tannery workers were pushing rail trucks filled with waste products over the area and working amongst heaps of foul-smelling filth. The land as well as the river had become contaminated. When the council acquired the site in the 1930s volunteers transformed the space into wildflower meadows.

We love *Alluvia* by Jason de Caires Taylor too (2008). There are some works of art that take your breath away by their audacity, and this is one.

Passing over Westgate Bridge with the fourteenth-century Guildhall and gardens on one side and the bustling Café des Amis and row boats for hire on the other, peer into the usually fast-flowing River Stour and try to make out two figures, both women swimming underwater, their hands stretched out above their heads as if pushing against the flow. The figures, made of cement and recycled glass resin, are embedded into the floor of the river. There is an interaction between the continually striving human figures and the river environment for during the summer months plant life starts to appear on the bodies and can cover them entirely. An overcast sky, heavy rainfall or storm conditions can also make the figures disappear from sight. At night, because the silicone bodies are internally illuminated, what you see is a faintly disconcerting eerie glow from under the water.

The Bull.

Jason de Caires Taylor is one of Britain's most exciting sculptors. He has become world famous as the founder of the first underwater sculpture park in the West Indies, which is rated one of the top wonders in the world. The city can justly boast that he has strong links to Canterbury for as a young sculptor he learned stone-carving techniques in Canterbury Cathedral.

Whitefriars Shopping Centre has two exceptional works of art. Firstly, the water clock (above Ernest Jones jeweller's), created by eight Year 12 students from Simon Langton's Grammar School for Boys in July 2015. This is fitted with a regressive pump in its base that powers the water upwards and at a high speed, enabling it to be recycled. Its Roman numerals and classical clock hands were carefully designed to reflect Canterbury's history.

Alluvia.

The water clock,
Whitefriars.

Underfoot in the square and sandblasted into the York paving stones are *The Pits* (2005) by Janet Hodgson. These reproduce drawings mapping the archeological finds made in the Whitefriars site during a major excavation project undertaken in 2000–03 before it was developed into a shopping centre. Janet enlarged the archeologists drawing to life size and her sculptures mark the actual position of the recorded digs – mainly ancient cess pits that yielded valuable evidence about Canterbury's past. The work was commissioned by Land Securities and Canterbury City Council.

One sad little plaque that can be easily missed in the square records that John Stone, an Austin friar, was executed in 1538 for 'resisting Henry VIII'. His cruel death – a spectacular hanging drawing and quartering – was carried out on 'the Dongeon' (i.e. Dane John). The Austin Friary of which he was part and which gives its name to the square extended over 1.5 acres. When the friary was being closed down it was noted that the community was very poor.

We also love the simple horse trough that stands in an open space in the High Street beside Nasons department store. It has a biblical text that reads, 'To our patient comrades in the horse lines. He paweth in the valleys. He rejoiceth in his strength' (Job 39:21).

The trough, is in effect, a sad memorial to the hundreds and thousands of horses and mules that served alongside the troops during the First World War. Some were cavalry horses but others were used to haul food, ammunition, equipment and other supplies to the front lines and the soldiers who had often witnessed them died from gunfire, wounds or starvation could do little to help them. Monuments to animals used in warfare are rare. This one was set up in the 1920s by the men of the Royal East Kent Yeomanry who were

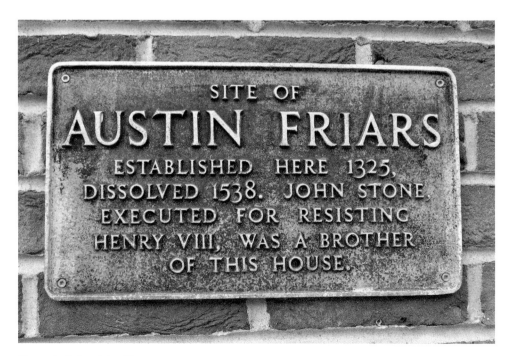

Plaque to Father John Stone.

The horse trough.

highly regarded and affectionately known as the Buffs. The trough is associated with a memorial cross to the Buffs and the original position of the two monuments was in the old city market.

This bronze *Muse of Poetry* statue by Edward Onslowe Ford in honour of Christopher Marlowe does not appear on the Canterbury City Council Statue Trail. It was commissioned by the Marlowe Memorial Committee and originally given pride of place in the Buttermarket where it was unveiled by Henry Irving in 1891. Soon called 'Kitty' by the locals, it also fell out of favour with the good citizens, many of whom felt that the nubile nymph, who wears only a slip of veiling round her hips held by a thread, was a little 'racy' for Victorian taste. After various attempts to screen her unacceptable nudity from the cathedral and the public (such as shrubs and railings) the muse soon found herself elsewhere – Kings Street, Dane John Gardens and finally, well shaded by a tree, outside the Marlowe Theatre. She has twice been rededicated: first by Hugh Walpole and more recently by Kenneth McKellen. She has been described as 'quaint and pretty' – a description which could not be accorded to the often drunk, excitable, vitriolic and totally brilliant Marlowe who died in a brawl aged twenty nine and famously is thought to have loved 'tobacco and boys'.

The Martyrs Memorial takes some finding because it is embedded in a housing estate. The best way is to approach it from the Wincheap roundabout. Take the first turning on the left (into Gordon Street) after passing under the railway bridge, and then turn into Martyrs Field Road. This was once a bare field off Wincheap and a site of unrelieved horror when over a short period of years during the reign of Mary I live burnings took place. Ten women and thirty-one Protestant martyrs died in here. The 25-foot-high memorial is granite on a concrete foundation in which granite is embedded. It is topped with a Canterbury cross.

Left: Muse of Marlowe.

Below: Martyrs Field Road.

10. Secret Parks and Gardens of Canterbury

We are spoiled for choice when it comes to selecting our secret Canterbury gardens. Not to be missed, though, is the amazing 200-year-old plane tree (*plantanius orientalis*) that stands outside Tower House and is instantly recognisable from its swollen trunk. Its secret is that it is believed to have subsumed a circular metal bench that once surrounded it.

But here is our choice of secret gardens and we start with the Great Stour Way, which was opened on 21 May 2011. OK, it is not precisely a park or garden – except that you *are* in the Garden of England! This is actually a 3-mile traffic-free surface road that runs mostly alongside the River Stour and is happily shared by cyclists, bird watchers, walkers, runners and dog walkers with pets on a lead – all thanks to Kent County Council and Sustrans Charity. You pick up the marked trail in Westgate Gardens and just keep going. The path leads you initially through Westgate Park, past a big adventure play area called Toddlers' Cove, then Bingley's island and Tannery Fields. After this the path leaves the park and moves through ancient water meadows and meadows, past Thanington and Tonford with yet more fields and farms until it arrives at the village of Chartham. It is an easy flat path set in a lovely part of Kent. If, like us, you find an hour's quiet rambling a tad exhausting, a bus ride or short train journey gets you back to Canterbury from Chartham very quickly. The cycle route is part of the National Cycle Network – Route 18.

The Plane Tree, Westgate Tower House.

One of our favourite gardens is Canterbury Cathedral Lodge Hotel's charming and secluded Camponile Garden with its stunning views over the south side of the cathedral. The garden, which is on a high mound, takes its name from its twelfth-century bell tower – the 'campanile' (or *clocarium*) that once stood on this great mound of earth to the south of the cathedral. It was hung with the largest and heaviest of the cathedral bells. When the tower was severely damaged in an earthquake in 1382 the then archbishop described it as 'many noxious spirits ... expelled ... from the bowels of the earth'. Though the tower was subsequently restored it did not survive the closure of the cathedral abbey. In 1540, on the orders of Henry VIII, when the last five bells weighing over 12 tons were sold off, the tower was dismantled and the mound reduced in size.

Canterbury Christ Church University stands on the fabulously historic site of the outer precinct of St Augustine's Abbey and is part of the Canterbury World Heritage Site. The pleasant modern university buildings were once set round flat well-manicured green lawns, but there have been changes.

For the last few years the university has sought to transform itself into a 'biodiversity hub'. To this end, various small areas of the campus have been – or are being – transformed into small areas of food or plant production that are monitored. The areas selected are those which in the medieval period were involved with food production (e.g. the monks' vineyard, wheat fields, orchards, hop gardens and medicinal gardens).

Nowadays students and staff are encouraged to grow their own fruit, vegetables and herbs in raised beds on what was once rather boring neat lawns.

The Camponile Garden.

Above: Raised beds, Christ Church
University Campus.

Right: Blessing the ale.

A small hop garden has been created with varieties of Kentish hops; they are planted, tended and picked by students and staff. There is even a blessing of the hops and of the ale by the university pastor.

What was once an empty flat lawn is now an orchard created as part of the 50th Jubilee celebrations in 2012. The university sourced old Kentish varieties of fruit trees to reflect the site's history, such as the Beauty of Kent (once a Victorian delicacy but discarded by today's buyers, who considered it 'too irregular in shape for commercial use') and Cat's Head, which was brought over to England by the Norman invaders.

Look out for the 'wild life bank' with its accompanying poster to inform us that included in the original 'long season meadow mixture' are species such as common and greater knapweed, lady's bedstraw, meadow cranesbill, ox-eye daisy, common toadflax, cowslip and dark mullein and assuring us that 'the flowers attract a wide range of birds that feed on their nectar, leaves and seed'. These are exciting projects.

The Lost Gardens of the King's Palace

Yes, Canterbury, like Heligan, has its own Lost Gardens. They were once in the abbey precinct. Now, of course, the old abbey is a fully excavated site laid bare. After the abbey's closure its stone was quickly sold off and its buildings reduced to two or three courses of stone – mere humps and bumps over a great area – with the exception of the abbot's lodging, which Henry VIII's master masons had quickly converted into the 'King's Lodging' or 'Palace'. All that remains today of this particular building is one wall part, which shows its Tudor brickwork.

But in the seventeenth century, when the palace was still proudly standing amid acres of crumbling ruins, the building was let to Sir Edward Wooton. In 1615 he engaged the most famous gardener of the day – John Tradescant the Elder. In five years Tradescant transformed the robbed and razed monastic site into a series of stunning gardens of different character and in different styles. There were three formal areas of 'knots' or mazes, with other areas dedicated to orchards. One descriptions tells us that there were: 'Faire Gardens and Orchards, sweet Walkes, Labririnthlike wildernesses and groves; rare Mounts and Fountaines all of which together take up the encompassing space and circuit of neere 20 or 30 Acres; In more part of which those rare demolishe'd buildings sometimes appeare in much glory and Splendour.'

Tradescant didn't just focus on rare flowers and plants. His kitchen gardens were particularly noted for their succulent fruits such as melons – he claimed that the secret of his success 'lay in the sheep's dung – that of goats and cows being considered too strong'. The wild pomegranates he produced were also much enjoyed.

All that remains today of these once famous gardens is, of course, the area – now an historic archaeological site – and one stump of one tree planted by the master himself (you can find it in Christ Church University grounds).

The Tranquility Gardens is a garden we enjoy. It is part of the Canterbury City Cemetery on Westgate Court Avenue and is managed by the council. The cemetery, originally 12 acres in 1876, had a further 8 acres added in 1923. There is a little Victorian double chapel with a pretty spire. What we like about the whole thing is its great peacefulness – and its wonderful trees. Walk about the paths and try to identify the Indian chestnuts,

yew, birches (not silver), beeches, tulip trees, lawsonia, spruce, parsimony trees, cherry trees, limes trees, copper beeches, redwood, walnut, Kentuckiae and spindle trees to mention but a few.

For years Canterbury was a garrison town with strong links to the 'The Buffs' or East Kent Regiment and their memory lives on here – over 200 war graves for both world wars (including some enclosed in a special formal war cemetery). The row of graves whose stones are at a diagonal were civilian war casualties that died during the three-night Baedecker Raids on Canterbury in the Second World War; the gravestones are at an angle to represent the bomb blast that hit them.

Right: John Tradescant's tree.

Below: Westgate Cemetery.

11. Literary Canterbury

Geoffrey Chaucer (c. 1340–1400)
Chaucer was MP for Greenwich and is certain to have visited Canterbury. He may well have gone on a similar pilgrimage to the shrine of St Thomas to the one he describes in *The Canterbury Tales*, in which he shows extensive knowledge of the route down the A2. In the prologue he mentions 'Bobbe-up-and Down' (Harbledown) as the penultimate stop.

John Ryman
John Ryman was a late fifteenth-century Canterbury friar with a gift for writing comic verse, such as this one celebrating the end of Lent and the anticipation of Christmas feasting, dated around 1474:

Fare wele advent, christmas is cume,
Fare wele fro us both alle and sume.

With paciens thou hast us fedde [paciens = 'patience']
And made us go hungrie to bedde:
For lak of mete we were nyghe dedde.
Fare wele fro us both alle and sume.

While thou hast been within oure howse
We ete no puddyngis ne now sawce,
But styinking fisshe not worth a lowce
Fare wele fro us both alle and sume.

Thou hast us fedde with plaices thynne,
Nothing on them but bone and skynne;
Therefore our love thou shalt not wynne,
Fare wele fro us both alle and sume.

Above alle things thou art a meane
To make oure chekes both bare and leane;
I wolde thou were at Boughton Bleane.
Fare wele fro us both alle and sume.

Com thou namore here nor in Kent;
For iff thou doo, thou shalt be shent; [shent = 'shed']

It is ynough to faste in Lent.

Fare wele fro us both alle and sume...

John Ryman seems to have a grudge against Boughton Blean, presumably because there was a rival Carmelite friary there.

Christopher Marlowe (1564–93)

Marlowe lived with his parents at No. 57 St George's Street, which was damaged in Second World War bombing and demolished. His parents, John and Katherine, were married at the Church of St George the Martyr in 1651 and Marlowe was christened there in 1564. His father was a shoemaker and the family home was probably his workshop too. Marlowe attended the King's School and won an Archbishop Parker scholarship to Cambridge University. During his visits back home he got involved in several pub brawls in Canterbury, but he did some spying for the government and had friends in high places who got him out of trouble. For example, in September 1592 he apparently attacked a tailor with a staff and dagger near Mercery Lane; civil charges were pressed and then dropped.

There is a monument to Marlowe, depicting the Muse of Poetry and locally nicknamed 'Kitty', outside the Marlowe Theatre, which previously stood in the gardens. The pedestal shows characters from his plays *Tamburlaine, Barabas, Doctor Faustus* and *Edward II*.

Marlowe's birthplace. (Courtesy of Canterbury Heritage Museum)

THE MARLOWE HOUSE

The original structure as seen from the rear, looking down St. George's Lane.

Izaak Walton (1593–1683)
The author of *The Compleat Angler* was a frequent visitor to Canterbury and his book mentions the famous trout at nearby Fordwich on the River Stour. He met his future wife in Canterbury and they were married at St Mildred's Church in 1676.

Richard Lovelace (1618–58)
The Lovelace family had strong links with Canterbury. Richard's great-grandfather was a Canterbury MP and the family at one time owned Greyfriars. The Cavalier poet Richard Lovelace often stayed in Canterbury, which was the site of the conflict leading to the Second Civil War. Lovelace was imprisoned and wrote his poem 'To Althea From Prison', with its famous lines 'Stone walls do not a Prison make'.

Aphra Benn (1640–89)
Aphra Benn, Britain's first professional female writer, was born at Harbledown. Her father, Bartholomew Johnson, was a Canterbury barber who apparently moved up the social hierarchy, possibly through marriage, and became overseer of the poor for St Margaret's Parish in Canterbury in 1654 and then Lieutenant-General of the English colony of Surinam and thirty-six other islands in 1663. The family accompanied him, but he seems to have died on the outward voyage and the family returned. Soon afterwards Aphra appeared in London, having the surname 'Behn' and launched her professional career as a dramatist, producing eighteen plays, including *The Rover*, and a pioneer of the short novel, including *Oroonoko*.

Daniel Defoe (1661–1731)
Defoe preached at the Anabaptist Church on the former Blackfriars site in 1724.

Richard Barham (1788–1845)
Richard Barham, author of *The Ingoldsby Legends* was born at No. 61 Burgate Street. The house was destroyed by bombs in the war. Many of his legends have Kentish links and one, that of Nan Cook, is set in Canterbury (*see* chapter 13).

Jane Austen
Jane's brother Edward was adopted by his cousins, the Knights of Godmersham. When Edward took up his inheritance the widowed Mrs Knight moved into White Friars House, which was destroyed in the Blitz. Jane often visited her and stayed overnight and mentions going to Canterbury for shopping, concerts and balls, which were held in Delmar's Assembly Rooms, above the Canterbury Bank. She socialised with relatives and friends in the Cathedral Close at, for example, at Meister Omers and the Deanery, and she dined at Linacre House.

Jane also visited Canterbury Gaol in Longport with her brother Edward a magistrate, when, in her own words: 'He went to inspect the Gaol, as a visiting Magistrate, and took me with him. I was gratified – and went through all the feelings which People must go through I think in visiting such a Building.'

She also dined and danced at Chilham Castle.

Linacre House in Cathedral Close, where Jane Austen dined with friends.

Charles Dickens (1812–70)

Charles Dickens featured Canterbury in *David Copperfield*, the 'House of Agnes' near Canterbury West station being used for the heroine's home: 'At length we stopped before a very old house bulging out over the road: a house with long low lattice-windows bulging out still further and beams with carved heads on the ends bulging out, so that I fancied the whole house was leaning forward, trying to see who was passing on the narrow pavement below.'

Uriah Heap's house has two suggested sites (both destroyed in the Blitz): Lower Chantry Lane and in North Lane. Dickens is thought to have written some of *David Copperfield* while staying in Priory House, on the corner of Broad Street and Lady Wootton's Green, which was also destroyed in the Blitz. The Sun Inn featured as 'The Little Inn' in the novel. Dickens gave a reading from *David Copperfield* at the newly created Theatre Royal in Guildhall Street in 1861 and praised his audience as 'the most delicate I have seen in any provincial place'.

Joseph Conrad (1857–1924)

Conrad had several Kent addresses, his last abode being the Rectory at Bishopsbourne. His funeral was held in St Thomas's Roman Catholic Church and he is buried in Canterbury Cemetery. The inscription on his tomb is by Spenser and was chosen by Conrad for the title page of his novel *The Rover* (1923): 'Sleep after toile, port after stormie seas, Ease after warre, death after life, does greatly please.'

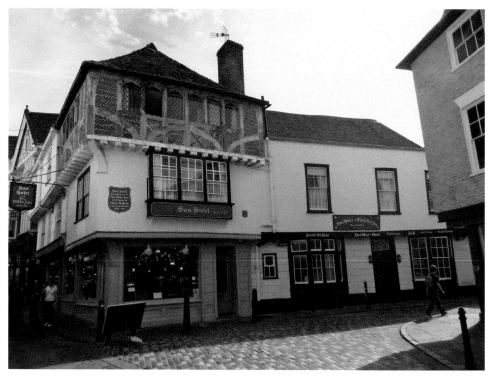

The Sun Inn.

Conrad's Grave, Westgate Cemetery.

Mary Tourtel (1874–1948)

Mary Tourtel illustrated the Rupert Bear books. She was educated at the Simon Langton School for Girls and trained at the Sidney Cooper School of Art in St Peter's Street. She is buried in St Martin's Cemetery.

Somerset Maugham (1874–1965)

Somerset Maugham came from Whitstable and was educated at the King's School, Canterbury, and drew on his experiences there for his novel *Of Human Bondage.*

T. S. Eliot (1888–1965)

Eliot's play *Murder in the Cathedral* was commissioned by the Friends of Canterbury Cathedral for the 1935 Canterbury Festival; it was first performed in the Cathedral Chapter House.

DID YOU KNOW?
A friend of the poet Thomas Gray, who often visited Canterbury, claimed that St Nicholas's Church at Thanington Without was the inspiration for his famous 'Elegy in a Country Churchyard'. The curfew bell (sounding from the cathedral) and the lowing cattle certainly fit Thanington better than Stoke Poges.

Mary Tourtel's Grave, St Martin's Cemetery.

12. The Paving Stones of Walter Cozens

Walter Cozens (1858–1928) was a man who truly loved Canterbury and its old buildings. As a city councilor for the years 1922–25 and as one of the founders of Canterbury Archaeological Society as well as one who helped promote Canterbury Art Council, he left a considerable mark on the city. Cozens was a local builder with premises on the High Street. His family home was a converted and extended old windmill in Windmill Close on St Martin's Hill, half a mile from the centre of the city.

Photo of windmill house.

Canterbury has him to thank for a series of 'historical stones', which he had carved and positioned at his own cost throughout the city in the 1930s, each one marking a 'lost' building that had once been historically important. Most of these locations had been entirely forgotten. No one knows how many stones Cozens actually planted throughout the city, or indeed how many have been lost since his day. War damage must have added to the disappearance of some. Others may have become so eroded that people considered them unsightly and had them dug up. But some have survived. Every day tourists and residents tramp over them or pass them by, most happily unaware of their existence.

Cozens is buried in St Martin's graveyard and his memorial incorporates a large Sarson stone.

This list is courtesy of Jonathan Butcher. They are also to be found on the CHAS website.

Greyfriar's Gate
Royal Mint
T. S. Cooper
Chequers
The Jews (Stone) House
Doges's Chantry
Black Prince's Chantry

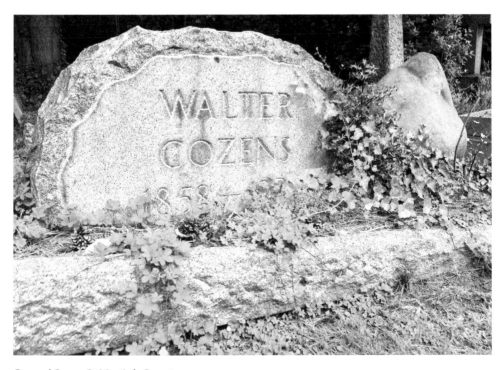

Cozens' Grave, St Martin's Cemetery.

Northgate
Wincheap Gate
Blackfriar's
Roper Gate
Knights Templar
T. S. Cooper

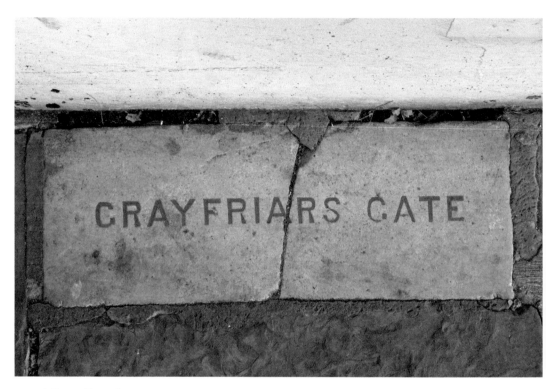

A Cozens' 'stone'.

13. Legendary and Ghostly Canterbury

Legends

St Mildred

St Mildred settled in Thanet with her community of nuns in around AD 733. She was an excellent organiser and businesswoman, arranging for the grain on her highly productive convent farms to be shipped upriver to London where it was sold in Cheapside. Many years later, after her convent was destroyed by Vikings, her sacred miracle-working relics were moved to a church at Canterbury. Mildred's body reputedly had previously refused to budge, but now she docilely permitted her remains to be transferred by the Canterbury monks, an obvious sign of her approval.

Conquest House and the Murderers of Becket

The four knights who murdered Becket – Reginald FitzUrse, Hugh de Moreville, William de Tracy and Richard le Breton – arrived in Canterbury on 29 December 1170 and are said to have left their weapons in the house of Gilbert the Citizen, now known as Conquest House. After being enraged by Becket they returned to collect their weapons, before returning to the cathedral and killing the archbishop. In the surviving Norman undercroft of Conquest House there is a secret passage the knights may have used to escape.

The Black Prince's Well, Harbledown

The Black Prince's Well is on a minor road at the back of the almshouses and former leper hospital at Harbledown. In the medieval period the well had a reputation for curing every kind of eye complaint, as well as leprosy. The Black Prince is said to have drunk from the well and to have asked for water from it on his deathbed in 1376. To commemorate this royal interest, the stone well head was later decorated with the prince's insignia of the three feathers (a badge taken from the King of Bohemia at the Battle of Crécy).

Joanna Meriwether

In 1543, Canterbury townswoman Joanna Meriwether confessed to having cast a spell on a young woman named Elizabeth Celsay and her mother with a holy candle. Meriwether ultimately admitted that she had built a small fire over Elizabeth's faeces and allowed wax from a burning church candle to drip over it. She had later told neighbours that this would cause the 'girl's buttocks to divide into two parts'.

The Mayor and the Archbishop

This is a tale told in a footnote in Richard Barham's *Ingoldsby Legends* (1837). In or around the year 1780, a worthy named Charles Story cut the throat of a journeyman papermaker, was executed on Oaten Hill, and afterwards hung in chains near the scene

Above left: Conquest House.

Above right: Secret passage in Conquest House.

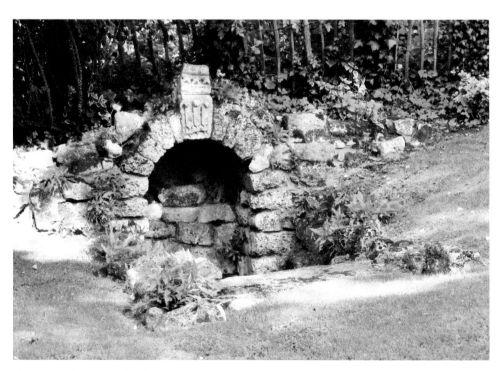

Black Prince's Well, Harbledown.

of his crime. It was to this place, as being the extreme boundary of the city's jurisdiction, that the worthy mayor with so much naivety wished to escort Archbishop M. on one of his progresses, when he begged to have the honour of 'attending his Grace as far as the Gallows'.

DID YOU KNOW?
Foster Powell walked from Canterbury to London Bridge and back in 1787 in under twenty-two hours to win a bet of 25 guineas; the return distance is 112 miles.

Ghosts
Archbishop Sudbury's Ghost
Arhbishop Simon Sudbury was murdered in the Peasants' Revolt and his ghost is said to haunt a bastion on the city walls named after him in Pound Street, dressed in grey robes. His ghost has also been reportedly seen in the cathedral.

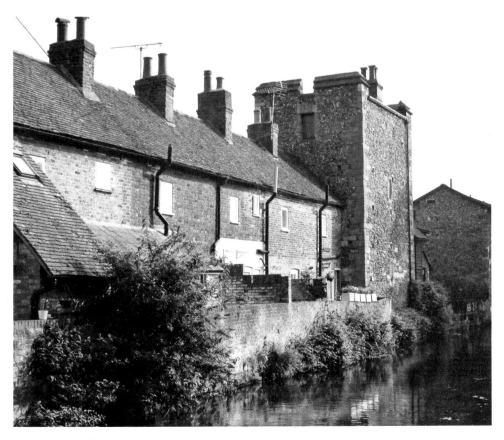

Archbishop Sudbury's Tower.

Nell Cook

Nell is the most famous Canterbury ghost and is said to appear on Friday evenings at 'The Dark Entry' at the cathedral, which links Green Court to the cathedral buildings and runs beneath the Prior's Lodgings. Nell's ghost haunts this passage and she is reputedly buried under on some flagstones near the doorway leading from cathedral grounds to Kings School. Her tale is one of many early stories collected and embroidered by Richard Barham of Canterbury in his *Ingoldsby Legends* (1837). Nell Cook's real name is said to be Ellen Bean, a cook to one of the canons living in the Prior's Lodge in the reign of Henry VIII. Barham locates the scene at the start of his tale.

From the 'Brick Wall' a long narrow vaulted passage branches off to the right that is paved with flagstones and is vulgarly known by the name of the 'Dark Entry'. Its eastern extremity communicates with the cloisters, crypt and by a private staircase with the interior of the cathedral. On the west it opens into the Greencourt, forming a communication between it and the portion of the Precinct called the 'Oaks'.

The tale is set in 'A back parlour in Mr John Ingoldsby's house in the Precinct'. Ingoldsby enquires why his nephew is frightened to go in the Dark Entry on a Friday evening: 'I dread that Entry dark with Jane alone at such an hour, It fears me quite – it's Friday night! And then Nell Cook hath pow'r!' 'And, who's Nell Cook, thou silly child? -and what's Nell Cook to thee? That thou should'st dread at night to tread with Jane that dark entrée?' The nephew replies: 'Nay, list and hear, mine Uncle dear! Such fearsome things they tell of Nelly Cook, that few may brook at night to meet with Nell.'

The nephew then recounts the tale of how an elderly canon has employed a suspiciously attractive cook, Ellen, whom he nicknames 'Nan Cook' – 'They all agreed, no Clerk had need of such a pretty Cook.' When a very attractive, pretty, supposed niece, of the Canon arrives to stay, Nell becomes both suspicious and jealous:

> Now, welcome! welcome, dearest Niece; come lay thy mantle by!'
> The Canon kiss'd her ruby lip – he had a merry eye, –
> But Nelly Cook askew did look, – it came into her mind
> They were a little less than 'kin', and rather more than 'kind'.

Her suspicions aroused, Nell places tongs and poker in the girl's bed and as these are not removed realises the girl is sleeping with the canon. She then listens, watches and poisons them!

> And still at night, by fair moonlight, when all were lock'd in sleep,
> She'd listen at the Canon's door, – she'd through the keyhole peep –
> I know not what she heard or saw, but fury fill'd her eye –
> She bought some nasty Doctor's stuff, and she put it in a pie!

The bodies of the lovers are found and buried, but Nelly disappears. It is rumoured that she's been done away with by the monks and eventually her remains are found under the flagstones. And there are hauntings:

But one thing's clear – that all the year, on every Friday night,
Throughout that Entry dark doth roam Nell Cook's unquiet Sprite.
On Friday night was that Warden-pie all by that Canon tried;
On Friday night died he, and that tidy Lady by his side.

William Jacob (c. 1623–92)

William was a prominent Canterbury physician and MP for Canterbury. In September 1652 he treated Henry Jacob for gangrene, but his patient died and was buried at All Saints' Church. Shortly afterwards Jacob was woken by the apparition of the deceased, who 'laid a cold hand on his face' and was recognisable by the distinctive cut of his beard. A maid also saw the apparition on another night.

The Old Weavers

The Weavers was so-named because of the occupation that went on there on the banks of the Stour – special windows gave extra light for work at the looms. It is now a restaurant. The ghost of a grey lady has been seen ascending the staircase.

Tiny Tim's Tearoom, No. 34 St Margaret's Street

When restoration took place earlier this century workmen found children's teeth and ringlets of their hair, along with the names and dates of birth and death of three children behind some panelling. This discovery seems to have activated their ghosts. The children's

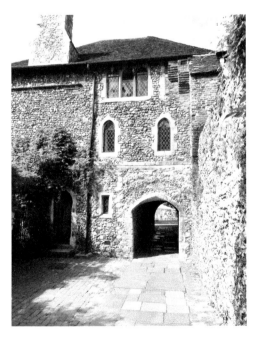
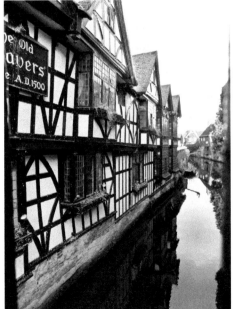

Above left: The Dark Entry. (Courtesy of Nell Cook)

Above right: The Weavers.

Tiny Tim's Tea Room.

ghosts unnerve staff and customers by appearing and disappearing and by whispering and playing behind the panelling. They also move objects, turn taps on and whisper to the guests.

The White Hart
Ghosts include that of a small boy crushed to death by corpses in the cellar (formerly the mortuary of St Mary de Castro; the boy's ghost sometimes materialises in an upper room – built later). Ghosts of men and women wearing Victorian dress, and sometimes grey shrouds, have been reported. Moaning voices have been heard and odd black shapes appear as figures.

Theatrical Ghosts
The Marlowe Theatre is said to have had a ghostly actor on the right-hand (facing) side of the stage witnessed in 1967. The Gulbenkian Theatre at the University of Kent had one siting of a ghostly stage hand dressed all in black, but several reports of noises like the climbing of a ladder on stage.

The Cycling Mayor
One of the strangest modern hauntings are the reports of a former mayor in regalia cycling through the streets of Canterbury.

14. Canterbury's Jewels and Regalia

The Civic Regalia and Jewel

When not on show, Canterbury's fabulous civic regalia and jewel is normally kept well under lock and key at the City Hall and can only be seen by appointment.

These are used by Canterbury's mayor – the city's first citizen who is elected annually from amongst its city councilors. The post is an ancient one dating back to the time when 'the Bailiffs of the City of Canterbury were assisted in the execution of their duties by a special court and by special officials'. The mayor then served as the city magistrate and presided over the local law courts. Today's mayoral duties involve a number of ceremonial, charitable or historical events such as the Christmastime visit to Archbishop Sudbury's tomb in the cathedral. This archbishop was beheaded in the Tower of London in the Peasants' Revolt and his body buried with a lead cannonball to replace his lost head.

Civic regalia, whether it is clothing or ceremonial items, has all to do with pomp, pageant and ritual. It is theatrical, richly made, brilliantly colourful and distinctive.

The Burghmote Horn

This wonderful musical instrument is the oldest piece of civic regalia in Canterbury. The Court of the Citizens (a forerunner of today's city council) known as the Burghmote was established in the reign of Henry I, if not before, where it is recorded that the city fathers were summoned 'by the sounding of a brass horn'. In 1673 accounts tell us that the city crier was paid 4s per annum for blowing the horn to summon the mayor to the Burghmote. In the past it was blown outside the house of each individual aldermen and councilor. Today it is only used on the occasion of a new mayor and when a new sovereign is proclaimed.

The Mace

A mace was originally used as a weapon but later became a symbol of royal authority. Canterbury's glittering mace is carried ceremoniously before the mayor as a symbol of royal authority for he is the king's deputy. For this reason maces are not generally carried inside cathedrals and churches and their precincts 'for therein their [i.e. the monarch's] jurisdiction ceases'. Canterbury's beautiful present mace is of silver gilt; it was made in 1681 at the cost of £60 10s and weighs 121 ounces; it replaced an earlier version that was smaller.

The Sword

James I granted Canterbury the right to appoint 'a Sword Bearer' by royal charter. The sword is carried in front of the mayor – an unusual privilege as normally only the king reserved the right to be preceded by a sword. In 1988 a new sword was commissioned

The Burghmote Horn.

when Elizabeth II granted Canterbury's mayor the title of 'Lord Mayor'. Today it is usually only carried in the mayor-making, Remembrance Sunday, freedom ceremonies and a few other civic events.

The Coat of Arms
This jewel worn by the mayor has armorial bearings of the city and district of Canterbury and represents the symbolic link between Church and Crown. It shows the golden royal lion surmounting a white badge with three black choughs (Archbishop Thomas Becket's badge) and has the inscription *Ave Mater Angliae* – Hail Mother of England.

The Lord Mayor's Chain of Office
The first ever lord mayor's chain was made in 1616, but was not passed on as it is today.

The Robes
The lord mayor's ceremonial robes are of rich damask with gold wire trim and ornaments. They are worn with white gloves, a lace jabot at the throat and lace cuffs. The tricorn hat has a gold loop and decorated with ostrich feathers.

DID YOU KNOW?
Francis Bennett-Goldney (1865–1918) was Mayor of Canterbury from 1906–11 and later Member of Parliament for Canterbury. He was honorary curator of Canterbury's Royal Museum and Art Gallery, honorary Athlone Pursuivant at Dublin Castle and honorary military attaché to the British Embassy in Paris. During his lifetime Goldney was regarded as a gentleman and pillar of the community. Following his death in 1918 in a car accident it was discovered that he was a long-term thief; his home was full of items stolen from Canterbury Museum and elsewhere. It is now thought that he was involved in the theft of the Irish Crown Jewels in Dublin Castle in 1907. The case of the missing Irish regalia has never been solved.

The mayor's costume.

The Masonic Museum

The book is all about secret Canterbury and a local museum gives a unique opportunity to find out about the Masons – a secular society with a real presence in Canterbury. Once upon a time Freemasons had the reputation of being exclusive and secretive – a male-only society that recruited uniquely by word of mouth, with grades of initiation and secret signs and symbols that could only be identified by the brethren etc. Today the society allows some of its rituals and highly symbolic artifacts to be put under scrutiny and is proud to be identified with its many charitable works.

The Freemasons' Museum is in St Peter's Place, next to the Westgate Towers, and opens daily from 10–4 all year round. It is free (though donations are welcome). The building was purpose built and has been recently revamped.

We looked at some of the fascinating regalia and 'jewels' used in Masonic ritual. Individual lodge members have their own regalia according to their level of membership and it includes aprons (indicating level of ritual) and Masonic jewels. The aprons are obviously designed to emphasize the hierarchical nature of the order as well as linking into the society's historical past.

There is 'lodge-owned' regalia as opposed to an individual's regalia. The former is used mainly for formal ceremonies and includes the all-important Master's gavel, a blindfold for initiation ceremonies, officers' aprons, the tiler's sword and lodge jewels for each of the lodge's officers. Posters explain the significance and use of these particular items and some items are on display in the display cabinets.

The jewels include a whole variety of objects, some of which are on display. Those that are worn (and not all are of precious metals) are perhaps better described as badges, though some are worn as rings. All have a high symbolic content, usually with representations of set squares, compasses and slide rules. Some are attached to a ribbon and worn on the Mason's collar or pinned on his breast.

Important images include the sacrificial lamb, the all-seeing eye, the winged angel, the letter 'G' (for 'God') and the ashlar, which reflect the moral code embedded in Masonic philosophy. These symbols appear everywhere and on every kind of object, including the jewels.

The society continues to intrigue and fascinate.

DID YOU KNOW?
The origin of being 'black balled' is said to have originated with the Masons when casting secret votes on membership using white and black wooden or ivory balls.

Above left: The all-seeing eye.

Above right: The ballot box.

15. Canterbury's Pubs

Canterbury had a substantial array of historic pubs. Many survive, but some of the most famous have been destroyed or ceased to be pubs. Most historic pubs have had their names changed at least once, but the rate of name changes has escalated recently with a number of historically irrelevant names, sometimes generated by chain pubs to the detriment of Canterbury's local history. Some new names, however, such as 'The Thomas Tallis' are relevant and inspired. Paul Skelton's 'Dover Kent Public House Archive' online is very helpful in tracking the origins, former names, and early photos of historic Canterbury pubs.

Pubs with Cricketing Links
The Olde Beverlie claims to be the cradle of Canterbury cricket, being adjacent to the St Stephen's Ground where Kent played an All England Eleven in 1841. The famous Victorian cricketer Fuller Pilch managed the Beverley Ground from 1842. A few years later the club moved to the current St Lawrence's site and Pilch retired to become the landlord of the Saracen's Head in Burgate. This historic pub was disgracefully demolished

The Olde Beverlie.

by the council to make way for the ring road in 1969 despite widespread protests by the Canterbury Society among others and schemes to move and reconstruct it. It began life as a hospice for pilgrims in the fifteenth century and stood just within the Burgate, the rear wall being built from flints from the city wall. It held a festival for woollen drapers in 1718. There was a second Saracen's Head in Canterbury: in the High Street and dating back at least to 1539. This survives, though much restored, and used to be called the County and Tudor Bar and is currently the Abode Hotel. The Olde Beverlie, dating from 1570, survives unscathed with its adjacent almshouses.

The Eight Bells

This remains a very friendly local pub and freehouse in the London Road, St Dunstan's. The first known Eight Bells on the site was built in 1708, a rambling timber-framed building with commodious livery stables to the rear, where travellers could keep or hire horses; for over 150 years a sign hung outside the inn advertising 'Bait and livery stables'. (The word 'bait' is derived from an Anglo-Saxon word 'to feed' and refers to food offered to travellers.) The name of the pub reaches back to early links between inns and churches, whereby the number of bells housed in the church belfry sponsored the inn name – St Dunstan's Church having a peal of eight bells. The first recorded owner, Nathanial Laythen, was described as being a 'vesturer' of the city of Canterbury. By the late nineteenth century the inn had fallen into disrepair and was demolished in 1898 and rebuilt on the original foundations using many of the original timbers.

The Eight Bells.

An insight into the operations of the Victorian licensing laws and opening times is given in an incident recorder in the *Dover Express* in 1869:

Public-house Offence

On Thursday, Thomas James, proprietor of the 'Eight Bells' public house, St Dunstan's, was charged with unlawfully selling a certain quantity of beer in his house before half-past twelve on Sunday morning last. Defendant pleaded in extenuation that out of the four men who were in his house he gave a pint of beer each to two, they being in his house on business. The other two persons told him they had been travelling by road. The Superintendant said the house was always kept very orderly. Fined 2s 6d and 9s costs.

The Unicorn

The Unicorn is a popular haunt for local societies and is located near Canterbury West station. It was built as a house for a woollen draper called Robert Budden in 1593 and was registered as an alehouse called The Unicorn in 1664.

The Flying Horse

This has confusingly been renamed the Corner House, a much less attractive name. It is just outside the city walls, near the beginning of the Old Dover Road. It was originally known as the Rose, but was licensed under the name of the Flying Horse in 1792.

The Old Gate Inn

This was built near the toll gate on the Old Dover Road and was originally known as the Sign of the Gate. In 1781 it became a coaching house with accommodation for travellers.

The White Hart

This was built on the ruins of a former church, St Mary de Castro (near the castle) in 1837, and the pub's cellar was once a mortuary. The pub garden was part of the graveyard and tombstones were lined up against one of the walls. The pub is said to be extensively haunted (*see* chapter 13).

The Cherry Tree

This is probably Canterbury's oldest pub, being called the Fleur de Lis in 1372. It is in White Horse Lane, which hints at the name of a lost pub. The Cherry Tree is haunted by a cat.

The Falstaff

This claims to be early fifteenth century and was perhaps built outside the West Gate to accommodate pilgrims and other visitors who arrived after the curfew to find the gate closed for the night. It was originally called the White Hart and vestry meetings of the nearby Church of the Holy Trinity were held in the inn in the sixteenth and seventeenth centuries. It was extensively renovated in the seventeenth and eighteenth centuries to accommodate carriages and increase accommodation and was renamed The Falstaff in 1783.

The Falstaff.

The Monument

This pub can be traced back to 1803 and, unusually, has retained the same name, which derives from a cross that stood between the pub and St Dunstan's Church in the middle of the road junction of London and Whitstable roads. Recent inn signs, and in fact those going back to 1960s, have used an image of the cross by the Buttermarket, but the original cross was a simple crucifix venerated by pilgrims outside the church. We have not been able to find out when this cross was removed, but, amazingly, we have spotted it on a seventeenth-century map published in J. Charles Cox's *Canterbury: A History of the Ancient City*. A claim on a website that the pub is fifteenth century is not borne out by the absence of a building on the site on the seventeenth-century map.

The Thomas Tallis Alehouse

This attractive fourteenth-century half-timbered building in Northgate was formerly part of St John's Hospital and opened as a speciality good alehouse in March 2016, specialising in Kent beers and cheeses. The sixteenth composer Thomas Tallis worked for the cathedral for a time and lived in Canterbury.

The Pound

Today this delightfully quirky pub and restaurant dovetails into the historic No. 14c West Gate Tower and gives you access to its museum. The original building was purpose built in 1829 as a gaol extension to Westgate Towers when it functioned as a prison and as the gaoler's house. The platform over the main doorway was used by debtors, who were

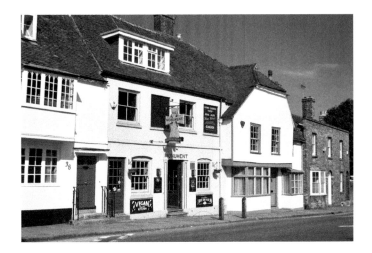

The Monument.

Thomas Tallis Alehouse,
formerly part of
St John's Hospital.

allowed to promenade during daylight hours and no doubt could converse with passers-by in the street below and those passing through the gate. A door from this area led to the debtors' cells and common rooms where the sexes were strictly segregated.

In 1907 the police station was further extended and given six police cells that strictly conformed to official guidelines. The doors of these were built of oak and lined with sheet iron and provided with a ration trap and an inspection hole. To the left of the doorway there was a small electric lamp and each cell had an oak bed frame and flushing toilet. There was also a charge room and a parade ground.

Today's pub is a heady mix of modern and old. There is an outside terrace overlooking the river, the bar has glass walls and ceilings, neon signs point the way into the darker somewhat claustrophobic cells, and other rooms now comfortably set out as places to have a quiet drink or as eating places. It is a sympathetic renovation. Cocktails seem to be the order of the day.

Above: The Pound.

Below: Police cells in the Pound.

Bibliography

Barlow, Frank, *Thomas Becket* (Orion, 2000).

Bateman, Audrey, *Victorian Canterbury* (Barracuda Books, 1991).

Brown, Peter; Hutchinson, Stuart; & Irwin, Michael, *Written City – a Literary Guide to Canterbury* (Yoric Books, 1986)

Cameron, Janet, *Canterbury Streets* (History Press, 2005).

Cozens, Walter, *Old Canterbury* (Reprint by Nabu Press,2011)).

Crampton, Paul, *Canterbury Before the Blitz* (Meresborough, 1992).

Doel, Fran & Geoff, *Folklore of Kent*, (History Press, 2003).

Doel, Fran & Geoff, *A Kent Christmas* (Sutton, 1990).

Doel, Fran & Geoff, *A Kent Christmas: A Further Selection* (History Press, 2009)

Eliot, Chris, *Egypt in England* (English Heritage, 2011)

Lyle, Marjorie, *Canterbury – 2000 Years of History* (History Press, 2002)

Maylam, R.; Lynn, M.; & Doel, G. (eds.), *Percy Maylam's the Kent Hooden Horse* (History Press, 2009)

Potter, Jennifer, *Strange Blooms: The Curious Lives and Adventures of the John Tradescants* (Atlantic Books, 2006).

Skelton, Paul, 'Dover-Kent Public House Archive'.

Townsend, Terry, *Jane Austen's Kent* (Halsgrove, 2015).

Urry, William, *Thomas Becket: His Last Days* (Sutton, 1999).

CHAS (Canterbury Historical and Archaeological Society) – scanned selection of guides from previous trails published by the Canterbury Urban Studies Centre and Canterbury Environment Centre. A full list of these publications appears on the CHAS website.

The Oaten Hill District Society – a wide range of booklets relating to the Oaten Hill area.

Acknowledgements

Our thanks go to Jonathan Butchers for generously sharing his research on Canterbury; Michael Steed of the Canterbury Commemoration Society for his inspirational and informed insights into Canterbury's past and culture; Peter Henderson archivist of King's School for generously giving of his time and knowledge to show us the synagogue and mikveh and to Corinne Finch for arranging the visit; and Dr Peter Rands for showing us the University of Canterbury Christ Church bio-studies including the hop fields and for forwarding us helpful, relevant photos and information.

Thanks go to the trustees of the Crab & Winkle Line – Jonathan Norman Baker, John Burden and Robin Townsend – for their great kindness and generosity.

Thanks are also due to the very helpful volunteers at the Kent Museum of Freemasonry for the kind permission to take and use photos; Bob Collins, museum guide Westgate Museum – our grateful thanks for his knowledgeable guidance; Hugh Norton, trustee to the French Church, for help and information; the Dean & Chapter Canterbury for the permission to take and use photos in the cathedral and precincts; the friendly helpful staff at Canterbury Cathedral Archives; Linda Burton and other staff for their unfailing helpfulness at the Beaney Public Library; Cherry Simpkin for her helpful information on the Society of Friends; the manager of the Pound Cafe and Restaurant (public house); Craig Bowen, collections and learning manager of the Canterbury Museums and Galleries; Jenny Bell, friend and guide at Canterbury Christ Church Cathedral; Michael Scarce (Civic Office), with sincere thanks for all his time, effort and enthusiasm; Stephen Burke, Master of Eliot College; and Thomas Doel for valuable assistance with photographs and computing.

All photos not otherwise acknowledged are by Fran, Geoff and Thomas Doel.

Your Towns and Cities in th

❖

Tynedale
in the Great War

Your Towns and Cities in the Great War

Tynedale
in the Great War

Brian Tilley

Pen & Sword
MILITARY

To the 1,300 men and women of Tynedale who gave their lives in the Great War – and to the many hundreds more who survived to tell the tale of Jack Johnsons, poison gas, barbed wire and breathtaking acts of courage and selflessness.

First published in Great Britain in 2015 by
PEN & SWORD MILITARY
an imprint of
Pen and Sword Books Ltd
47 Church Street
Barnsley
South Yorkshire S70 2AS

Copyright © Brian Tilley 2015

ISBN 978 1 47382 801 8

The right of Brian Tilley to be identified as the author
of this work has been asserted by him in accordance with the
Copyright, Designs and Patents Act 1988.

Printed and bound in England
by CPI Group (UK) Ltd, Croydon, CR0 4YY

Typeset in Times New Roman

Pen & Sword Books Ltd incorporates the imprints of
Pen & Sword Archaeology, Atlas, Aviation, Battleground, Discovery,
Family History, History, Maritime, Military, Naval, Politics, Railways,
Select, Social History, Transport, True Crime, and Claymore Press,
Frontline Books, Leo Cooper, Praetorian Press, Remember When,
Seaforth Publishing and Wharncliffe.
For a complete list of Pen and Sword titles please contact
Pen and Sword Books Limited
47 Church Street, Barnsley, South Yorkshire, S70 2AS, England
E-mail: enquiries@pen-and-sword.co.uk
Website: **www.pen-and-sword.co.uk**

Contents

6

Acknowledgements

The publication of this book would not have been possible without the support of the editor and proprietors of the *Hexham Courant* newspaper in Northumberland, who allowed me unrestricted access to the bound volumes of the paper from the First World War years, despite the fact that some of the pages of the century-old documents are as fragile as a butterfly's wing; that trust is much appreciated.

Great thanks also to my wife Maureen, for her great forbearance in putting up with the endless hours of research and sweeping up the dust from 100 years of history from the bedroom floor. Thanks too to all those people who allowed me to reproduce their photographs and to photographers Kate Buckingham and Tony Iley for copying so skillfully the photographs from the Courant files. I am grateful for the help of Colin Dallison of Hexham Local History Society, along with Prudhoe Local History Society, Haydon Bridge Local History Group and the Heritage Centre, Bellingham. Finally, thanks also to book editor Irene Moore, who opened the door to this exercise, for her sound advice and encouragement.

Brian Tilley

Chapter 1

1914 – The gathering storm

THERE WERE FEW men better at dispensing death from the back of a galloping horse than Charles Beck Hornby.

A military career spent mostly in India had made the Hexham landowner an expert at the arcane sport of pig sticking, when giant forest wild boar were pursued through the undergrowth on horseback and speared with a lance. The conventions of pig sticking dictated that 'as a startled or angry wild boar is a fast runner and a desperate fighter, so the pig-sticker must possess a good eye, a steady hand, a firm seat, a cool head and a courageous heart'.

As such, it was encouraged by the army in India, and Hornby was one of its supreme exponents. It was also in India that Hornby earned his nickname 'Butcha' – not from his pig sticking exploits but from his youthful looks – *butcha* is Hindi for 'Little One'.

The inexorable march of technology was already making warfare a more long distance and less personal pursuit by the outbreak of the First World War, and meant that the days of the cavalry charge were all but done. But Bangalore-born Captain Charles Beck 'Butcha' Hornby, of Sandhoe Hall, which stands overlooking the Tyne on the outskirts of Hexham, still had time to give the cavalry charge one last hurrah in the opening days of the war, and write his name into the history books.

For 'Butcha' Hornby is credited with spilling the first drop of German blood in hand-to-hand conflict of the war, as well as leading the first cavalry charge by British troops on European soil since the Battle of Waterloo 99 years earlier.

To call it a cavalry charge is perhaps

Captain Charles 'Butcha' Hornby, who drew the first blood in hand-to-hand combat in August 1914.

a little grand, but what is true is that by the end of the skirmish early on the morning of 22 August 1914, Hornby's cavalry sabre was decorated with German blood. Hornby was the 4th Dragoon Guards' adjutant for three years from January 1911 and, on the outbreak of the First World War, he was sent to France with the British Expeditionary Force as second-in-command of C Squadron of the 4th (Royal Irish) Dragoon Guards.

His place in the history books was reserved around 6am on 22 August, near the village of Casteau to the north-east of Mons in Belgium.

He wrote in his diary:

'We received information that a cavalry regiment was west of Soignies and that two other encampments estimated at 3,000 each were in that same neighbourhood. Lieutenant Veniveux with one captain and one man was sent to Casteau Camp on a report that some of the enemy had been seen there and reported that a hostile patrol had commandeered two bicycles from the chateau of Gen Donny and had retired on Soignies. The squadron moved out of St Denis at dusk and lay in a field hard by ready to move – no fires, and no smoking or talking allowed. Moved again before daylight for shelter of a neighbouring wood, in the hope of being able to capture a hostile patrol in the morning. The squadron moved at 5.30am through a wood to Casteau Camp and there the horses were watered. It was just decided to send a patrol to Soignies when a group of German cavalry was seen coming down the road. An ambush was prepared but it was impossible to conceal all the horses in time. The German troop halted and then retired, pursued by the first troop under SSM Sharpe, and one or two men from the fourth troop.

'A long chase of over two miles along the road resulted in the capture of three prisoners and the killing and wounding of several. Fourth troop came up in support, and into dismounted action against the main body of the enemy's squadron, and caused them some loss.'

Hornby makes no mention of his own part in the charge in his diary, but there is little doubt that it was he who dealt the first of the mortal blows with his 1908 pattern trooper's sword, for when he returned to barracks later, he handed the weapon to the armourer to be re-sharpened, with apologies for the German blood still on its blade.

Among those taking part in the charge was a reservist called Tilney, who wrote in 1932: 'I followed the captain as he went down the right

hand side of the road. He took a German on the point of his sword, just as I had seen the lads do at Shorncliffe with the dummies. I couldn't have a hand in the fun, so I crossed to the other side of the road, and took on a chap with a lance, whom I captured.'

The German lancers – 4th Cuirassiers of the 9th Cavalry Division – were the advance guard of General Alexander von Kluck's First Army, which was about to advance on Mons. They were not regular soldiers but, according to one account, 'young Bavarian ploughboys' who had only been conscripted into the army a few weeks earlier. One of the prisoners indicated he was very pleased to have been captured, as he would not have to play any further part in the war.

While Hornby made light of the incident, it clearly impressed arguably the most colourful soldier ever to wear British uniform, his great friend and commanding officer, Sir Adrian Paul Ghislain Carton de Wiart VC KBE CB CMG DSO, the man thought to be the model for the character of Brigadier Ben Ritchie Hook in Evelyn Waugh's trilogy *Sword of Honour*. Of Belgian and Irish descent, he served in the Boer War, First World War, and Second World War; was shot in the face, head, stomach, ankle, leg, hip, and ear; survived two plane crashes; tunnelled out of a PoW camp; and bit off his own fingers when a doctor refused to amputate them. Describing his experiences in the First World War, he wrote: 'Frankly I had enjoyed the war.'

In his memoirs *Happy Odyssey*, de Wiart wrote:

'Butcha Hornby was one of my best friends. He had the courage of a lion, and a heart of gold. He was a very hard rider after pig and a fine polo player, but he never allowed himself to drift into semi-professionalism as did so many officers. He had the distinction of being the first British officer to kill a German with his own hand. He was pursuing a German patrol and catching up with them. He hesitated, wondering whether he should put his sword through the nearest Hun. The Hun had no such hesitation, and attempted to drive his lance into Hornby, who then killed him with his sword.

'A few days later Butcha received a severe wound in the spine and was never able to soldier again. It was a tragedy for the regiment, and real loss to the Army, for if ever a man had been marked out for success, it was Butcha. In my opinion, out of a wonderful lot of officers in the regiment, Butcha was the most outstanding of them all. He had a tremendous sense of duty and was that rare thing in a man, completely unselfish. His career as soldier finished, he brought to his mental and physical suffering

all the remarkable courage he had shown in his active life – without a tinge of self pity or a word of complaint.'

Hornby was always destined for a career in the army as his father, John Frederick Hornby, was a colonel with the 12th Lancers. Born in Bangalore in India in 1883, he was educated at Harrow and went straight into the army at the age of 18 as an ensign in the 4th Dragoon Guards. Two years later he was promoted to lieutenant, becoming a captain in 1909. He saw action in the Second Boer War.

For his efforts at Casteau Captain Hornby was awarded the Distinguished Service Order, gazetted in February 1915. Just before the war he had married Dorothy Henderson, the daughter of his next door neighbour Charles Henderson at The Riding, Acomb, and became the grandfather of Charles Enderby, current owner of The Riding and chief executive of Hexham Racecourse. In the Second World War, Hornby was too old for active service, but did his bit by knitting balaclavas and other woollen items for the troops. It was noted that he knitted leading with the left hand, in the German manner – a legacy of the German governess of his youth. He served as a magistrate in Hexham for 25 years and lived until 1949.

There had been little hint of the horrors to come in the Hexham of early August 1914. Although the war clouds had been gathering over the Balkans for months, local newspaper the *Hexham Courant* was more

Fusiliers muster in Beaumont Street, Hexham, outside what is now the Queen's Hall.

Men of the 4th Battalion Northumberland Fusiliers march down Priestpopple in the town en route to the railway station.

concerned with the cost of street lighting in Corbridge, a flower show at North Wylam and a swimming race in the Tyne at Warden. It was therefore with some indignation that in the paper of 8 August, on page five – two pages after a debate on the advisability of allowing Sunday evening music in Hexham park, and how much to charge the operator of a switchback ride in the Market Place – the paper noted that Britain was at war with Germany. The leading article thundered:

> *'Germany seems quite reckless as to the consequences of her actions. It would be futile to say how many nations of Europe will be involved ere the insolent author of it all, Germany, has been taught the lesson she so sorely needs.'*

Columnist Ariel added:

> *'Some of the older generations may have recollections of the Crimean War, and a larger number will have fresh in their memory the outbreak of the Boer War. Yet I opine our townspeople have been more stirred this week than on any other previous occasion, watching the coming and goings of our citizen soldiers.'*

Across the district, men were quick to volunteer for the army – and the farming community sent not only their workers, but also their horses by the hundred. The Abbey Grounds in Hexham were closed to the public

The Prudhoe detachment of the Northumberland Fusiliers stands ready at the town's railway station.

so the Territorials could assess the horseflesh provided.

On the day war was declared, the (Hexham) Company of the 4th Battalion Northumberland Fusiliers was called up for service. They were joined at their headquarters in Battle Hill by the companies from Bellingham, Haltwhistle and Haydon Bridge – a muster of 271 men. Before leaving for their induction training in two trains, they were supplied with dinner at the Corn Exchange. The editorial comment in the *Courant* of 8 August read:

> *'Deeply interested crowds watched patiently for hours on Tuesday night the going and coming of our citizen soldiers, to their HQ and to the Corn Exchange, their baggage being deposited at the last named place; while equally large crowds witnessed the departure of the Territorials for their destination on the following day. One must remember that the sons of the Heart of All England have always been noted for their loyalty and their patriotism.'*

The excitement of the Territorials' departure from Hexham was intensified when a fire broke out at the rear of the Gem Picture Palace. The flames spread to the neighbouring North Eastern and Black Bull hotels, which were saved by the actions of clientele chopping out burning window frames and dousing small fires. The Gem was burnt to

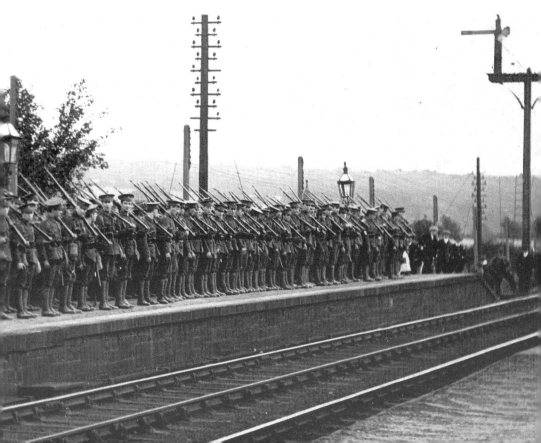

The soldiers' 'ask and receive' reading tent at Hexham, where Territorials could ask for everything from pins, needles and thread to postcards and writing paper.

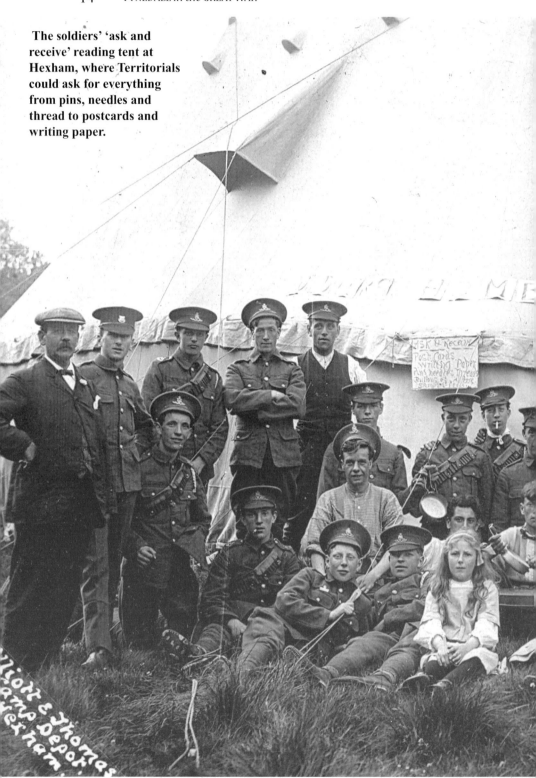

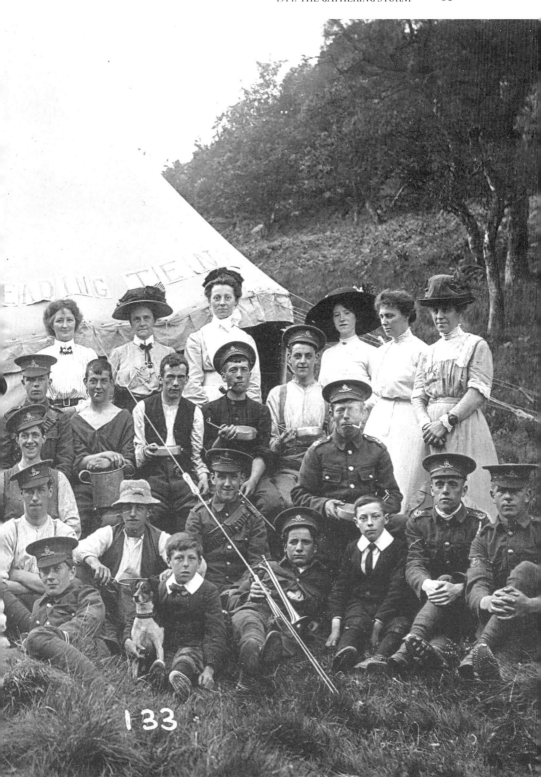

the ground however, and total damage was estimated at up to £4,000.

Directors of the Mickley Coal Company announced that they would pay the wives of men in their employment serving in the forces 10s per week and 2s for each child. At Ovington hundreds of people turned out to cheer the local Territorials on their way, accompanied by the village band. The drill hall was packed with people singing lusty songs and waving Union Flags in a fervour of patriotism. Alas, the soldiers had turned up 24 hours too soon, and were all sent home to come back the following day.

The Duke of Northumberland, as Lord Lieutenant of the county and chairman of the county council, established a fund in the second week of the war as head of a committee comprising the High Sheriff, the chairman of the quarter sessions, and the chairmen of local authorities throughout Northumberland. The aim of the fund was fourfold: to the relief of distress to the civil population; the support of wives and families of those called to arms; aid to the sick and wounded, and other objects of a similar nature.

The duke kicked off the fund with a personal donation of £5,000 and a pledge of £1,000 a month thereafter. Viscount Ridley of Blagdon Hall also contributed £5,000 along with Thomas Taylor of Chipchase Castle, near Wark; while at the other end of the scale, the working people of the district were chipping in their shillings and sixpences.

At the same time, Lady Allendale launched a separate plea for support to the Soldiers' and Sailors' Families Association (SSFA), and Mrs Straker of the Leazes established a committee of some thirty ladies to make garments for soldiers, for which there was a great need. They were asked to make shirts, dressing gowns, nightshirts, handkerchiefs and various hospital requirements. Department store Robbs of Hexham was quick to point out it had all the requisites for providing comforts for soldiers and sailors, from army flannel material to full nurses' uniforms, including Sister Dora caps and aprons.

Tynedale Colliery announced it would be paying wives of servicemen 10s a week with a further 2s 6d for each child, and widows and mothers would also receive 10s. Pitmen at West Mickley agreed to contribute a penny a week towards a fund for the families of workmates at the front, with pit boys paying a halfpenny.

Hexham-based Tynedale Rugby Club cancelled all fixtures until further notice, as practically every first and second XV player from the club joined the colours on the outbreak of the war. From those who volunteered, forty-nine past and present players gave their lives.

They were: William Adamson, William Alder, Benjamin Alexander, Rollo E. Atkinson, John A. Bagnall, Ernest Batey, William Braidford, Percy Braidford, John Brydon, Thomas Burn, Thomas W. Burn, Thomas Cathrae, William Coulson, William Elliott, John M. Emerson, Bertrand D. Gibson, John Grierson, Noel F. Humpheys, William Jefferson, Stanley H. Kent, Drew Little, Frank O. Mail, Alexander Morrison, William M.B. Nanson, Fred Nevison, Norman Oxland, Arthur Patterson, Lionel D. Plummer, George Potts, Ryde Rayner, Michael Reed, Andrew G. Richardson, Charles N. Ridley, John W. Robinson, George S. Robinson, Jos. W. Robinson, John Robson, James Robson, William J. Robson, John R. Robson, Andrew Snowdon, Harry J. Spencer, William Summers, William R. Thew, Arthur Thompson, David T. Turner, Ernest Walton, George P. Walton and Isaac Whittaker.

For a small rugby club, this was a massive toll, and testament to the loyalty of the men, both to the country and their comrades. The death toll included a number of the club's finest players – as well as that of Sammy, the half-bred Border terrier who had become the mascot of the 1914 cup-winning team and had gone off to the war with them.

Of the fifteen players in that Tynedale team which had won the Northumberland Senior Cup in 1914, five did not survive the war – William and Percy Braidford, Fred Nevison, George Potts and George Walton. The gallantry of those who served was rewarded by no fewer than thirty-five medals, including five Distinguish Service Orders, fourteen Military Crosses, two Distinguished Conduct Medals, and, not

The Tynedale Rugby Club first XV which won the Northumberland Senior Cup in 1914. Five of the team did not return from France.

least, the *Croix de Guerre, Croix de Chevalier* and *Medaille Militaire* awarded to Tynedale men as battle honours by the French.

Among the dead was Noel Forbes Humphreys, a Welsh rugby union international who was part of the first official British and Irish Lions squad that toured South Africa in 1910. He played for Tynedale RFC in what has been termed their golden years, the decade up to the outbreak of the war, when they won no fewer than fifteen trophies, including the Northumberland Senior Cup on three occasions and the Senior Shield four times in a row between 1909 and 1912. Humphreys was a fly half of such talent he caught the eyes of the Lions' selectors for the first official tour of the British Isles team to South Africa. Despite playing for the British team, he was never selected for Wales.

He was a captain in the Tank Corps (10th Battalion), and was mentioned in despatches as well as being awarded the Military Cross. He was mortally wounded on 23 March 1918 and died three days later and is buried at Etaples Military Cemetery.

In January 1921 the club honoured the fallen by opening a new pavilion at the north end of its Dene Park ground in Hexham as a memorial to those who had lost their lives. The new building had been a former army hut, bought out of the proceeds of a subscription list launched the previous year and erected by voluntary labour. At the opening ceremony, performed by the President of the Northumberland Rugby Union, Harry Welford, a brass tablet bearing the names of the forty-nine men who had given their lives, presented by the club president, George Gibson, was dedicated by the Rector of Hexham, the Rev. J.V.C. Farquhar. The plaque is now displayed in the entrance hall of Tynedale RFC's present clubhouse at Tynedale Park, Corbridge, alongside another commemorating the twenty-seven past and present players who died in the Second World War.

Facing howling shells, clattering machine guns and vicious barbed wire, the soldiers of the First World War endured conditions unimaginable in the modern world. They were expected to walk forward from mud-filled and rat-infested trenches into a solid hail of withering fire, with every chance of death or serious injury. Yet for four long years they did just that, and it took a special breed of man to walk calmly into the firestorm created by the German machine guns.

Every one was a hero, but even in that special breed, there were those whose nerve and valour placed them into the category of super-heroes. These were the men who displayed courage above and beyond the call

of duty, putting king and country and their colleagues above their own safety. These were the men who won the Victoria Cross, that ultimate emblem of courage personally instituted and commissioned by Queen Victoria and her husband Prince Albert in the wake of the Crimean War. The modest cross of base metal was originally fashioned from the metal of Russian guns captured at the Battle of Sebastapol in the Crimea in 1855. It came with a plain purple ribbon, and bore the simple legend 'For Valour'.

Frederick William Dobson VC.

It was not easily won – but in only the second month of the war, a Tynedale-born Guardsman picked up the honour for his exceptional courage. Ovingham-born Frederick William Dobson (27) produced not one act of supreme bravery, but two. He was serving with the Coldstream Guards, having returned to the crack regiment after originally enlisting in 1906. He served for three years before returning to civilian life as a miner at Backworth.

At the outbreak of war though, he was back with his regiment, and landed at Le Havre on 13 August 1914, as a member of the original British Expeditionary Force. He was involved in the rearguard action from Mons, finishing up at the French town of Le Cateau, from where a counter-attack was sprung, driving the Germans back to the River Aisne. It was here that trench warfare was born, as both sides dug themselves in. On 28 September three men of Dobson's battalion were exposed to murderous fire from German trenches just 150 yards away when early morning mist suddenly cleared as they were crossing a field of mangel-wurzels, catching them in the open.

One managed to get back to British lines, despite being shot in the arms and legs, but the other two went down. A call went out for volunteers to bring them in, and Dobson was first to put his hand up. As he crawled forward to help his stricken comrades, the German troops sought him out with raking fire. He played dead, before crawling forward and managing to reach one of his comrades – only to find he was already dead. He tried to retrieve the man's rifle, but was unable to do so as he was lying on it. After taking papers from the dead man's pockets to confirm his identity, he crawled backwards to his own lines, pursued by the hail of lead, but somehow escaped with only a bullet through the heel of his boot.

As if that act of heroism were not enough, he volunteered to go out again to bring in the second man, not knowing if he were dead too. He employed the same tactics, crawling through the mangels until he could pinpoint exactly where the wounded man was lying. A sudden burst of speed took him to the injured soldier, and he succeeded in dragging him back to the British trenches, with the aid of a Corporal Brown.

For his part in the rescue, Corporal Brown was awarded the Distinguished Conduct Medal – but he was killed in action three days before the announcement was made.

Dobson was genuinely astounded when he heard he was being awarded the VC, and wrote to his wife: 'I only took my chance, and did my duty to save my comrades. It was really nothing, but I shall never forget the congratulations and praise I received from our officers, my comrades and our brigadier general.'

Dobson became a national hero, and King George V insisted on pinning the Victoria Cross on the brave Guardsman's breast personally when he heard he was in London on leave, having been wounded. No one knew exactly where Dobson was though, and a desperate search was mounted in the capital before he was located, in civvies. He was rushed to the headquarters of the Coldstream Guards and was issued with a full dress uniform before being marched to Buckingham Palace to meet the king.

Britannia bids the workers of Britain to take up arms against tyranny.

Dobson survived the war, despite once being in the trenches without relief for a full twenty-seven days. He died in November 1935 and is buried in Ryton Cemetery, outside Gateshead. His Victoria Cross is displayed at The Guards Regimental Headquarters (Coldstream Guards RHQ), Wellington Barracks in London.

The recruitment campaign went on with Lord Kitchener appealing via the *Hexham Courant*:

'Take a message to the Northumberland miners. Tell them that I have often had occasion to thank heaven that I have had the Northumberland Fusiliers at my back. Tell them from me that I have often relied on the Northumberland Fusiliers in the past, and I know that I may do so in the future, I need their assistance, and those who give me their aid will have the opportunity of proving their worth.'

Patriotic Tynedale folk continued to volunteer in their droves, as the drums played and bugles sounded throughout the district. Enthusiastic meetings were held in many villages in response to Kitchener's call to arms. They filled the Sele in Hexham with the vigorous singing of the soldiers' anthem 'It's a long way to Tipperary' and they were encouraged by the stirring strains of the local bugle band.

Among those who answered the call was the curate at Hexham Abbey, the Rev. W.C.B. Williams, who resigned as a curate to join the Fusiliers as a private after ten years' experience in the cadet corps at university. Seven of the nine gardeners working for John Noble at Sandhoe Hall had joined Kitchener's Army. Mr Noble had agreed to pay them half their wages whilst away, and to look after their dependants should they not return. There was anger at Bellingham Petty Sessions when an Elsdon poacher was prosecuted by the Tyne Salmon Conservancy Board for being in possession of a gaff while salmon were spawning in the Elsdon Burn. When told the board had nine river watchers on duty looking out for poachers, chairman of the bench John Robson observed: 'These men would be much better engaged in serving their country than watching over fish that on many cases are going to die anyway. It is painful to see so many men engaged in this work.' The board said it would encourage those of its men who were able to join the forces once the salmon season was over.

There was an impassioned plea in the *Hexham Courant* of 14 November 1914 from a man signing himself Drill Sergeant, calling for even more volunteers from the area. He asked:

'Is it possible that after our forefathers were trained in so many

years of Border wars into being self reliant and brave, that half a century of luxury and ease has reduced us to degenerate weaklings, able to talk bravely around the village pump and abuse the Germans loudly in the village pub, but lacking the courage to take a fair share in defending our country against a common danger? All our advantages of civilisation and refinement are being threatened, but with Lord Kitchener's 'Your Country Needs You' Appeal ringing in their ears, our football fields are full, and our country fairs crowded, with healthy strapping young fellows, each primed with a puny excuse of which they are secretly ashamed. I ask in all seriousness what is the matter with the men of the Dales? They are not playing the game.'

Hexham became something of a garrison town, every vacant building being commandeered as billets for 'our gallant lads'. Political clubs – Unionist and Liberal – at once forgot their differences and threw open their finely equipped premises for the use of the citizen army as canteens. Among premises used as billets were the Town Hall, Corn Exchange, Red Cross Hall, Battle Hill House, Gibson House, the Drill Hall in Hencotes, Market Street Depot, Hallstile Bank, the Old Liberal Club, workhouse schools, Congregational schoolroom, and the Primitive Methodist School room. The parade ground was on the Sele, and officers' quarters were at the Old Grammar School, Hill Crest, and Portland Lodge.

There was criticism of the young men of Allendale in Caledonian's column in the *Courant* when he wrote:

The men of Allendale have not put on a very big show of the war; I know of only four Allendonians who have gone to actively fight for their country. It appears that so far as Allendale is concerned the territorial movement has died out completely. At the present juncture, the woman of Allendale are doing more than the men with their support for the Red Cross Society.

Special constables were enrolled by the Bellingham magistrates for the purpose of protecting the water pipelines running from Catcleugh Reservoir near the Scottish Border down to Whittle Dene Ponds on the outskirts of Newcastle from enemy action.

Local businesses were not averse to taking advantage of the anti-German feeling, notably optician John Gibson, who urged customers not to 'read war news through German lenses' stating all his lenses were made by our own countrymen. 'To capture German trade would be a

(2) THE HEXHAM COURANT, SATURDAY, MAY 29, 1915.

DALESMEN WHO HAVE JOINED THE COLOURS.

A FEW ALLENDONIANS.

OTHER NAMES WILL BE GIVEN ON THIS PAGE FROM WEEK TO WEEK.

PTE. W. HENDERSON,
4th N.F.
Allendale.

PTE. W. C. DICKINSON,
4th N.F.
Allendale.

PTE. H. HENDERSON,
4th N.F.
Allendale.

PTE. W. SHORTRIDGE,
4th N.F.
Allendale.

PTE. J. REED,
4th N.F.
Allendale.

PTE. E. HARRISON,
4th N.F.
Allendale.

THESE BOYS DIDN'T SHIRK.

THEY WANT HELP!! Listen for a moment. Can't you hear them calling **TO YOU?** **BE A MAN.** There's a King's uniform waiting for **YOU.** Go and put it on **NOW.**

GOD SAVE THE KING!

A suggestion that the men of Allendale were not doing their bit was countered by this provocative poster indicating the opposite.

Local businesses were quick to cash in on any anti-German feeling. Gibson's the opticians urged people not to view the war through German lenses, record player salesmen Forsters urged customers not to play patriotic music on German machines, while department store Robbs urged women to buy British corsets.

much bigger deal than picking up German colonies,' he thundered.

Thomas W. Forster, cycle and motor agent of Hexham, took a front page advertisement to say: 'Do not play patriotic music on German instruments, but buy a genuine English-made gramophone and records'. Department store William Robb and Sons of Hexham appealed to the district's

women to do their bit. In a large advertisement in the *Hexham Courant*, the company stated:

'One of the direct consequences of war is unemployment, with its attendant evils, shortage of money and lack of food. It becomes therefore the bounden duty of every woman who is able to do so to support those industries that provide employment for British Labour and so remove to some extent the black cloud which menaces so many of our British homes. Every woman in Hexham can help by insisting that the necessities she buys are British made by British Labour. The famous WB Reduco and WM Nuform corsets, of which we have just received a large consignment, are every one of them made in a Portsmouth factory employing English work people, amongst whom are a number of the womenfolk of our gallant Jack Tars. As a further appeal to your patriotism, we have persuaded the manufacturers to grant us a special extra discount and we are giving the whole of this to the War Relief Fund. Buy a WB corset today and help your countrymen.'

At this early stage of the war, there was little real hostility to the Germans as a race, for at the time, there were a considerable number of Europeans, including Germans, working in the lead and zinc mines operated in the Allen and South Tyne Valleys by Belgian company Vieille Montagne. The Germans had mixed in well with the English, holding good jobs, marrying local girls and raising children who were christened at the local church and went to local schools.

When collections were taken up locally to help the war effort, one of the leading fundraisers was the German wife of one of the miners. However, the Germans who lived locally and worked for the Vieille Montagne started being arrested as aliens. Among them was Frederick Carl Schmidt, aged 36, a foreman at the Carrshield mines in the West Allen valley. He was taken to Hexham, under escort, but he was a popular figure locally, who had married a Ninebanks girl, and whose children went to Ninebanks School. A petition was got up in Allendale to plead for his release, and it proved successful, with Herr Schmidt able to resume his position at Carrshield.

However, the respite was a brief one, for on the orders of the Home Office, he was re-arrested early in September. Another petition was got up, but by this time, reports of fatalities were coming in from across the Channel, and only two signatures were obtained.

Schmidt was arrested by Whitfield village bobby Police Constable Tinlin

Nenthead

The Vielle Montagne lead and zinc mine at Nenthead, whose international workforce contained many Germans.

and handed over to the military authorities in Newcastle. He was never allowed back to Ninebanks, even after the war, and his wife and children eventually joined him in Germany. There was a tragic aftermath to the reunion, for early in the Second World War, a German train was strafed by an Allied aircraft – some say it was a Spitfire, others an American aircraft – but Carl Schmidt's daughter Freda was among the dead.

Later in the war, as casualties mounted inexorably, attitudes had hardened, and when the English wife of a German worker at the mines was walking through Nenthead with her children, she had the contents of a chamber pot thrown over her, and was told: 'Get off back to Germany, and take your German bastards with you'. A man wrote to Allendale Parish Council:

'Why should we have any Germans in Allendale? I have personally seen strange sights and others have seen lights they have been unable to account for. If the Zeppelins find they cannot successfully

carry on their work from the east, what is to stop them going far north and sailing over our important munition works guided over by lights of Germans inland? Every German should be interned as English people living in Germany have been. If this was done, there would not be the fear of the spies and traitors who pose as friends in our midst. Every Englishmen in the village should take an interest in this until all the Germans have been removed.'

Not all foreigners were reviled, for the country as a whole had taken to its heart 'Brave Little Belgium' for its efforts in heroically resisting the German war machine as it drove its army through the heart of Belgian neutrality. The Northumberland War Refugees Committee was started in October 1914, to assist the London War Refugees Committee to find hospitality for Belgians in Northumberland.

Northumberland as far west as Riding Mill was a prohibited area for foreigners, so a large number of refugees were sent to Hexham and its neighbourhood. The Hexham Branch of the Northumberland War Refugees Committee was formed, and in December 1914 the first batch of Belgian refugees – numbering between forty and fifty – arrived in Hexham. During the next few months others arrived at irregular intervals until, including those maintained by private hospitality and by private committees, there were about 400 Belgians in Hexham and the neighbourhood.

Amongst those who were chiefly instrumental in giving private hospitality was Mrs John Noble of Sandhoe, who maintained upwards of fifty Belgians for the whole period of the war at her own expense. The unfortunate people arrived with practically only the clothes they stood up in, and a clothing depot was started to meet their needs at 16 Fore Street. Local chemist John Gibson lent rooms for this purpose and also provided a room which was used as an office for the clerical work and interviews during the whole time that the Belgians were in Hexham. A library of French and Flemish books was also organised, and proved a great success. After a time, work was found for a large number of the men and those women who could be spared from the care of their children. Most of the men were finally either called up in their groups for the Belgian Army, or went to the National Projectile Factory at Birtley, Gateshead.

To raise money for the refugees, farmers at Hexham Mart bought and resold the same lamb sixty-five times, raising £35 10s for the cause, as more and more Belgians flooded in. Jurors who conducted an inquest into the death of a recruit found dead on the Hexham–Carlisle railway line near Stocksfield gave their jurors' fees to the Belgian Relief Fund, while Hexham store Robinson and Son in Fore Street announced that

The ornate font cover at Hexham Abbey and carved sign above the former offices of Gibson's chemists in Fore Street, Hexham, both the work of Belgian refugee Josephus Ceulemans.

for the convenience of Belgian refugees, it would in future be displaying prices in its windows in both English and French.

Some of the Belgians stayed for the full four years of the war, and one in particular left his mark on the town. He was skilled woodcarver Josephus Ceulemans, whose work in Hexham can still be seen a century later. The doorway to the former Poundstretcher store in Fore Street features a beautifully carved sign of intricately woven vine leaves. It was the former pharmacy owned by John Gibson, the man who gave his rooms to the refugees at the start of the war, and Ceulemans engraved the doorway as a thank you on behalf of his countrymen.

And visitors to Hexham Abbey also have cause to be grateful to the modest Belgian, for one of the glories of the 1300-year-old building is the 20-foot high tabernacle covering the font. For seventeen years, Abbey rector Canon Sidney Savage had been trying to find someone to piece together the original fifteenth century font cover, smashed during the Dissolution of the Monasteries. For centuries, the pieces lay in a forgotten corner of the Abbey, few knowing what they were, until Canon Savage said he wanted the historic icon restored.

He proposed moving the font from the south transept of the Abbey to the west end of the new nave. A stained glass baptistry window had

been inserted in the west end when the nave was built in 1908. As part of the move he intended that the fifteenth century tabernacle cover for the font should be restored. In his design for the restoration the architect Charles Hodges filled in the missing parts by duplicating the corresponding existing pieces, but needed someone skilled with a chisel to carry out the delicate work.

In stepped M. Ceulemans, whose efforts still inspire many visitors to the Abbey, and certainly delighted Canon Savage, who wrote: 'M. Ceulemans – cruel product of the Devil's cruel war – has been of great blessing to us. He has the heaven-born gift and the soul of a true craftsman, and when Mr. Hodges got him away from the Continental finish to that of the past masters of carving of the rugged North, he has excelled in his work, which gives more than satisfaction; it gives joy. His work shows that the true medieval spirit still exists, for Wittenberg did not crush the reverence and art of Belgium. All who have subscribed to this work, and all who gaze at it will rejoice.'

After the first few weeks of the war, when they disappeared from the streets completely, the Breton 'onion johnnies' made a welcome return to Hexham, although they were in sparser numbers than usual, and some familiar faces were missing – presumably on active service in France. As well as selling prime onions the Bretons entertained townspeople with lively renditions of 'La Marseillaise'.

Clothing for the Territorials was an early requirement. They weren't provided for in the same way the regular army was, even when they were called up for duty, so Queen Mary issued an appeal to the Needlework Guild and its branches nationwide, asking members to help make good

Staff hard at work making clothes for the Territorials at the Hexham War Hospital in 1914.

the shortfall. An officer with the 4th Northumberland Fusiliers, wrote to the *Courant*: 'There is a terrible want here of underclothing for our men, mostly shirts and socks and the adjutant and myself would like to know what we can expect from Hexham for the Hexham company at present. There is a far greater need here than in Belgium.'

The *Hexham Courant*, in what was the first of several such campaigns, immediately joined in with a 'Socks for Soldiers' appeal. In the years that followed, it sent everything from sandbags to 'comforts' such as sweets, pipes and soap to the front line. Within a month the Heddon Guild of Work had despatched twenty-seven hospital kit bags to the front, each containing: a flannel day shirt, a calico nightshirt, a pair of slippers, a pair of socks, two towels, two handkerchiefs, one sponge, toothbrush, soap and a tin of Vaseline. The Corbridge War Depot reported soon afterwards it had sent almost 900 garments to hospitals, the British Red Cross and to the 4th Northumberland Fusiliers.

By the middle of September, news was starting to come in of casualties. Lieutenant Ian Straker of the Leazes was seriously wounded in the Battle of the Marne, and there was talk of Prudhoe Hall Colony for the Feeble Minded being commandeered by the Government as a convalescent home for wounded soldiers. The first fatality from the district was Private Edward Baty of the Coldstream Guards, who died on 21 September from pneumonia after being wounded. A Hexham man, he was regarded as one of the best boxers in the entire Brigade of Guards, as well as being a fine swimmer.

Private John Surtees from Matfen, a well respected tailor with a business in Stamfordham, was killed in France soon after, as the reality of war started to sink in. Another early casualty was Lieutenant Charles Lindsay Claude Bowes-Lyon, the eldest son of the Hon Francis and Lady Anne Bowes Lyon, of Ridley Hall, near Bardon Mill. He was a nephew of the Earl of Strathmore, and a cousin to the future Queen Mother. He was serving with the 3rd Battalion, The Black Watch when he was killed in action at Ypres at the age of 29.

Ironically he had already had one brush with an early death, when he was one of the few survivors of the *Empress of Ireland* ocean liner disaster in May. RMS *Empress of Ireland* sank in the Saint Lawrence River in Canada, following a collision with a Norwegian collier in the early hours of 29 May, killing 1,012 of the 1,477 people on board. Bowes-Lyon was a very keen cricketer and had a cricket pitch laid in the grounds of Ridley Hall so touring teams could play there. He was

described as of genial and kindly disposition, and was exceedingly popular with the tenantry at Ridley Hall.

Letters home from soldiers were starting to come through, and one of the main areas of concern was not the German guns, but the lack of tobacco.

Trooper William Metcalfe of the Imperial Yeomanry wrote that they were billeted at a farm, where the farmer had fled because of the fighting: 'As you can imagine, we are living like lords on poultry, pork chops and veal. Only one thing is missing; could you please send some smokes? Could you send me some Woodbines as soon as possible? English cigarettes are very scarce indeed. Our fellows have killed hundreds of Germans, but as quick as they are killed, others come up. I don't think it will be long before this business is finished.'

Alas, Trooper Metcalfe was killed in November 1914, when a shell scored a direct hit on the stable where he was tending his horses.

Trooper William Metcalfe, of the Imperial Yeomanry, killed in November 1914 by a direct hit on the stable where he was working.

Another early casualty was Hexham's Private Matthew Riley serving with the West Riding Yorkshire Regiment. He was shot in the shoulder while fighting in Belgium, and returned home to a hero's welcome. He was met at the railway station by 240 members of the Territorials as well as a large crowd of the public, and was carried shoulder high to his home in Market Street which was decorated with bunting. The triumphant procession was headed by two buglers and the crowd sang the National Anthem most lustily.

Haydon Bridge postmaster Mr Beattie received a letter from former village postman, Private John Gray of the Northumberland Fusiliers, of the deprivations being suffered at the front after being wounded at the Battle of Mons. He said: 'It rained shells and I lost my namesake John Grey in the first few minutes. It turned too hot for our lot and we had to beat a hasty retreat. We were led into places which were sure death traps and had many a good starving for want of food and tobacco. Talking of tobacco, we had to smoke our tea. I smoked five tea allowances. We took tea out of the kettle and dried it on our trench tools.'

Reports were coming in from the front of Germany treachery, with the enemy accused of dressing in French and British uniforms and then launching surprise attacks. A Tynedale officer wrote: 'This sort of thing is a daily occurrence, and only makes things worse for the sausage

makers when our infantry gets into them.'

Allendale's Washington Blair, serving with the Coldstream Guards, wrote to his parents in December 1914 that the Germans appeared to be losing heart and the fighting was not as fierce as it had been. He said: 'I have been at the front for three months, and have only been wounded twice – once in the hand and once in the neck. I have lost two rifles, one bent double by shrapnel.'

Also writing to his parents, Norman Purvis of the Imperial Yeomanry wrote of 'bullets flying like hail' and said: 'It's awful to see your own friends falling by your side.' On a brighter note, he added that he and his comrades had caught a chicken and found some carrots and potatoes and leeks and enjoyed some grand broth.

Corporal William Civil from Wark wrote of shrapnel shells and bullets flying by like a drove of bees. He added: 'Thompson Davison from Hexham had his horse shot from underneath him the other day. The German Uhlans (Prussian cavalry) are bad shots; he would have been killed if they had been any use. We were on patrol when we ran into some wire and were seen by a group of about fifty Uhlans about 100 yards away. They opened fire and knocked Thompson's horse over, but he ran 150 yards back to our lines without being hit again.'

Trooper William Robson, of the Northumberland (Imperial Yeomanry) Hussars wrote to his father in Hexhamshire: 'This is very nice country to live in, but the war has made it into terrible condition. The people in the towns are very clean and very kind, and will give you anything you want. We are being well fed, but have been in some tight spots. It is fine sport shooting Germans; it is better than shooting rabbits. There are any number of shells flying about but none of us has been hit with one yet, although one or two have bullet wounds. There are a lot of flying machines passing over our heads.'

Fellow Hussar A. Charlton, from Birtley, near Wark, added: 'The Yeomanry have proved themselves up to concert pitch, and have

Lieutenant Hugh Taylor, of Chipchase Castle, Wark, whose body was handed back to the British during in the Christmas Truce of 1914.

done some really good work. I would dearly love to get back for the Matfen coursing meeting – have you heard anything about this fixture? I will be jolly glad when I receive your cigarettes and snuff, as you cannot get any worth having out here.'

Amidst the horror of the trenches, there was a sneaking admiration for German efficiency from Lieutenant Hugh Taylor of Chipchase Castle, Wark, serving with the 2nd Battalion, The Scots Guards. He wrote to a friend:

'From an infantryman's point of view, it is the hostile artillery that one sees, or rather feels more of, and I must confess that the German artillery is really rather wonderful. They kept concentrating fire on various portions of our lines from all quarters, and in many cases practically blew the trenches to bits. Our guns did not seem able to keep their fire down at all, but I believe they have done a lot of execution among the German infantry. Perhaps the most extraordinary thing is the amount of ammunition the Germans seem to have. They shell all day and every day, often it appears quite by chance, and must use tons of steel and powder with very little result. But it is the artillery that wins them any success they get, that and the machine guns. Their infantry would have very little chance by itself, for they seem to have no idea of how to use a rifle.'

Lieutenant Taylor bemoaned the fact that the war appeared to involve the Germans shelling the British trenches, and then strafing them with machine-gun fire, before walking the infantry in. The British would then counter-attack and drive them back again until everyone was back where they started. Lieutenant Taylor wrote: 'It is a very poor system of fighting – one feels rather like a lot of coconuts on a stand! We would do anything to have a fair and square infantry battle!'

Alas, Hugh Taylor lived only a few short months after sending his fateful letter, cutting short a promising army career. Educated at Harrow and at Balliol College, Oxford, where he graduated with honours, he joined the Scots Guards in June 1904, becoming lieutenant May 1905, before being made captain shortly after sending his letter home in November 1914.

He had been machine gun officer of his battalion before the war, and was made up to brigade machine gun officer on going to the front. On the night of 18 December 1914 he led an attack on the German trenches near Rouges Bancs, and succeeded in occupying part of them. On his way back to the British trenches to report the success, he was cut down by machine-gun fire and died instantly.

A few days after his death, he played his part, albeit unknowingly, in one of the most poignant episodes of the war, when his was one of the bodies exchanged during the informal Christmas truce. His body had been left where it fell, close to the German trenches, but the German soldiers, from Saxony, carried it over to the English trenches, with heads bared and bowed. He was buried in the military graveyard at La Cardonière Farm.

On Christmas Day, each side collected and brought the dead to the centre of the space between their respective lines. Two trenches were dug, and the British and Saxon soldiers were buried, the English chaplain reading the service, which was translated into German as he read. The soldiers afterwards fraternised for some hours to the intense annoyance of the high command. Hugh Taylor was mentioned in Field Marshal Sir John French's despatch of 14 January 1915, for gallant and distinguished conduct.

Haltwhistle's Tom Jarvie, serving with the Cameron Highlanders, gave a graphic account of trench warfare in a letter home to his wife. He wrote:

'We fought for three days and nights. The enemy came up in droves, like cattle to be mown down; they came in such numbers that it was impossible to stop them but we stood in the trenches until they were in beside us. There was a bayonet charge, and they had thirty of us prisoners, but another regiment rushed them and got us all back off them, as well as taking some of the prisoners. All the time this was going on, the shells were bursting all over us and the rifle shots were terrible. I heard our brigade took 1,500 prisoners, and it will be impossible to tell you how many we killed as they just kept coming so close you couldn't help hitting them. I dare not think about the poor fellows we left lying but I came through it all without a scratch. There is no one to thank but God, which I will do until my last breath.'

Back in Hexham, as the nights started to draw in, the Northumberland Fusiliers in training at Hexham were at a loss with the pierrots stopping their popular summer performances on the Sele for their winter break. However the recruits were given the use of both the Liberal and Unionist Club premises, as well as a heated and well-lit room at the local Wesleyan Church in Beaumont Street for leisure use. It proved so popular an additional larger room was also provided.

The war really began to come home to Tynedale folk when the wards at the First Northern General Hospital, located in buildings that are now

The Germans were not the only cause of death on the Western Front. Corporal James Robson, of Hexhamshire, died in France in February 1915 after contracting scarlet fever while serving with the Northumberland Hussars.

part of Newcastle University, began to overflow. With 2,000 beds, it was the biggest army hospital in the UK, but by Christmas 1914 it had treated 12,000 soldiers and desperately needed to free up beds by moving on those that could convalesce elsewhere.

Soldiers treated there were then sent to continue their recovery at military auxiliary home hospitals – usually known as VAD (Voluntary Aid Detachment) hospitals. VAD members were trained in first aid and nursing and they assisted the qualified nurses appointed by the Red Cross and St John's Ambulance Brigade. In Hexham the pre-existing convalescent home at the south end of Hextol Terrace became the Third Northumberland VAD hospital, with an annexe in nearby Cotfield House. Dilston Hall became the Fourth Northumberland VAD hospital.

The 1st Hexham Troop Baden Powell Boy Scouts did good work in assisting in the collection of equipment for the local hospital at the convalescent home in Hextol Terrace. The troop had been mobilised ever since the outbreak of the war. They also rendered service whenever required in connection with recruiting work under the Derby scheme,

A public appeal helped pay for this Napier ambulance to transport wounded soldiers from the railway station to Hexham Hospital – and for two others like it.

when they acted as orderlies and messengers at the local offices, and in distributing literature from time to time. The troop also undertook to attend on Wednesday evenings at the war work depot, with their trek cart, and take the packages of clothing, bandages, etc. to the station.

When the first of the wounded soldiers arrived at Hexham railway station on 9 January 1915, local gentry supplied their cars to transfer them to the hospitals. However, it quickly dawned that Tynedale needed properly equipped vehicles and a public fund-raising appeal was launched for the £450 needed to buy an ambulance that met army specifications. The response was such that by July, Tynedale possessed an ambulance and three Ford cars fit for purpose.

Columnist Ariel wrote in the *Courant*:

'A few weeks ago, I recorded the wonderful success achieved by Doctor Stewart of Hexham in his appeal for funds to provide motor ambulances for the various units of the "Fighting Fifth" that are at the front. So splendid was the response that he was able to purchase a Napier and three Ford cars, fully equipped and up to government standard.

'The Napier has now been delivered and the three Ford cars will shortly be also available for the work of helping the

Northumberlands at the front. The Napier has been named by Doctor Stewart 'The Tynedale' and as it is the premier car, the compliment to this district will be appreciated. The Fords will be named The North Tyne, The Bamburgh *and* The Adam Scott. *The last is named after a well-known North Country sportsman, having been a magnificent supporter of the fund. Each car will bear an inscription that it was presented by the Northumberland branches of The Red Cross Society for service with the Northumberland Fusiliers in the field.*

Doctor Stewart had still some £200 in hand with a suggestion it should be used to help pay for an X-ray apparatus.'

Wholesale prices soared, with flour going up from 29s 3d for 20 stone to 46s overnight. Caster sugar rose to the dizzying height of 6d per pound. Lyons and Liptons engaged in a libel action in the High Court, with Liptons forbidden from suggesting that the board of Lyons was made up of Germans.

Life in Hexham went on as usual, and with Halloween just round the corner, two boys aged 15 and 16 were brought before Hexham Magistrates for stealing turnips from a farmer's field at West Wharmley. They were seen to take a single turnip each from a field of several hundred to use as turnip lanterns, and were each fined 5s, with the option of seven days in prison.

A contaminated well at Lowgate was blamed for causing an outbreak of enteric fever in Hexham which resulted in one death, and at least four other people seriously ill. The overcrowding in the tenement block in Gilesgate, where there were often five people living in one room, was blamed for encouraging the spread of the disease. A motor cyclist was brought before the Hexham court for travelling through the town at the dangerously excessive speed of up to 30 mph and was fined 7s 6d.

Soldiers being what they are, two Territorials from Haltwhistle found themselves up before the local bench for stealing two rabbits worth 2s from a grocer's van at Haydon Bridge. Obadiah Armstrong and Henry Wilson told magistrates it had only happened because they were drunk. The chairman of the bench said he deeply regretted seeing two men in uniform on such a charge, but took a lenient view, dismissing the case on payment of costs.

At the same court widow Hannah Todd appeared accused of allowing her donkey to stray on the public highway after a cyclist almost ran into it. She said she could not keep her ass off the road and was fined 2s.

The recruits held a field day at Dene Park, home of Tynedale Rugby

Despatch rider Ulric Porteous returned from the front with a metal flechette, designed to be dropped from aircraft in their thousands to inflict damage on Allied troops.

Club, where they engaged in long jump, high jump, seven-a-side football, tug of war and a sack fight. There was also a smoking concert at the Abbey Hotel,

Hexham's Medical Officer of Health complained of the extreme difficulty he was experiencing in getting horses to pull the ambulance, as they had all been requisitioned by the army.

Despatch rider Ulric Porteous came home to Hexham with a war trophy in the form of a metal arrow, known as a flechette, dropped from an aeroplane by the Germans. About the size and weight of a pencil, it did not look formidable, but when dropped in great numbers from a height of 3,000-4000 feet, the weapons would do a lot of damage to a tightly packed body of men, he commented. He also spoke of the carnage caused by the German heavy artillery pieces which fired the Jack Johnson shells – so called because they were big, black and extremely destructive. They were named after the world heavyweight boxing champion, described as the most famous and the most notorious African-American on earth. The so-called Galveston Giant was the first black world heavyweight boxing champion and liked nothing better than taunting the white establishment with his effortless superiority over every Great White Hope put in front of him.

Chapter Two

1915 – Lambs to the slaughter

AFTER A PROLONGED sojourn at Blyth on the Northumberland coast, where they had undergone intensive training since being mobilised, the men of the 4th Battalion Northumberland Fusiliers finally left for 'a destination unknown' in April 1915. Mobilised at the outbreak of the war, the men were now regarded as one of the most efficient territorial battalions in the country. Although they left Blyth by train at 7am on April 20, the station platform was lined with wives, mothers, sisters and sweethearts. Some had waved off their menfolk for South Africa a decade or so earlier, but while the Boer War volunteers numbered in their hundreds, there were thousands embarking for the killing fields of France and Flanders. The *Hexham Courant* recorded at the time:

> *'Many were the handshakes these bold men received, and their clinging wives and sweethearts, who bore themselves so bravely, could not help smiling through their tears at the men were lionised by all concerned.'*

There was almost a carnival air as the men sailed for France, but gaiety soon turned to horror as within less than a week, the greenhorn fusiliers were thrust into the maelstrom of the Second Battle of Ypres against battle-hardened German troops. They were flung straight into action on the Aisne at Langemarck, supporting the Canadians around Ypres – and the inexperienced troops were given a real mauling, with casualties heavy. Among those killed was Lieutenant Drew Little of the Durham Light Infantry, who lived at Hexham House in the town. He was a noted hockey player who had represented Northumberland many times. He was struck by shrapnel and died instantly. Among the wounded from the Northumberland Fusiliers were Captain Lionel Plummer, Captain Roly

Lieutenant Drew Little, of Hexham, killed in the Battle of Ypres in April 1915 while serving with the Durham Light Infantry.

Webster, Lieutenant Clive Joicey, Lieutenant J.S. Allen and Second Lieutenant J.W. Robinson

Despite the heavy toll of German guns and gas attacks, the mixture of farmhands, pitmen, estate workers and countryfolk of the 4th Battalion Northumberland Fusiliers acquitted themselves so well over the next few days that the Commander-in-Chief of the British Expeditionary Force Sir John French paid them a personal visit to praise their courage and fortitude. He told them:

> 'Men of the Northumbrian Brigade: I want to thank you personally for what you have done over the past ten days. In the ordinary way, all units that come here are given a certain time to accustom themselves to their surroundings before being sent forward, but a serious emergency arose. We had this treacherous attack under cover of asphyxiating gases – the men who use them are not worthy of the name soldiers – and because of this villainous proceeding, I had to call upon you to support the Canadians in the trenches. That alone would have been a sufficient trial for a new division of regular troops trained for years at Aldershot, but you especially distinguished yourselves. You took St Julien in the face of heavy shellfire which was hotter than any previously during the war. No matter that you had to retire; you established yourselves and did all that you were asked to. You behaved magnificently and I wish to thank every officer, non-commissioned officer and man.'

The consensus afterwards was not appreciation of what Sir John had said, but that he had taken the trouble to come to speak to the men in person – even though they were reluctant to go on parade so early, as it meant they did not get their breakfast until after 2pm!

The special correspondent of *The Morning Post* wrote: 'Although the major part of the glory of the Langemarck Battle properly belongs to the Canadians, it must not be overlooked that the English Territorials were in it too, and bore themselves with the utmost gallantry. For many it was their baptism of fire, but on all hands I hear warm eulogies of their steadiness and courage. They behaved like seasoned troops.'

And a brother officer wrote to 'Butcha' Hornby: 'The Northumbrian Terriers had a hell of a fight on Monday, and succeeded in doing what another division had failed to do. The Northumbrians had been in the country for less than a week, and this a good omen of what we may expect from Kitchener's Army.'

A first hand account of the 4th Northumberland Fusiliers' baptism of fire was provided by Lieutenant Wilfrid Joseph Bunbury, whose book *A*

The front line officers of the 4th Battalion Northumberland Fusiliers prepare to leave their embarkation point at Blyth in April 1915, under the command of Lieutenant Colonel A.J. Foster.

diary of an officer: With the 4th Northumberland Fusiliers, in France and Flanders, from April 20th to May 24th, published by the *Hexham Courant*, gives a valuable insight into the exploits of the part-time soldiers of Tynedale, so many of whom never returned.

The Fusiliers left Blyth by train, and travelled the length of the country to Folkestone, where they boarded the troop ship to take them to France. They landed at Boulogne, and after a night's sleep, travelled by train to Cassell – the men in open-sided cattle trucks, thirty to the van, and the officers in first class carriages. They were eventually billeted in farms round a village called Oudeezeele, and Bunbury wrote: 'I soon had my men fixed up quite comfortably in a hay loft where there was quite a good sized pond, where they spent most of the afternoon bathing and washing their clothes.'

They received a cheery welcome from the colonel, who read out a list of field punishments they could expect if they stepped out of line, including a significant number which carried the death penalty. Bunbury sent out his man Sergeant Amos on a search for refreshments for the

officers' mess, and he came back with a bottle of red wine, which cost a franc, and another of champagne, which was four francs. Bunbury noted that all the local farms seemed to produce their own beer, which sold for 10 centimes, or a penny per glass, but it was extremely mild, so much so that he had seen children of three or four drinking it with their meals, which he found 'curious'.

The Fusiliers arrived at Ypres early in the evening of April 24 and the men built themselves shelters with branches, waterproof sheets, and blankets, which not only protected them from the sun, but also hid them from patrolling enemy aircraft. Bunbury wrote: 'Some of our heavier guns were in position quite near us, and we could distinctly feel the concussion from them, whenever they fired, which they were doing constantly throughout the day. A number of German shells exploded fairly near us, as they were searching for these guns, but we had no casualties from them.'

The men had expected a few days to acclimatise, but they had scarcely finished tea when they were told to pack up and head for a forward position. Bunbury wrote: 'We reached Ypres about 11pm and, although the Germans had only commenced shelling the place a few days ago, the town was rapidly becoming a mass of ruins. There were huge shell holes in the middle of the roads and streets, and a number of unburied corpses lay about, while the whole town appeared absolutely deserted.'

He said that the Germans appeared well served by spies, concealed in the ruins, who signalled to the Germans whenever British troops were passing, for as soon as they passed, every kind of shell, including Jack Johnsons, incendiaries, high explosives, and shrapnel were simply 'showering down'. He reflected:

'We were treated to a truly gorgeous spectacle, as the shells came hurtling over our heads, and more often than not exploded right in one or other of these fine buildings, not more than 30 yards from where we stood. The incendiary shells in particular produced a wonderfully fine effect, as they seemed to set fire to the whole interior of these buildings, which appeared to burn furiously with a very bright flare, at the same time giving off dense clouds of smoke, which poured out of the roofless ruins; the grandeur of the sight of these splendid old buildings being consumed with flames, while shells constantly burst against their walls, or passed through their windows bereft of glass, enhanced as it was by the darkness of the night, baffles description, and the only thing I could think of

(8) THE HEXHAM COURANT, SATURDAY, MAY 1, 1915.

THE ROLL OF HONOUR.—LOCAL OFFICER KILLED.

A HEAVY LIST OF WOUNDED OFFICERS AND MEN.

L. D. PLUMMER. CAPT. ROLAND WEBSTER. LIEUT. R. ALLEN. LIEUT. CLIVE JOICEY. SECOND LIEUT. J. W. ROBINSON.

[J. Bacon and Sons, Newcastle. Photo by] [J. Bacon and Sons, Newcastle. Photo by] [J. Bacon and Sons, Newcastle. Photo by] [J. Bacon and Sons, Newcastle. Photo by] [T. P. Edwards, Hexham

Among those Northumberland Fusiliers killed or wounded soon after arriving in France were (from the left): Captain Lionel Plummer, Captain Roly Webster, Lieutenant Robert Allen, Lieutenant Clive Joicey and Second Lieutenant J.W. Robinson.

to liken it to was the burning of Rome.

'We suffered no casualties at first, but just before we moved on again a high explosive shell burst just over the tail of our 7th Battalion, who were just in front of us, and not 20 yards from where I stood, and killed or wounded about fifteen men. Once a Jack Johnson burst just in front of me, not 10 yards away, making a huge hole in the ground into which you could have put a horse and cart; but beyond spattering us all with a shower of mud it did no one any harm. A small fragment hit me on the back of the neck but did not even cut the collar of my jacket.'

He said when the Northumberlands came under fire, 'our fellows showed no sign of funk, and lay absolutely still where they had been told to, and soon began to joke about the shelling.'

The Fusiliers were eventually sent forward to the front line to provide reinforcements to the Canadians, and Bunbury was told by one Canadian that the whole ground to be crossed was being swept by flanking fire from a German trench away to the left and that anyone who went up to the front trench in daylight was almost certain to be shot. He said:

'I set forth with all the men I could collect, but, as soon as we got over the brow of the rise, and began descending the other side, we

became exposed to heavier shell fire, and the bullets began whistling about unpleasantly near. With little cover the men with me quickly scattered, and followed on in small groups making use of whatever cover was available, so soon there were no men left with me.

'I became conscious of bullets whizzing by both ears, and I quickly guessed I was being sniped at from within our own lines, so seeing a small mound of earth just ahead of me I doubled up to it and flung myself flat down behind it, and no sooner had I done so than several bullets plumped into it from in front, which amply confirmed my suspicions. The mound only gave me cover if I lay absolutely flat with my face practically on the ground, and as the bullets continued whistling close past and above me, and I had no weapon to attempt to reply with (only having a walking cane and my revolver with about ten cartridges).

'I had an awful five minutes, as I felt it was certain death if I attempted to go forward, and my only alternative was to remain there and funk it. I said what I fully expected would be my last prayer, and mentally bade farewell to all my dear ones. I first tried to draw my opponent's fire by raising my cap, but he was too old a hand to be deceived by this. I then had a good look round, and saw what I thought was a ditch about 20 or 30 yards to my right, running down the hedge, and determined to make a dash for this.

'Hoping once again to draw his fire (which I really believe I did

Among the casualties at Ypres from the Northumberland Fusiliers officer corps were (from the left): Captain C. Chipper, Captain G.L. Hunting, Lieutenant M. Carrick, Lieutenant H.B. Speke and Second Lieutenant C.L.P. Scaife.

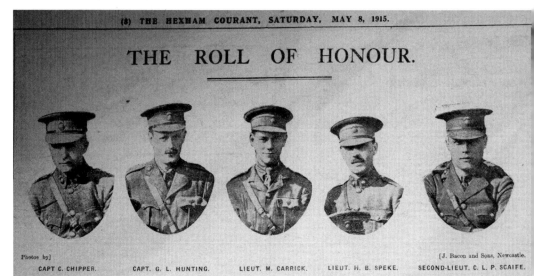

(8) THE HEXHAM COURANT, SATURDAY, MAY 8, 1915.

THE ROLL OF HONOUR.

Photos by] [J. Bacon and Sons, Newcastle.

CAPT C. CHIPPER. CAPT. G. L. HUNTING. LIEUT. M. CARRICK. LIEUT. H. B. SPEKE. SECOND-LIEUT. C. L. P. SCAIFE.

this time, as I heard several bullets whistle past), I made a feint at rising to the left of my cover, just showing myself for a brief instant on that side, and then immediately rising, and dashing off as fast as I could run to the right, and, having safely reached the ditch, I threw myself into it. As I made my way along this ditch, which was half full of water, I came across the bodies of four dead men, including two Canadians and one Northumberland Fusilier, within a few yards of each other, who had probably been shot by the same sniper, while walking down behind the hedge, believing themselves screened from view, and therefore safe.'

Bunbury deduced the sniper was hiding in a shelled-out cottage, and sent out two men to try to bag him. This they did, by dint of careful stalking – and discovered the German gunman was wearing a British uniform.

Bunbury said afterwards: 'Looking back on this I have not the slightest hesitation in saying that this was my most unpleasant experience, as it was the only occasion on which I was conscious of being threatened with funk, and I regard it as almost miraculous that I escaped untouched, and most sincerely thank God.'

Bunbury recovered to get as many of his men as possible together and return to the fray. As he advanced he came under more fire again from a party of Germans wearing British uniforms, who had succeeded in mounting a machine gun behind British lines. He said:

'I found by this time that I had become perfectly accustomed to the shelling, and no longer ducked at the sound of them bursting near at hand. I had also learnt the sounds of the different kinds of shell, from the Jack Johnsons which make a noise which is a cross between an approaching express train and a gigantic top, to the shrapnel from which you can feel safe if you hear it whistling, as then you know it is passing over you. There are also the high explosive shells, and the "coal boxes", which are a kind of miniature Jack Johnson which, when they burst, seem to throw out a quantity of ashes, but which do little harm generally speaking; one of these appeared to fall on two men quite close to me this afternoon, hiding them from view altogether for a minute or two, but I found that one was only slightly wounded, and the other only had both legs broken.'

The village of St Julien was the objective on April 26, when the scattered Northumbrians were able to regroup. They found themselves under yet more heavy artillery fire with the bombardment directed by spotter planes which circled overhead, apparently unchallenged by the Allied forces. Bunbury wrote:

'I could see the line of shells getting nearer and nearer, and they fell at such regular intervals that one could tell with a certain amount of accuracy where the next shell would fall. They jumped our first line without a single shell falling into the trench, and as by this time they were getting too near to be pleasant. I lay down at the bottom of the trench, and passed the word to my fellows to do the same, and not to attempt to stand up. They rapidly approached us, and as the Jack Johnsons began bursting only a few yards in front of us they descended with a thunderous thud which shook the ground, and caused portions of the sides of our trench to come tumbling in.

'So near were they getting that I would have bet any money on some of the next line of shells falling into our trench, but though some of them fell not more than 10 yards behind it, and several pieces of high explosive buried themselves in the front of the trench not a foot above my head, none fell into the trench, and we had not a single casualty from this bombardment.'

The German shelling went on all morning but in the early afternoon, at a moment's notice the Northumberlands were ordered to advance to the attack in a north-easterly direction. Bunbury recorded:

'Practically from the moment we started off we had to face a perfectly hellish shelling, which increased in intensity as we advanced, shells of every description literally raining on us from our front, right flank, and rear, while it seemed to me in the excitement of the advance that our artillery were giving us no support whatever.

'The line of our advance lay for about a mile over open ground, and after we had gone a short way, in addition to the inferno of shells in which we were, we became exposed to a very heavy rifle and machine-gun fire from the German trenches, which were directly in front of us near a wood at the top of some rising ground, and in such a position that they could fire right over what turned out to be our advanced trench, down on to us.

'The small arms fire was intense, and the nearest thing I can liken it to is a gigantic swarm of angry bees buzzing all around one. Men were falling on every side, and I felt an intense

Lieutenant Wilfrid Joseph Bunbury – aka The Bun – of the 4th Battalion Northumberland Fusiliers, whose personal diary gives a graphic account of the battalion's gallant contribution to the Battle of Ypres.

excitement, but there was no time for thinking, and my one idea was to push on as fast as possible, and to get as many men as possible to follow me, and keep going.

'One could scarcely hear one's own voice for the awful din, and it was only by shouting at the top of one's voice from mouth to mouth that an order could be conveyed any distance. When Frank Robinson and I got up to lead forward again, the men, who were perfectly splendid throughout, rose and followed us like one man, the order to advance being scarcely needed. From this point on we were in full view of the German position, and men were falling thicker than ever, but we kept plugging along as fast as we could with our heavy packs, etc. and the perspiration was fairly pouring off me, as though I was in bad training, instead of being as hard as nails.'

After getting away virtually scot free thus far, Bunbury made the mistake of peeping over a trench parapet to determine the next line of attack, and felt something hot touch his cheek:

'For a moment I thought that I had been hit. I turned to a man behind me, and asked him if I was hit, but he told me that it was only a graze, and there was only a tiny trickle of blood. It was a narrow shave, but left no more mark than a small razor cut would. I then went on again, but by this time I only had a handful of men still with me.

'Then a Jack Johnson burst, as it seemed, just over my head, and the concussion threw me face downwards on to the ground, while when I looked round, there was a huge hole just behind me, and several of the men following me were lying wounded on either side. Where it had actually fallen there was no trace of a soul and I fear that three or four of the poor fellows were blown into little bits or pounded into the ground. We found the trench occupied thinly by the 4th Seaforth Highlanders, who gave us quite a little reception, but more Northumberlands gradually struggled up. The trench was soon full, while others who came up behind dug themselves in behind the trench. The Seaforths, who were a splendid lot of men, however, seemed well supplied with smokes and eatables, and they plied me with Virginian cigarettes, which I smoked with more enjoyment than I ever remember doing before, and bread and marmalade, which I enjoyed almost as much.

'It was not until I had cooled down a bit, and looked back on the troops still advancing over the ground we had traversed, and had time to take in the groups of dead and wounded which were scattered

about everywhere, while more men were still falling every minute, that I realised how marvellous it was that any of us had reached the trench untouched. The memory of this day will probably remain with all of us who were there to our dying day, and I cannot thank God sufficiently for bringing me safely through it.

'As long as I was advancing I had scarcely seemed to notice the shelling, although practically every yard of the ground we came over was ploughed by them, while except in a few cases I was not conscious of having noticed the fallen men who thickly strewed the ground. While looking back I could see some distance away a man evidently wounded out in the open who was apparently attempting to help a worse wounded man to some cover, and only regret that I could not identify the gallant fellow with any certainty, as a deed such as this certainly deserved to be reported.'

Towards dark, one of the Seaforths spied some Germans advancing from a wood, evidently as reinforcements to their trench, and the two Seaforths and Bunbury opened fire, and each gave them twenty or thirty rounds rapid. Several fell and the remainder dispersed; shortly after, three Germans, all of them wounded in two or three places, came in and surrendered.

There was more excitement on April 28 when a German Taube spy plane was winged by anti-aircraft guns, and came quite low over the dug-

Headquarters staff with the Northumberland Fusiliers – note Sammy the terrier sitting on the CO's knee.

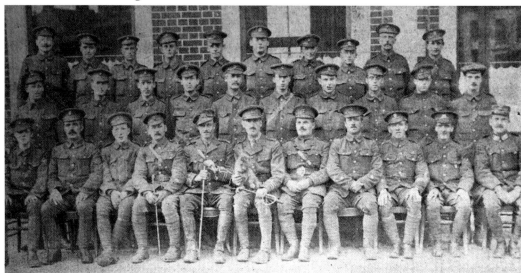

outs, whereupon all the Allied troops anywhere near opened rapid rifle fire on it, with the result that it crashed a short distance in front of the trenches. There was quite a rush among the men to go up and see the wreckage and the Germans started shelling the spot and several were wounded. Both the men in the aeroplane were dead.

One of the most fought over parts of Flanders was the infamous Hill 60, which changed hands several times during the conflict. Bunbury took a working party out to the hill while it was in Allied hands, and he noted in his diary passing several ruined chateaux, including Hooge, where the smells were 'something appalling', with many scarcely covered corpses of men and beasts, and evidence of atrocities, with the body of a Canadian sergeant reputedly crucified to a door.

One German attack that did succeed afflicted the colonel who, after feeling unwell for some time, went to see the MO – and discovered he had contracted German measles! May 2 brought renewed German activity and Bunbury reported for the first time that he experienced the use of poison gas by the Germans. He wrote:

'We were subjected to a determined attack with the help of that damnable poisonous gas. It was a clear bright day and there was a fresh breeze blowing from the east which aided the enemy considerably. From where we lay we could clearly see the gas blowing down towards us in a thick light-green coloured cloud, a good many feet in height, from about half a mile away. Soon, a number of the Lancashire Fusiliers, who had been up in trenches in front of us, came struggling back coughing fearfully, clutching at their throats and fighting for breath. They were indeed pitiable sights, and many of the poor fellows took temporary shelter from the shelling in our dug-outs, where we could hear their terrible coughing on all sides of us. The faces of the worst cases assumed an awful ashen colour.

'By this time the gas had reached us, and everyone had to put on whatever makeshift respirators they had. We only had woollen scarves which, tied over the mouth and nose, were, however, better than nothing. The German attack was then launched, and our front line being only thinly held, they got through both first and second lines, and were coming on up towards us, when the Dublins and the Cavalry Division, which had been lying near us, rushed at them with the bayonet, and got them fairly on the run. They did not give up the chase until they were well beyond our front line, by which time one of the Dublins told me afterwards not a single one of the Germans was left alive.'

Through an impressive display of flying skills, a German pilot managed to land his aircraft which had been hit by anti-aircraft fire on May 20, but his efforts were in vain – the pilot was shot by the French troops who reached him first. In his pockets were perfect plans of the Allied gun positions and support trenches. There was also frustration for the Fusiliers, who had been delighted to see some heavy British guns brought in to match the might of the Germans weaponry. However Bunbury wrote:

'The RMA are putting together a giant 17-inch howitzer, called Granny, in a farmyard about a quarter of a mile behind us. She is a fine looking weapon, mounted on a permanent platform, and her shells stand about 5 feet high. I went across to have a look at her this evening, but the fellow in charge told me they only have fifteen shells for her, and they cannot fire at all without direct orders from General Headquarters!

'Some of us had wondered why the 4.7s, which are posted near us, had not been firing at all since Sunday, but the colonel, who had met the officer in command of the artillery, told us the reason was that they had no shells left. I am afraid that this disgraceful state of affairs is pretty general among our heavier artillery, as I had on a previous occasion seen some naval guns near Poperinghe, for which, I was told, they had no ammunition.

'Our artillery, as at present constituted around here, is absolutely futile in dealing with the much greater quantity of heavy metal the Germans hurl at us every day, even when officially there is "nothing doing". The French, on the other hand, seem to have any amount of ammunition, and only a day or two ago one of their batteries near here fired over 1,000 rounds in one hour. It is absolutely sinful the way in which the public at home are being humbugged into believing that all is well. Much capital has recently been made in the home Press about our ascendancy in the air service. This evening we counted no fewer than seven aeroplanes up at the same time, of which at least four were German. I could not make out the distinguishing mark of the remaining three, but from the manner in which they were shelled I should be very surprised if more than one or two of them were ours.'

Bunbury wrote on May 21 that he had been told by a Frenchman that about 2,000 Germans, who were almost surrounded by the French, were on the point of surrendering when their own people in the rear opened fire on them and mowed them down almost to a man. He was also pleased to

report that proper respirators had been issued composed of a loosely packed gag of cotton waste soaked in hyposulphite of soda that covered the mouth and nose, enclosed in netting, which also formed a veil to protect the eyes when tied round the head. The arrival didn't come a moment too soon, for later the same day, the Germans made an exceedingly powerful gas attack, which forced the Allies out of their front line trenches, which had to be recaptured. Bunbury wrote:

> 'We advanced to some dug-outs where we took shelter for the time being. The shelling by now had become quite heavy, and many of those that fell near us were gas shells. The gas from these shells has rather a different effect from the choking sensation created by the green gas, which is pumped out of the trenches, as it attacks your nose and eyes, making them run continuously, and also making the eyes very sore. At one time three gas shells burst almost simultaneously within 20 yards of me, and some of the men were badly affected, but fortunately I managed to get my respirator on in time to save me from any bad effect. The only effect the gas had on me was to give me a splitting headache.'

While the gas didn't get him, he was shot in the foot during the advance and had to take himself out of the front line. He said in his diary:

> 'By slow degrees, and with numerous halts, I made my way back about two miles, until I felt I could not move another inch, and therefore remained at a dressing station in the grounds of a chateau between Ypres and Brielen, where there were already about 40 or

The Battle of Ypres claimed the lives of (from the left): Private W. Donnelly of Hexham, Private Hugh Hudspith of Corbridge and Private J.H. Whitfield, of Keenley.

PTE. W. DONNELLY, HEXHAM. PTE. HUGH HUDSPITH, CORBRIDGE. PTE. J. H. WHITFIELD, KEENLEY.
Reported Killed in Action. Killed in Action on April 26th. Killed in Action on April 26th.

50 wounded or gassed men. While on the way back I passed numerous poor fellows who had been gassed in varying degrees, and it was very pitiful to see the worse cases, as many of them were sitting or lying in ditches by the roadside looking a ghastly greenish colour and coughing painfully. Nothing could be done to ease them until motor ambulances came along to pick them up, and I should think that many of them would have been mercifully released if one of the shells which were dropping all round had put them out of their misery.'

He noted that the motor ambulances belonged to an American called Colby, who was running them at his own expense for the Belgian Army. Having heard that the Allies had a great number of casualties, and, as there was not much doing on the Belgian front, he had brought his cars down on spec to see if he could assist. Bunbury was among those taken to a place called Adinkerke, where Lady Bagot ran a small mobile hospital of thirty beds for the Belgians just outside the railway station. He wrote:

'Both Lady Bagot herself and the staff gave us a great reception, as we were the first British they had had through their hands. They gave us all a wash, followed by a good meal, which I am sure most of us really appreciated, as for many of us it was practically the only food we had had all day.'

Bunbury spent several months in hospital before returning to action as physical training officer, first to his battalion, then to his brigade, and subsequently to a command depot in Ireland. He arranged successful sports at Redcar in the summer of 1916, when he was complimented by the general, and when at Ballyvonare Camp, Buttevant, County Cork, he started games for the men, cross country runs, and boxing matches, all of which were greatly appreciated by the convalescent soldiers in his charge. He got orders to return to France and left England on 8 March 1917, and was attached to the 6th Battalion Northumberland Fusiliers.

Five weeks later, he was killed in action leading an attack on an enemy post. His colonel wrote: 'He was leading an attack in a conspicuously gallant manner and was the first man into the enemy trench when he was hit in the face and died painlessly. We recovered his body and buried it at night. His death was a great grief to me as we were great friends when he was in my company, where he always earned our admiration for the thorough way in which he carried out any work entrusted to him.'

Wilfrid Joseph Bunbury was the second son of Colonel Charles Thomas Bunbury (formerly of the Rifle Brigade) and Lady Harriet Bunbury, of

Cotswold House, Winchester. He was educated at Beaumont and St George's College, Weybridge, and at Ushaw College, Durham, and before the war worked with stockbrokers Wise, Speke & Co, in Newcastle on Tyne.

He was a very keen sportsman, playing hockey for the St George's Hockey Club, as well as playing several times for Northumberland at half-back. He was also a keen cricketer, playing for Northumberland County Club, the Yorkshire Gentlemen and the Borderers. He was a member of the Portland Park Tennis Club, at Newcastle, where he played most days during the season. He left a wife, Dorothy, and two young daughters.

Before the Fusiliers were pitched into the front line, an officer wrote from the front that he was stationed in a chateau, and while he could hear the guns in the distance, it was quiet and peaceful where they were. However, he noted all the work in the field was being done by old men and women, with no sign of any able-bodied men. He said: 'I have asked lots of children where their fathers are, and the invariable answer is "my father is at the war", or "my

Second Lieutenant Colin Smith Kynoch of Stocksfield, a prominent figure in the coal trade before joining the Durham Light Infantry, who was killed in April 1915 at Ypres.

father is dead". It is awfully sad. The people in England do not realise what war means; at one farm close to here, there is a little Belgian boy, about eight years old, who saw his father killed before his eyes and his mother and sisters taken away. He has never seen them since, and one can only imagine their terrible fate.'

He said the French people were very kind, and went to all kinds of trouble to get them things, but shuddered: 'The sanitary conditions in France are very primitive and it is a good job that all the men were inoculated.'

One unnamed officer wrote:

'We got the order that we had to retake St Julien and were on the move when the Germans saw us. We came in for some terrible machine gun and rifle fire, but the men came on splendidly. I had gone about 300 yards when I was hit by a bullet in the foot, and could not go on.'

Private T. Heppell, of Wall Fell, wrote:

'It was on the Saturday night that we really got to know what being under fire was like, for as we were going through Ypres, the Jack Johnsons started to come in at us. What a fine town it must have been, but it's all battered to pieces now. They shelled us all the way to the trenches, and a few horses were killed. It was 7am on Sunday that the battle began, and I never wish to see it again. I don't know how I got so far without being hit, because the shells were bursting all round us. It was when we were making a bayonet charge that a sniper got me, I was only about 30 yards from the trenches when I was hit, and had to crawl 300 yards back.'

Writing from a Red Cross hospital in Hayes, Kent, he said: 'I got a bullet in the left hip, but I should be all right again soon. This is Tuesday, and we only left England last Wednesday.'

Another Fusiliers office wrote:

'We received orders to attack a village. I don't think we had got clear of the wire when their artillery opened up, and for 200 yards we advanced in rushes as fast as we could, while every gun for miles around appeared to be firing at us. How anybody got through it I don't know – it was simply hell while it lasted. The way the men came on was simply magnificent. Eventually we came across a ditch going our way, and about eighty men got into it. Fortunately, the Germans couldn't quite get our range; the shells were bursting short and the shrapnel going over, so we escaped with only about three men hit. At the end of the ditch we had about 50 yards of open space to cross to another bit of cover, well exposed to rifle fire. I meant to run across those 50 yards as hard as I could run, but I was soaking wet up to the waist, had my full kit on, a rifle in one hand and two entrenching tools in the other, so my rush was only a very slow walk. That 50 yards seemed very long!'

In a letter to his father in Hexham, Private J. McNaught wrote:

'We had the honour of being inspected by Sir John French this morning, and we are not only proud to be with the Northumberland Brigade, but of the way Sir John spoke of us. He said we had done what no other territorial force had manage to do and what several regular troops of many years standing had never even attempted to do. The fighting last Monday was supposed to have been the most severe that has taken place so far, and through us going straight up to reinforce the line was the means of taking the position.'

Writing to his wife about the battle, another unnamed Fusiliers officer said:

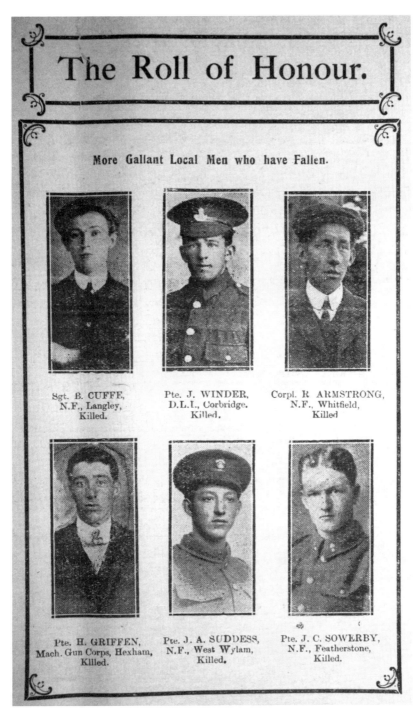

In June 1915 the pages of the *Hexham Courant* were filled with the faces of those who would not be coming home.

'We had just finished tea when heavy shell fire started, and we saw a crowd of men coming down through our lines, running all over the place followed by a greenish cloud of smoke. The damned scoundrels had opened up on them with poison gas. You cannot imagine what they were like, sick and coughing, and nearly bursting their lungs, or staggering about, many of them unconscious. They did pepper us, with Jack Johnsons in front, behind and in the rear parapet, but I don't think we had a man hurt. When we had to withdraw, by George, everyone was tired. The roads were dreadful to march on, and our feet were all cut to bits. We lost nearly all our horses and had to walk, but our little terrier Sammy has been wonderful in all the scraps. He was blown up by a Jack Johnson the other night, but is still quite chirpy. You never saw anything like the country beyond Ypres. The smell of the dead is rotten, and there is not a house that has not been shelled.'

The British were not prepared for the use of gas, and instead of gas masks, they were only issued with mufflers to put round their mouths when the gas clouds came over. Most of the victims were said to be gasping for breath, their faces black, hardly able to see, and all of them coughing as though suffering from acute bronchitis.

Private Johnson of the Fusiliers wrote to his brother in St Wilfrid's Road, Hexham:

'It's awful hearing a gassed chap coughing and moaning, because you cannot relieve them any. The only cure is fresh air, and something hot to drink. Hundreds die from it, and a painful death it is too. If those dirty Germans would stop their filthy work and start a fair fight, we would beat them in a week with the point of a bayonet. They know they are beaten, and this is their spiteful revenge.'

It was not only the use of gas which put the Germans in a bad light. Lance Corporal John Ord wrote to his parents in Pearsons Terrace in Hexham:

'I was out on Tuesday morning looking for snipers, who were firing on our stretcher bearers, and it was the most awful time of my life. They asked for volunteers, and I went out, as they could not get the wounded in. One of the wounded lads lay on the field all night and when he was trying to get a drink from his water bottle, the sniper shot him in the back. I helped to carry him in, and although we were shelled all the way, we were fortunate in never being hit.

'The Germans tried the fume shells on our men again, and you

Doing their bit were the five sons of the late John Cowen of Diamond Square, Priestpopple, Hexham. The eldest Thomas, was in the remounts department, and was in France for two years. Second son William was in the Army Service Corps, Jack volunteered the day war broke out and was in France with the 4th Battalion Northumberland Fusiliers from April 1915, while Percy, aged 19, was in training in Newcastle.

have no idea what they are like. It was just a cloud of yellow vapour, and it doesn't half hurt your eyes – it is enough to suffocate an ox. We are provided with things to avoid it – a muffler you tie round your nose and mouth – and even that is bad enough. How our brave fellows stood it I don't know because after they fire it, the Germans advance, but our men in the front trench held on, and mowed them down with Maxims and kept our line unbroken.

'We are resting now at a farm a good way from the firing line and there is a pond where we can bathe – even though it is full of frogs. It's A1 having a swim after being in dirt up to the neck. What a treat it is to walk round without shells bursting around your ears. We sleep in a shed, and it's champion among the hay, with nothing to disturb you except a stray rat or pig – and the hens are a trifle early in rising.'

Private Hogarth of Hexham wrote to his friend John Scott after being wounded at Ypres:

'The Germans had the range to a yard – their spies see to that. The shells were coming down thick and fast and the rain was in torrents; we were wet to the skin, and covered in clay from head to foot. Things were pretty quiet until 3pm, when Jack Johnson went bang, and you would think heaven and earth were going to meet. We got the order to advance in extended order, and lie down in a ploughed field. Then we had to advance again, and now we were under

machine gun and rifle fire. You have to get down pretty smart when they turn the machine guns on you. It is more like harvest day, reaping men instead of corn. I got mine in the back and it pinned me to the ground. Sergeant Smith took my pack off, and then had to leave me until nightfall and I never want to go through that again. The bullets were coming round me like a swarm of bees and I could not move. I thought every minute I was going to die.'

However, he was found by an Irish doctor and two of his men, who took him to a shed and dressed his wounds and he was eventually taken back to base by motor ambulance, and eventually to hospital.

Drummer J.W. Forster, of Hexham, was involved in the fighting with a group of Indian troops, who were forced to retreat through clouds of gas and rifle bullets. He wrote:

'It was absolutely ruining them but they kept going, although the German Maxims were mowing men down all round. Then I saw two Indian troops cut a sniper to pieces with their knives from where I was lying.'

Private A.W. Sharp, of Haltwhistle, wrote to his brother:

'We have dropped into the hottest place in Europe. I think the Germans have been spending the morning in prayers, and hymns of hate invoking the help of their Almighty to carry on their Devil's work. Having thus prepared their forces with God's and the Kaiser's good wishes, these fanatical animals started a feverishly violent attack. All their energies, their forces of blood or iron and powder were put into play to smash up our lines. The gain, if any, was small. But what of the men? They must have lost many more than us, I am convinced.'

Private Alfred Dodd, of Swinburne Cottages, Barrasford, wrote of crawling along a ditch for 200 yards before finding himself within 300 yards of the German lines. He wrote: 'Our chaps accounted for a few snipers, Captain Dixon getting two. They were all dressed in British uniforms.'

Prudhoe's Private T. Wright of the 4th Northumberland Fusiliers wrote to his mother:

'We broke through the lines and took a village, with lots of German prisoners. Tell Father I am killing my birds well. It is great sport out here shooting Germans, but I have been to hell, and got back safely.'

An unnamed officer wrote to the *Courant* about the genuine anger of those

at the front when they heard tales of men at home wanting to cash in on the war. He said:

> 'Nothing makes us sicker than reading about people striking for war bonuses, and wanting bigger wages for shorter hours. Martial law, and a few severe examples being made by shooting a few of the ringleaders would please us immensely. Life is cheap enough out here in all conscience, so why should it be so much more valuable at home?'

One young eagle who sadly did not see out the war was John Aidan Liddell, son of wealthy land and colliery owners John and Emily Liddell, of Prudhoe Hall, and Sherfield Manor, Basingstoke, Hampshire. He attended Stonyhurst College in Lancashire from 1900-1908 where he was known as 'Oozy' Liddell because of his fondness for messing about with engines and chemicals. He then went on to Balliol College, Oxford, where he distinguished himself reading zoology.

In 1912 Aidan joined the 3rd Reserve Battalion of the Argyll and Sutherland Highlanders. However, he was also very keen on flying and obtained his Royal Aero Club Ticket (No. 781) in the spring of 1914. He learned to fly in a Bristol Biplane – better known as the Boxkite – at the Vickers School at Brooklands in Surrey. On the outbreak of war, he accompanied the 2nd Battalion Argyll and Sutherland Highlanders (Princess Louise's Own) to the front in France with the rank of captain, and was placed in command of the machine-gun section of the battalion. He was in the trenches for forty-three consecutive days, serving with such distinction that he was not only mentioned in despatches, but was awarded the Military Cross on 14 January 1915.

He was himself wounded and invalided home, but after his recovery, he eschewed the trenches to join the infant Royal Flying Corps in May 1915. He was back at the front on 23 July, and eight days later, whilst on a reconnaissance mission in the Ostend-Bruges-Ghent area in enemy occupied Belgium, his aircraft was raked by enemy machine gun fire. He was severely wounded in the right thigh, which caused him to black out, with his aircraft plummeting nearly 3,000 feet in an inverted dive. He somehow succeeded in bringing the stricken

Aidan Liddell VC, a hero on the ground as well as in the air.

aircraft back under control, despite the fact the control wheel and throttle control were smashed, as were parts of the undercarriage and cockpit. He succeeded, still under heavy fire, in bringing the plane back to Allied lines, half an hour after being wounded, saving not only the aircraft, but also the life of his observer. For his bravery, Liddell was awarded the Victoria Cross, but his injuries were so severe that his leg had to be amputated. Septicaemia set in, and he died of his wounds a month later at De Panne, Flanders, Belgium, on 31 August 1915, aged just 27. He is mentioned on the war memorial at Prudhoe, as well as on memorials at Basingstoke Old Cemetery, Hampshire, the church at Sherfield on Loddon, St Joseph's Church in Pickering, Yorkshire, Stonyhurst College and on a plaque at the Church of the Holy Rude, Stirling. An In Memoriam tablet was erected to Aidan Liddell in the Scottish Naval and Military Residence, Edinburgh, and his Victoria Cross is on display at the Lord Ashcroft Gallery's Extraordinary Heroes exhibition at the Imperial War Museum.

It wasn't only in France that men of Tynedale were fighting and dying in the droves. Arthur Patterson of Hexham was killed while fighting in the Dardanelles, and his uncle wrote to a friend: 'The Turks have been very cruel to our wounded, but tell my sister that they didn't get Arthur – he was killed instantly.'

Arthur Patterson (25) had been a clerk with William Fell and Company before the war, and was also a player and honourable secretary of the Tyneside Rovers Rugby Club. He was also a staff sergeant with the Church Lads' Brigade in Hexham, as well as being a former member of the Abbey Choir.

One of the bloodiest and most notorious conflicts of the First World War, with thousands of people dying on both sides, was the infamous invasion of the Turkish peninsula of Gallipoli, in a bid to take Constantinople and secure a safe sea passage to Russia.

Most of the men fighting for king and country in 1915 were from the famous ANZACs – the Australia and New Zealand Army Corps. But it wasn't just the Aussies and Kiwis battling the fanatical Turks.

Also in the trenches was a remarkable man from Bellingham, whose involvement in the battle has come to light in a letter home to his sister. He was Michael Walton, who was born at Woodburn in 1888, but later moved to lodge with his uncle at Rawfoot Farm on the outskirts of Bellingham. Although he was from a farming background, he took up a career in banking and at the age of 25 seemed set for life when he was offered a regional managership with Lloyds Bank.

e. J. Bell, Pte. M. Martinson, Pte. T. Hedley Lce.-Cpl. T. R. Shaw, Sergt. W. Turnbull,
l Warwickshires. 4th N.F. K.O.S.B. 4th N.F. 4th N.F.

The North Tyne capital of Bellingham was well represented at the front. Doing their bit here are Private J. Bell of the 4th Royal Warwickshires, Private M. Martinson of the 4th Northumberland Fusiliers, Private T. Hedley of the King's Own Scottish Borderers, Lance Corporal T.R. Shaw of the 4th Battalion Northumberland Fusiliers and Sergeant W. Thompson of the 4th Battalion Northumberland Fusiliers.

However, he turned his back on the world of finance, and with one of his pals, decided to emigrate to Australia. He'd only been there a matter of months when the Great War broke out and Michael – a keen sportsman – jumped on to a train straight to the recruitment office in Perth. After some initial difficulty, he joined C Company of the 16th Battalion of the Australian Army as an orderly clerk on 19 September 1914.

Three days before Christmas that year, he was aboard the Australian troopship, the HMAT *Ceramic* en route to the Middle East.

What happened next he revealed in a letter to his sister Margaret who was living at Plashetts in the North Tyne. In matter-of-fact terms, he describes the sheer carnage which saw him the only survivor of his sixteen-strong unit in the 'Valley of Death'. He landed in Alexandria in Egypt, before boarding another troop ship to the Dardanelles, where he and his men spent ten days on the island of Limnos where the troops were gathering for the invasion of Gallipoli.

That took place on 25 April 1915, when Michael wrote:

'We could see them fighting like blazes when going up the coast. We got into a torpedo destroyer straight away and off for the shore. Then, when she got as near as she could, we had to get into small boats. That was when it first began to try us a bit, as it was slow

work and the shrapnel was screaming around and bullets dropping. We were certainly lucky as we only got six wounded.'

Michael and his men went straight into the firing line as soon as they landed and after around five days, things started 'to get hot'. He wrote: 'It was moonlight and we could see swarms of Turks coming, blowing bugles and shouting "Allah". They did come too, right up to within 50 yards of our trenches, but they would not face the bayonets. They must have lost a terrible lot that night.'

The following day, the Australians fired a volley into some thick scrub, about 30 yards away, in front of the trenches. Michael wrote:

'About a dozen Turks jumped out of it. Our chaps nearly went mad and jumped up on top of their trenches in eagerness. There wasn't one got away; it was for all the world like shooting rabbits, as they were running and ducking in every way. We couldn't help laughing at them. As a rule, they don't care a hang for the bullets, but they will not have the bayonets. They ran like blazes.'

Soon afterwards, Michael and his men had to leave the trenches and sprint over 100 yards of open country exposed to the enemy shrapnel as well as machine-gun bullets. He wrote:

'I only touched the ground in places: I think I must have beaten all the running records ever known. I dropped into a shelter trench just as a shell burst behind me, and I heard someone yell "Oh". The shout had come from a chap who was nearly alongside me in the firing line. The shrapnel had finished him.'

Away from the fighting, the exhausted troops went down to the beach and had some tea – 'the thing we felt most in need of in the trenches' – and some pea soup taken from the pack of a dead Turk. They lay down and slept in their overcoats, but the next morning, they had to go into the 'Valley of Death' where they lost a number of men to snipers operating from a hill overlooking the trenches. The order then came through to attack the hill.

Michael wrote:

'We began to climb the hill just after six, after the artillery had given it a good pounding. Up we went with fixed bayonets, never firing a shot. When we got to the top we gave the Turks a bit of a surprise.

'They flew for a time, and turned and came back on us. We fought and dug trenches, but they were able to account for a good few of us. When daylight came we were fighting about ten to one and we put in the warmest four hours I have ever had. It wasn't war, it was

wholesale murder on both sides. The Turks had a long way the best position and they came within 50 yards of the trenches. Had they rushed they could have taken them easily.

'Out of 16, I was the only one left to hold 50 yards of trench.'

Michael was enjoying something of a charmed life, for although he was in the thick of the fighting, he was largely unscathed. 'I was beginning to think they couldn't hit me, because I had two bayonets shot off my rifle, one bullet through my cap, one just grazed my cheek, and one just left a mark in the peak of my hat.'

However, his luck finally ran out:

'It came like a 50-ton hammer. I had just had a shot and was coming down again, when a bullet got me. It went in at the bottom of the fleshy part of the hand and came out at the top of my wrist and settled in me. It makes you pretty sick for a while after you've been hit, but I am thankful it wasn't worse.'

He was taken down to a dressing station, before being sent on board a hospital ship, and all the time the Turks were firing at the wounded and the Red Cross men. He wrote: 'When we got a full boatload we sailed to Alexandria, but I am sorry to say we buried about 50 before we got here. I came out of the fight with just what I had on. I lost my pack and everything, but I was satisfied to come out with nearly a whole skin. I will be all right in a month or so, and be off back again.'

In fact, Michael was in a convalescent camp until the end of July. After rejoining the army, he was promoted from corporal to sergeant on 25 August, but by the end of September he was back in hospital, having been wounded again.

Michael was promoted again to warrant officer and when the fighting was over in the Middle East, he was sent to Europe to join the fighting in France. He was wounded yet again, before being commissioned as a second lieutenant, and taken away from the front to become an instructor. There he fell dangerously ill and was sent to England, where he spent more than two months in hospital.

On release, he could have had a staff job away from the fighting, but wanted to be back in France with his men. He did return in January 1917, but was captured by the Germans and remained a prisoner of war until being repatriated to England on 1 January 1919.

Also serving in the Dardanelles was Private Henry O'Callaghan, of the 9th West Yorkshires, who described to his mother in Hexham the landing in Suvla Bay, when the British troops were being shot down like rabbits as they got off the landing boats:

'I got off all right, but lost all my pals. We advanced with fixed bayonets under very heavy fire, and made a charge in which I got two to my credit. When we were stood down, we only had half the battalion left.

'The next day, it was fair hell in Acake [Achi] Baba with the Turks coming through right and left and I got a bullet through my leg. I had to creep from the firing line to the beach, which was about four miles, and it took me all day. How I got down God only knows, as the Turks were right on top of me, killing the wounded and robbing the dead. I will never forget the sight as long as I live.'

There were heroics at sea too, where Allendale's Cecil Hetherington was an apprentice on the steamer *Jacona*, which sank in the Moray Firth when it hit a German mine. The ship sank in less than two minutes, but Hetherington was lucky enough to come to the surface clinging to a piece of wreckage, with a number of other survivors.

After 10-15 minutes, he saw a boat floating upright some 75-100 yards away, and volunteered to try to reach it, as most of the other survivors were even more exhausted than him. Fully clothed, he swam out to the boat, and with great difficulty, managed to climb in to it, and bring it back to the wreckage. He picked up the master, Captain Organ and another man, and then searched through the water, and found seven other survivors. Captain Organ said that without the bravery of Hetherington many more would have drowned that day. When he returned to Allendale, Hetherington was guest of honour before a very large crowd, at a special event in the flower show field, where he was presented with a gold medal inscribed: 'Bravery at Sea 1915. Presented with a purse of gold to Mr Cecil Hetherington by his friends in Allendale and august visitors.'

Allendale's Cecil Hetherington, whose heroics following the sinking of the steamer *Jacona* brought him multiple honours, including the prestigious Stanhope Medal for the gallant deed of 1915.

Despite his bravery at sea, Hetherington was said to be 'too bashful' to say anything in response to the gifts. He was later recognised by the Royal Humane Society, the Shipping Federation and the Board of Trade, as well as being awarded the coveted Stanhope Medal for the gallant deed of 1915.

Chapter Three

1916 – Come and join us

WHILE THE FIRST line of the Northumberland Fusiliers went to France in April 1915 the second line headed west on a recruitment march, headed by the regimental band playing 'Tipperary'. At Haydon Bridge, they were liberally supplied with cigarettes, tobacco, cigars and aerated waters, and treated to a smoking concert, featuring amongst others, Miss Sadie Walton who very prettily danced the sword dance in Highland costume.

Nine men signed up, and the next day, it was on to Bardon Mill, where the soldiers each received more smoking materials, including a box of cigarettes with the note: 'With a kind heart to our British friends, from the Belgian refugees in Henshaw'. The route match continued to Haltwhistle

Mr and Mrs Wilson of Langley, pictured with their five soldier sons – four in the 4th Battalion Northumberland Fusiliers, and the fifth in the Black Watch.

the next day, where the town was bedecked in Union Flags and other bunting. A service in Holy Cross Church was addressed by Colonel John Clark, who said he had noticed a number of young men watching the parade earlier. 'I say to them, the time has come not to look on, but to do.'

While men were falling in France, there were casualties on the Home Front too, when a policeman from Chollerton, 22-year-old Robert Telford was killed while on duty at Willington Quay, Wallsend in June 1915, when a Zeppelin unleashed its deadly cargo of bombs on the Tyne.

In the spring of 1915, close upon 2,000 soldiers were quartered in the town, and thanks to the generosity of a few local gentlemen they were entertained to light refreshments, cigarettes, and a series of the best smoking concerts ever held in the town. The Rev. J. E. McVitie and the office bearers of the Presbyterian Church kindly placed their hall at the disposal of the management.

The good lady knitters and sewers of Tynedale, meanwhile, had gone into overdrive, supplying nightshirts, bed jackets and hot water bottle covers to the hospital wards, while landowners gave what they could in terms of raw produce, including vegetables, rabbits and game.

The Gem Cinema in Hexham started giving showings free of charge to convalescing soldiers, and a number of local businesses paid the families of members of staff who had enlisted, weekly allowances to keep their heads above water. Permission was granted by the governors of The Queen Elizabeth Grammar School to use the school premises as an emergency hospital of the Hexham detachment of the Red Cross.

An appeal went out to equip the hospital with everything from beds and bedding to hot water bottles, nightshirts, cutlery, rubber gloves and mustard for poultices. However, the education committee declined to sanction such a use for the school.

The Haltwhistle Working Group reported it had distributed over 1,000 garments, while the Hexham War Depot had sent out over 3,400. Of those, 1,700 had been sent to soldiers on active service, 620 to families in distress (including Belgian refugees) and 200 to the new Red Cross Hospital in Hexham.

One Mrs J. Welch, of St Winifred's Road, Hexham, won plaudits for knitting no fewer than fifty pairs of socks, including a pair for each of her

Mrs J. Welch, of Hexham, knitted no fewer than 50 pairs of socks for soldiers.

four grandsons fighting at the front. Miss Annie Woodman of Haydon Bridge, although 83 years of age, had knitted twenty-two pairs of socks for the troops, a record which could have improved had it not been for the fact she had been quite ill. Although born in Allendale, Miss Woodman had lived in Haydon Bridge for 81 years, and was slowly being regarded as practically a native…

Skilled Belgian workers needed for the ordnance shops of Elswick in Newcastle had nowhere to live, so it was agreed that temporary accommodation be provided for them in the building of Hexham racecourse, even though there was no mains water or sanitation.

By now, schools, farms and country estates had found a way to help too, sending eggs to the Newcastle depot of the National Egg Collection for wounded soldiers and sailors. In a few short weeks, pupils at Greenhead Church School collected 1,200 new laid eggs for the cause, and Falstone village forwarded fourteen dozen in one donation alone.

Annie Woodman, who at the age of 83, knitted 22 pairs of socks for the cause.

After the first rush, recruitment had fallen off in the rural areas by mid-1915, so it was decided that all suitable men should be visited at their homes by a well known and influential local person accompanied by two men in uniform.

With recruitment tailing off, the Earl of Derby came up with a voluntary registration scheme, under which men were told if they put their names down, they would only be called upon if absolutely necessary. Married men were told they would only be required once the supply of single men had been exhausted. The scheme was not a success, despite shamelessly using the execution of Nurse Edith Cavell by the Germans later in the year to encourage men to sign up.

The introduction of the National Registration Act in July 1915 was seen as a precursor to compulsory national service. Ostensibly, it was done to provide an indication of the full resources of the country for war purposes, but most felt this was a ruse as the moral blackmail of men to enlist was starting to founder and the carnage on the front left the army shorthanded. The best advertising brains in Britain were called in to produce posters encouraging men to enlist or face eternal shame, and

some members of the Suffragette Movement established the practice of handing white feathers to any able-bodied men they came across who were not in uniform. Ghoulish tales of German atrocities were also spread.

Ariel wrote in the *Courant*:

'The country wants men to serve in the field against our formidable foes and she wants workers for our munitions factories so that the output of the nation's workshops shall in all respects equal the demands of our fighting forces. The government has evolved the registration system to ascertain her full resources of manhood and womanhood, and if the voluntary system is not giving her the number she needs, it would be idle to suppose she would not take them by compulsion if occasion serves. The number of men who have flocked to the colours from this district under the voluntary system has shown that a fine spirit pervades the majority of them. But there are others. Some have excuses which should and will prevail, but some are shirkers, against whom no jibe or jeer, however bitter, will move. The register will reveal all these.

'The very nature of compulsion is abhorrent to a Briton, but these are not ordinary times. Many of us will be compelled to jettison our most cherished beliefs before we are through this dire struggle.'

As casualties mounted, the recruitment drive was stepped up a gear with more appeals to the district's conscience.

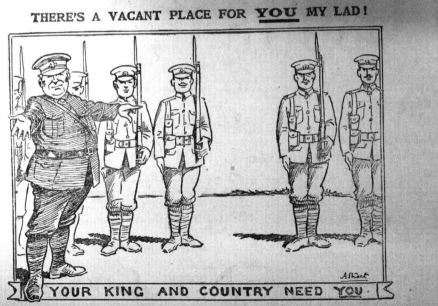

Lord Kitchener has obtained 900,000 recruits, and only 100,000 are needed to make up the first million. So take *your* place in the ranks, young man, at once, and enlist at the nearest recruiting office, for the sake of your King and Country.

It was pointed out though that in the rural areas, many farmers were already short handed and could not really spare many more of their farm hands for the front. To encourage recruitment, the men of the 4th Battalion Northumberland Fusiliers again marched the length of the district, with bugles blaring and the band playing. They were greeted at the Electric Picture Palace in Prudhoe, where, after stirring songs were sung by Drum Major Robinson and Sergeant Tully, twenty-two men enlisted.

In a letter to the Rector of Hexham, Canon Sidney Savage, an officer of the Northumberland Fusiliers wrote: 'We are finding the greatest difficulty now in getting recruits, and in Hexham and the surrounding district, there are a large number of young men who could enlist, but who I am afraid shirk.'

More than 1,000 people attended a service at Hexham Abbey, where Canon Savage gave a thundering sermon calling on the young men of the town to listen to their consciences. He said:

'There are far too many who have not yet toed the line. Poignant and bitter will be their regrets in the months and years to come. These are not the days for peace proposals and for criticism which any fool can give. Talk and counsel of such kind, how ever well intended, is stupid and harmful. To talk of peace now is positively criminal; it is dangerously near being accomplice to crime. Peace without righteousness is no peace. Today is the day of grim determination for war preparations and for training and discipline. The task of crushing brutal and savage Prussian militarism is not yet finished; our one and only business is to fight the Germans and crush them; if we fail they will brutally crush us. Whether we love or hate the Germans matters not. This is a rough war, and Germany shrinks from no brutalities. If she cannot slay enough of our brave men, who fight for England, she will give no shrift to the helpless and defenceless and the drowning struggles, with that hellish laughter which is the characteristic of Prussian Kultur.'

Not everyone was moved by the rhetoric, for at nearby Corbridge, a member of the parish council who had posted a list on the parish notice board of those men he believed were eligible to serve, was approached in the street by one of them, who threatened to smash his jaw for such temerity.

The *Courant* columns were filled with letters from the front as the 4th Northumberland Fusiliers took heavy punishment and had only two of their original officers still in action by the beginning of June. The German use of chlorine gas – 'the work of the very devil' – was widely condemned by the victims.

When the men of the 4th Northumberland Fusiliers marched off to war from Hexham, one of the recruits was a little smaller, scruffier and hairier than the rest. But he wasn't put on a charge by the company sergeant major – for Sammy was a dog. The six-year-old Border Terrier cross was the mascot of the battalion who were based at Hexham. Little Sammy had been raised from a pup by Lance Corporal George Urwin and was adopted by the soldiers when he started going along to their training sessions at the Drill Hall in the town.

So it was only natural that after completing their training, when the battalion marched off to the town's railway station for the killing fields of France, Sammy jumped on to the train with them. When the Fusiliers were involved in the attack on St Julien, part of one of the most infamous actions of the war, during the Second Battle of Ypres, Sammy was right in the front line, and like so many of his comrades in arms was wounded and gassed in the fighting which followed. Happily, he survived, and stayed with the Fusiliers for two years, living with them in the trenches.

In a letter home to his family from the front, Quarter Master Sergeant A.G. Richardson wrote: 'Tell the people of Hexham that Sammy is still going strong and goes wherever we go. He has had his dose of gas, the same as most of the rest of us, but he is all right now and enjoys chasing the pigs when we are billeted on farms.'

Sammy went on to become something of a national celebrity, with the *Daily Mirror* and other national papers producing features on him. He was described as probably the smallest mascot in the British Army and was well known to Tynedale Rugby Club players as he used to turn up to their matches, too, before his 'taste for powder' caused him to change his habits. He was blown up by a feared Jack Johnson shell on the Somme, but landed on his feet, apparently unscathed.

Then, tragically, the brave little terrier was killed in what is now called a friendly fire incident – he was accidentally blown up during a field firing practice at Warfusee in Belgium. In a letter home, Lance Corporal Frank Elliott, of Haydon Bridge, wrote after his death:

'Some of our chaps have gone out to look for him. He was a fine little chap and was never so happy as when the battalion was

The scruffiest recruit in the army, the 4th Northumberland Fusiliers' mascot, Sammy the half-bred Border Terrier which saw action on the Somme.

out for a march, headed by the fife and drum band; he always ran in front of the band.'

Following Sammy's death the following poem appeared in the *Hexham Courant*, courtesy of one J.A. Barton:

We didn't know his pedigree; what's more we didn't care; enough for us that Sammy was our darling everywhere;

Right from the colonel downwards and often upwards too, he was loved through all the regiment, a mascot staunch and true

He came to us from Gilesgate, back in that early fall when the finest lads of Tynedale obeyed their country's call

He came – we couldn't shift him – he must have known it then what others found out later, he'd found a breed of men

On every trying route march, and many a swell parade you could bet your life on Sammy, top dog of the brigade

And the way he seemed to know it was not by what he said, but by the cocksure swanky way the little beggar led

Though he wasn't on the roll book we took him on the strength, and when for King and Country we faced the foe at length

Guess Sammy wasn't backward in going forward where, everybody worth his grub did more than double share

Our first spell was at Ypres, where shells fell thick and fast, and bullets kept a whistling as though they meant to last

Yet Sammy stood the racket, the way a hero should, though hit, and gassed and shaken, his heart was sound and good

Then through the lengthening vigils, along the battle line, our pet was always faithful, as in the days lang syne

And often we have pictured, when thoughts would westward roam, poor Sammy's royal welcome when he came marching home.

But Sammy's march is ended, back home he'll never come, to the sound of martial music and the rolling of the drum

Yet hearts there are who'll cherish throughout the coming years, the memory of the mascot of the gallant Fusiliers

But who knows that out somewhere on a fair Elysian plain, he hasjoined up with the heroes he is glad to meet again

Where he's waiting for the coming of the chums he left below, till the Bugles of the Morning their Grand Reveille blow

The distraught troops thought they would have to lay their beloved mascot to rest on some foreign field, but in stepped the company commander Colonel Ridley Robb, who insisted that his tiny body be brought back to Blighty. The Fusiliers then paid for the services of taxidermists P. Spicer and Sons, of Royal Leamington Spa, to preserve the remains. They brought Sammy back to Hexham in a glass case and he stood proudly in the Drill Hall in Hencotes for the next 70 years – his collar bearing the Fusiliers' red and white hackle and surrounded by photographs of his life in service of king and country.

However, when the future of the Drill Hall in Hexham seemed uncertain a few years ago, Sammy was despatched with due ceremony to the Northumberland Fusiliers' Museum at Alnwick Castle, where he continues to hold court.

The manager of the Gem Picture Palace in Hexham sent out to the front a package containing 30,000 Woodbines, 7,000 Gold Flake, 3,000 Capstan Full Strength and 100 ounces of twist tobacco paid for by customers for the comfort of local lads. Thanking him, Captain F. Robinson wrote: 'I hope you can send us some more of the same, because now there are only 130 of us left out of 234.'

It wasn't only in the trenches that Tynedale lives were being put in grave danger. One of the great atrocities of the war was the sinking of the British passenger ship RMS *Lusitania*, pride of the Cunard line, by a German torpedo. Among those on board was Mrs Docherty, the daughter of Mr and Mrs T. Irving of Temperley Place, Hexham, with her two-month-old baby boy – the youngest passenger on board.

She and her companion, 'a Scotch girl', were at second luncheon when the torpedo hit. They were last to leave the dining room and Mrs Docherty had to scramble over rigging with her baby in her arms on the severely listing ship to reach the boat deck. There they were handed into one of the two remaining lifeboats, which was already just about touching the water because of the list of the ship.

Mrs Docherty, who survived the sinking of the British liner RMS *Lusitania* in 1915.

At the last moment, a young clergymen jumped into the boat to join his wife.

They managed to get away, only to be threatened by the funnels of the ship as it slid beneath the water, and then by the wireless apparatus, but the skill of the sailors of the lifeboat steered them to safety. There was no panic but a gasp of anguish came from the clergyman when his wife was suddenly plucked out of the lifeboat by a great surge of water. She was presumed lost, but incredibly Mrs Docherty spotted her in another lifeboat, so covered in soot as to be almost unrecognisable. It seemed she had been sucked into the mouth of one of the great funnels, and then spat out again. Once safely landed in England, Mrs Docherty was delighted to be reunited with 'the Scotch girl' who had also escaped the tragedy which went a long way to shift public opinion in the USA to joining the war.

The war had brought about a sharp rise in the price of food, and it was suggested that responsible families should restrict themselves to one meat meal per day, and to make the Sunday joint last until Tuesday. At the Brampton workhouse the local guardians decided to substitute rabbit for bacon, more soup was to be used, margarine used instead of butter and cheese only served on Wednesdays, which would save £53 per year.

The *Courant* launched an appeal for sandbags, which resulted in over 1,000 being presented to the War Department, but this was followed in August 1915 by a new appeal for sweets, pipes, soap, vermin killer, hair clippers, bootlaces, buttons, Bovril, and cafe au lait, all much appreciated at the front.

An article in the Hexham Abbey Parish Magazine in July 1915 said:

'It is doubtful if anyone, not actually in the field, at all realises what the word sandbag means to the soldier in the firing line, or how urgently millions, and yet more millions of sandbags are needed to stem the casualty lists.

'On June 16 the rector presided at a large meeting of the members of the Mothers' Union, when the matter of providing sandbags was taken up with deepest interest. A sample was inspected, and on alternate Wednesdays at the Institute the material will be supplied and instructions given to any ladies who will work at home. Some members of the Mothers' Union have kindly visited The Priory and have done some sandbag work and some talk in the garden.

'Miss Jackson, Netherton, has received the following subscriptions for sandbag material to be worked by those who are

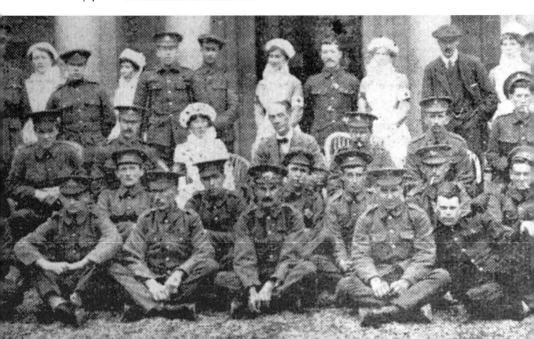

Wounded British soldiers relax at the convalescent home created at the stately home at the Chesters, near Humshaugh.

willing to give work: she has received 78 sandbags from ladies at the Hydro. One hundred have been sent to headquarters, and 260 are being made. There are further orders for 200 more. Miss Jackson reports that 850 sandbags have been made, and she asks for subscriptions and help for more. They are an indispensable necessity at the Front.'

A 'Cheer Up Club' was launched at the Abbey to be of service to the wives and mothers of soldiers and sailors. Two rooms were made thoroughly attractive for members to indulge in reading, writing letters, working, recreation and social fellowship. On Tuesdays and Fridays the rooms provided 'a welcome to many members; and the kindly feeling between workers and visitors is singularly happy. A special pleasing feature is that those who have been bereaved use the club.'

Mrs Straker, of the Leazes, undertook to collect parcels fortnightly from the Institute which members could send out to the front. She agreed to forward parcels and pay the carriage. The rector also offered rooms at the Institute for the use of the Northumberland Fusiliers each weekday evening from 6 to 9 and any other soldiers in the town were welcome to use the club.

The war opened up jobs thought to be a male preserve, with women delivering the post in urban areas, but this was nothing new. In Hexham in 1830, the post office was no larger than a small closet, and letters were delivered by an old lady, who carried them in the pocket of her checked apron. The office itself was managed by an old volunteer captain, who was never known to be in a hurry, and his clerk, who was never known to be in good humour. The two or three letters a day were supposed to be delivered by an old sailor but because of his bibulous propensities, his wife did the job, carrying them in her pinny pocket.

At the outbreak of war, the Defence of the Realm Act made it illegal to buy drink for soldiers, but in April 1915 the landlord of the Coach and Horses Inn in Priestpopple, Hexham, James Dodd, appeared before Hexham Magistrates charged with supplying intoxicating liquor to soldiers at the Hexham Show.

PC Rattray said he had seen three soldiers standing outside the beer tent at the show, and one of them was drinking whisky. Licensees were banned from selling drink to soldiers in uniform so he spoke to Dodd, who said there had been a crush at the bar during the show, and while there was no doubt the soldiers had drink, he had not served them with it. It was possible grateful civilians had brought the men drink to reflect their support for their actions at the front. The case was dismissed on the payment of costs.

In October of the same year, two police officers hid in the yard of the station at Gilsland, to keep observation on the Station Hotel. At 9.55pm a motor car, the property of Station Inn landlord Sidney Baldry, was driven to the hotel and two men in full military uniform got out and went into the hotel. After some twenty minutes the two policemen went into the pub and saw the two officers with beer, whisky and a soda siphon in front of them.

Lieutenant James Allen Bell, and Second Lieutenant H.E. Popham, of the Durham Light Infantry, were charged with being on licensed premises and Baldry was charged with serving them intoxicants. Defending, Mr Lightfoot said that two officers had been wounded and were both staying at the auxiliary convalescent hospital at Gilsland Spa. They were honourable men who would scorn to condemn themselves by lying and perjury.

Both men were suffering from grievous injuries, Lieutenant Bell having been shot through the lung, and Lieutenant Popham having a nervous breakdown. They had arrived back in Gilsland from Carlisle on the last train, and there was no car available to take them the considerable distance to the Spa. They knew the landlord of the Station had a car and went there to ask for a lift. It was not there at that time and

they were asked to wait in the tap room until it returned. 'At no time was intoxicating liquor asked for or served and there was not the slightest vestige of a suggestion it had,' said Mr Lightfoot. The cases were dismissed, but the police gave notice of appeal.

Despite the horrors of the trenches it was not all bad in France, according to one of the 4th Northumberland Fusiliers, who wrote that the men were staying in a chateau. He said: 'A transformation has come over the battalion since they left England. Their faces are tanned brown and there is a keen and alert look about them all. We have all become too familiar with death to worry about it and are all more or less fatalists. They spent a few francs on the local beer, but it did not go down too well with the Northumbrians who said: "Ah divvent think a barrel of it wad make thoo decently drunk". Their marching song was the rousing "Blaydon Races" usually led by the canny lads from Prudhoe.'

More than 200 wounded soldiers were now billeted at Hexham where regular entertainments were laid on by groups like the Wesleyan Guild. Comforts were still being sent out regularly to the servicemen abroad with a collection of fruit and vegetables being taken in Corbridge for local lads in the Navy.

There was also a request from Private Huntington of C Company of the Fusiliers for a melodeon to be sent out to France. He wrote to the *Courant*: 'We are currently supposed to be resting about 15 miles from the front, but there are six parades a day, and lot of marching. We are the only company in the battalion without any musical instruments. We have two or three very good players on the melodeon, if only we had one. If someone could see their way to sending out a medium-sized melodeon, it would be a great boon to the lads.'

The November hirings at Hexham were the most thinly attended in memory, with many of the young men who would normally be seeking work in the forces. Employers' prospects were not helped by the fact the band of the Fusiliers was marching in the town at the same time. Men were able to command record wages, with one getting £27 for the half year. Getting ploughmen and cattlemen was so difficult that £20 was given in some cases. Good women were getting up to £15 and girls £10.

Farmers had to give these wages or go without, said Ariel in the *Courant* who bemoaned the fact that 'gone were the shows and shooting galleries and the other familiar inducements for country people to part with their coppers.' At one time the stalls used to stretch the full length of Beaumont Street and on occasion into Priestpopple. One popular

feature which did return was Murphy's switchback, the fairground ride which took £8 9s 6d, which was divided between the Hexham Red Cross Society and Hexham Nursing Society.

Herbert Vipond, of High Shield dairy farm, near Hexham, was out at the front with the Army Service Corps, having been sent out early because of his expert knowledge of horses. He had been there for four months, when thousands of horses had passed him by, when he saw a familiar beloved face – that of his own horse Bonny, pulling a double transport wagon. He told his parents in a letter:

'I saw this wagon coming towards me and was struck by the uneasiness of the offside horse which I thought looked a bit like Bonny. Then I walked round and saw the knot on the hind leg and the white patch on her forehead, and I realised it was her. The driver said she was a very good horse and he liked her very much.'

Before being sold to the army for £50, Bonny had

Bonny in happier times, working in the Shire.

While serving with the Army Service Corps in France, Hexhamshire dairy farmer Herbert Vipond spotted a familiar figure coming towards him – his horse Bonny which had been requisitioned by the army early in the war.

been used by Mr Vipond on his milk round around Hexham and also won the tradesmen's class at the 1914 Tyneside Show. 'Many thousands of that class of horse went to France and it is remarkable that after nearly six months I found her,' wrote Herbert.

Four men from the 4th Battalion Northumberland Fusiliers were awarded the Distinguished Conduct Medal for acts of conspicuous gallantry in January 1916. First up was Company Sergeant Major J.W. Smith, who had already received the *Médaille Militaire* from the French for his coolness under fire, pinned on his breast on the battlefield personally by French leader General Foch. An old Territorial, he had fought through the South African War and was a crack shot. The citation said he had shown conspicuous gallantry on many occasions. He displayed the greatest bravery and coolness under fire, and was always volunteering to take on any hazardous tasks that needed doing, setting a splendid example to all ranks of devotion to duty.

Corbridge blacksmith Lance Corporal J.E. Mogerley received his award for volunteering to go out and bring in four heavily laden ammunition carts when under heavy fire. He was wounded in the head, but refused to go to hospital, showing great bravery and coolness.

Bandsmen J. Forster and A. Cameron, both from Prudhoe, received their awards for their work as stretcher-bearers, searching for and carrying wounded from 2.30pm until midnight, while under heavy fire. They were praised for their courage, coolness and endurance.

Lieutenant Stanley Kent, another of Tynedale Rugby Club's county cup winning team of 1911, was awarded the Military Cross. He was working in Canada when war broke out, and joined the Canadian Infantry as a private, gaining his commission in the field. He had already won the thanks of his commanding officer for capturing a German flag, but the Military Cross came as a result of his efforts at the head of a wire cutting party. He worked for six hours to clear a gap, and then led a raiding party through it. Despite being under constant fire from machine guns, rifles and bombs, he inflicted severe losses on the enemy.

Mentioned in despatches for bravery at Ypres while serving with the 4th Battalion Northumberland Fusiliers was Company Sergeant Major J.W. Smith, who refused to stand down despite being shot in the face. The Boer War veteran and crack shot went on to gain the *Medaille Militaire* from French leader General, later Marshal, Foch.

Sadly Stan Kent never returned to Canada, dying from his wounds just a few days after being told he was being promoted to captain. He said: 'Just one more scrap then I'll accept it.'

However, the cream of Hexham's young men continued to fall, including Second Lieutenant Frank Lees (26), who was standing in a dug-out with two fellow officers when a 'whizz bang' shell burst right beside them. Two of them escaped unscathed, but Lees was caught in a hail of shrapnel and died soon afterwards. Captain William Robb wrote of him:

> 'He was one of the best subalterns the battalion had. No-one ever saw him show the slightest sign of being scared and was always to be found on the part of the trench which was being most heavily shelled and if anyone was hit, he was first on the scene to do what he could for them. His quiet, unassuming courage was a tremendous source of strength to the company and of the many good men the battalion has lost, they never lost a better or truer soldier than Frank Lees.'

County cup winning rugby player Second Lieutenant Stanley Kent, who won the Military Cross as head of a wire cutting party, but died soon afterwards.

Later in the war, a young officer from Hexham, described as looking about 14 and a true cherub in khaki, was serving with the Border Regiment in an attack on a German pillbox. Although two machine guns were poking out of the slits in the concrete structure, he approached it, armed only with a revolver, and ran round behind the structure. Everyone expected him to be killed, but the youngster emerged with eight hulking Bavarians he had taken prisoner. He said he had been able to cow them 'by putting on a fierce look'.

He was Frank Lees's younger brother, Second Lieutenant Herbert Douglas Lees, of Hexham who was in fact 19, but during a dashing attack on the Western Front, his company commander was killed, so he led the charge himself. He took 125 German prisoners, as well as seizing the two machine guns. He was awarded the Military Cross on the field.

The war impacted heavily on the Thompson brothers, who were brought up in Hexham, as sons of the Unionist agent for the constituency, M.J.

Second Lieutenant Herbert Douglas Lees, who won the Military Cross after capturing two machine guns and 125 prisoners virtually single handed.

Thompson. The second son, Arthur Thompson, was killed on the second day of the Big Push on the Somme in July 1916. He was a noted rugby player, having played for Tynedale and Northumberland.

His elder brother Captain Eddie Thompson was hit in the leg by gunfire, but claimed in a letter home: 'I have had many a worse hack on the rugby field', while younger brother Lieutenant Wilfrid Thompson was also wounded, but not seriously. The following week, young Wilfrid was awarded the Military Cross for conspicuous gallantry. He went forward with only twelve men to the outskirts of a wood, and finding he was isolated, he retired to the enemy trenches, bombed out the Germans, and then held the trench for two days and two nights before being relieved.

The Thompson brothers from Hexham included Captain Eddie Thompson, who said disdainfully after being wounded, 'I've had worse hacks on the rugby field'.

Other brothers doing their bit were the four sons of John Dodds, of Prior Terrace, Hexham. Trooper John Dodds was in the Northumberland Hussars, having previously worked at the Black Bull in Corbridge. Lance Corporal Frank Dodds and Private James Dodds were both in the Royal Engineers, while youngest

Four Hexham brothers doing their bit were the sons of John Dodds of Prior Terrace. From the left they are Trooper John Dodds of the Northumberland Hussars, a former barman at the Black Bull in Corbridge; Private Frank Dodds of the Royal Engineers, a telephone engineer before the war; Private James Dodds, of the Royal Engineers who worked in a Newcastle dyeworks before the war; and Able Seaman Norman Dodds, who worked for a tea company before answering the call.

A group of soldiers from Humshaugh in November 1916: Back, from left: Private E.C. Charlton, Lance Corporal O. Saint, and Pioneer R.J. Bestford. Front: Private J. Henderson, Sergeant G. Robson.

son Norman was in the Royal Navy.

A Mrs Wood, of Middle Street in Corbridge was a regular sender of parcels to the men from the village at the front, and received a touching letter back from a group lead by Company Quartermaster Sergeant J.

Forster and others. They wrote:

'In civilian life we often appreciate things which appeal more to the intellect more than the appetite. Out here, the latter holds predominance. You see nearly every cottage crowded at night with Tommies, devouring plates of egg and chips, washed down with coffee. You may therefore judge that the handsome parcels you sent out on behalf of the good folk of Corbridge were received with great gusto by the boys. In the quieter moments, between the shelling, many of us enjoy a pipe of the tobacco or some of the cigarettes and under the subtle influence of My Lady Nicotine, our thoughts turn back to the village. We saw the bowling green re-peopled with the club's old members, and the various quoit pitches in full use and the older inhabitants listening to tales of the war on Coigns Corner or in the TD Club.

'Then a trench mortar would be heard from the German lines, someone would shout "Sausage" and our reflections would cease for the time being.'

Leading Seaman Louis Charlton, formerly of Allendale, died a hero's death when serving with the Royal Naval Division. Having survived the Gallipoli campaign, where he was wounded, he contracted enteric fever and was sent to Egypt to recuperate. He was then sent to France, where he was killed while trying to help a colleague caught in a shell blast. Writing to his sister, his commanding officer Lieutenant Commander P.H. Edwards said: 'The enemy were dropping very large shells, and when a sentry was struck, your brother, without any regard for his own safety, rushed from his shelter and was killed while tending the wounded man. No man could have had a nobler death.'

Another bright life full of promise was snuffed out with the death on the Somme of Captain Lionel Plummer, grandson of the founder of the *Hexham Courant* Joseph Catherall, and already involved in the running of the newspaper. Wounded at Ypres in 1914, he overcame a troublesome wound to return to the front, and had been cheering his men on at the second line of German trenches on the Somme when he killed instantly.

Nobody could have had a nobler death than Allendale's Louis Charlton of the Royal Naval Division, killed while trying to help a wounded comrade.

THE
Fighting Northumberlands.

Local Officers who Fell in the Somme Battle.

Capt. J. T. Henderson,
N.F.,
Killed in Action.

2nd-Lieut. H. A. Long,
N.F.,
Killed in Action.

2nd-Lieut. A. B. Waite,
N.F.,
Killed in Action.

2nd-Lieut. J. A. Bagnall,
N.F.,
Killed in Action.

Captain L. D. Plummer,
N.F.,
Killed in Action.

Among the victims of the Battle of the Somme was Lionel Plummer, of the 4th Battalion Northumberland Fusiliers, surrounded by other victims of the horrific conflict.

A fellow officer wrote to his family: 'Only one officer who went over the top came back unwounded but from the accounts of the few men from Lionel's command who got through, he behaved with the utmost gallantry, as he always did and with a courage and contempt for death that was magnificent. He died a hero's death.'

Lionel was a great sportsman, having played rugby to a high standard before breaking his leg, and taking up cricket, going on to represent Northumberland, and hockey when Tynedale were one of the top teams in the north of England.

Courant staff were further distressed early in 1917, with the news that a member of the reporting staff, Lance Corporal Nevison Barnfather – son of recently retired editor Thomas Barnfather – had been killed by a sniper while coming out of a trench.

There was double agony for Mr and Mrs G.H. Long, of Tynedale Terrace, Hexham, for just a few days after hearing their eldest son, Second Lieutenant H.A. Long of the Northumberland Fusiliers had been killed on the Somme, they were notified that their youngest son, Second Lieutenant Guy Steer Long, had also been killed in action, serving with the Suffolks. Gamekeeper Henry Mead, of Carrs Hill, Acomb, was also told both his sons, Private Fred Mead and Corporal Henry Mead had both been killed while fighting with the Northumberland Fusiliers.

Just as they had done at Ypres within days of landing, the Northumbrians again won the respect of all. Writing to a friend in Hexham, an officer said: 'We were given the post of honour just on the left of the now famous wood with a crack Bavarian regiment against us. Our boys bested them and took all they were asked to do. There was sharp work with the bayonet, and our fellows were on top all the time. The pace was heavy, as we had to pass through terrific enfilade fire from machine guns. Every officer who went over the top was killed or wounded; one company took its second objective commanded by a corporal. We captured three machine guns and a fair number of prisoners.'

Winning the Military Medal while serving with the Northumberland Fusiliers was Private E. McClafferty of Haltwhistle. He won the award on the Somme for shooting an enemy officer working a machine gun. He then assumed command of his company, and led the advance with great courage and determination, and then using the officer's revolver to kill several other Germans.

A hero of the Boer War, Captain J.H. Cuthbert, of Beaufront Castle, also died of the wounds he received at the Battle of Loos in 1915 whilst serving with the Scots Guards, bringing to an end a spectacular career.

The four sons of Mr and Mrs Robinson of Prospect Cottage, Corbridge, all did their bit. Private John Robinson was killed in action at the age of 24 in June 1917 while serving with the Northumberland Fusiliers. Brother Nicholas was wounded at Vimy Ridge, and discharged, while third brother William was also wounded, shot through the jaw. The fourth brother James escaped unscathed while serving in the Royal Navy.

He won the DSO in the Boer War, where he was also awarded both the King's and Queen's Medals, with eight bars. An old Etonian, he trained at Sandhurst and won the Army Revolver Championship in 1904. He served as High Sheriff of Northumberland and was 41 years old.

Also succumbing to his wounds was Observer William Robson (20), of the Royal Flying Corps, a native of Stocksfield. He was involved in a dogfight over German lines with ten enemy aircraft, and after shooting two adversaries down, Robson's pilot was killed, and the aircraft appeared to be coming down behind German lines. Although he had been shot in the head, Robson somehow managed to get the machine back under control, and land it in the Allied sector. A colleague who went to see him in hospital wrote to his mother: 'Your son was the hero of the 55th Squadron, and I hope to hear he has gained some honour.' His head injury turned out to be a fractured skull, which ultimately proved fatal.

Mr and Mrs J. Robinson, of Prospect Cottage, Corbridge sent four sons off to war, and one, John, was killed in action in November 1916

with the Northumberland Fusiliers. Before the war he worked at Jameson's brickworks. Brother Nicholas was invalided out of the Fusiliers after being shot at Vimy Ridge, and brother William was in hospital in Manchester, shot through the jaw while serving with another regiment. The only one unscathed was James, who was serving with the Royal Navy.

Chapter Four

1917 – Tribunals on trial

AFTER THE COLLAPSE of Lord Derby's scheme at the end of 1915, the Military Service Bill was introduced in January 1916, calling up all single men aged between 18 and 41 for military service. It was extended to married men in May of the same year. However, men had the right to appeal against being called up if they could prove they were engaged in work of national importance, their departure would create undue domestic or business hardship, they were medically unfit for service or had moral reasons for not wishing to fight.

Tribunals were held across the Hexham parliamentary division, and it was found that 291 single men and 145 married men who had failed to enlist for active service had good reason not to do so, However, there were 380 single men, and 678 married men who in the authorities' opinion had inadequate reason not to enlist under the Compulsion Bill.

Many appeals were heard in Hexham. The majority were from men involved in the farming industry, who argued their services on the land were as important to the nation as service overseas. Skilled ploughmen, shepherds, cowhands and harvesters were said to be indispensable, and in most cases, exemption was granted.

The debate about farmers and their contribution to the war continued, with a

2nd-Lieut. C. Curry. Company Quarter-master-Sergt. J. Curry.

Among those at the front in March 1917 were the four sons of Mr and Mrs Ralph Curry of Springfield, Haydon Bridge, They were Second Lieutenant C. Curry, of the Middlesex Yeomanry, a successful jockey in France before returning home to fight; Quartermaster Sergeant J. Curry of the Northumberland Fusiliers; Private C.S. Curry with the Army Service Corps and Private Ralph Curry of the Cavalry Brigade, serving with Mesopotamian Expeditionary Force.

Courant correspondent arguing that it was about time that farmers, their sons 'and other slackers' should change places with lads who had been at the front for three years. He wrote:

'I have heard farmers and their sons say they can't be done without but what about the hundreds of men who are unfit for service waiting to go into farm work? One farmer at Falstone has four fit men on his farm and he has just taken on another farm so he won't have to go into the army. Isn't there something wrong here? Don't they know we are at war? I don't call a man a coward who goes out to fight for his country so that women and children may be safe, but he who stays at home to hide behind a woman's apron.'

The Military Service Act of 24 June 1916 swept into the army every male British subject aged between 18 and 41, but provisions were made for the granting of exemptions for those whose regular work was in the national interest, or would cause undue hardship. The tribunals on exemptions from war service continued unabated but members of the Hexham board said they had reached the end of the line when the military representative Mr J.H.J. Kirsopp confirmed he would appeal to a higher authority if any cases went against him – a state of affairs which had pertained some time.

The chairman Herbert Lees promptly abandoned the hearing, saying he was not prepared to waste his time. His actions were supported by the *Courant* which said:

'Tribunals are judicial bodies, not recruitment agencies, although members themselves do not always remember the distinction, while the military will do all they can to get their man. They are not part of the military system and nor are they bound to carry out all the behests of the Army Council. The duties of these tribunals are of the highest importance if trade and industry is not to be wholly submerged. Their paramount duty is to protect men being called up if they are exempt. As a judicial body, they must act with the strictest impartiality in accordance with the evidence presented before them. In too many cases the military authorities have captured the tribunals and that is not right. The Hexham tribunal cannot allow their decisions to be automatically appealed against by the military powers.'

One application was rejected in Prudhoe from an insurance agent, who said he had 200 clients in the area, and no one could be found to take his place. The tribunal chairman asked whether a woman could be found to

carry out his work, to which he replied: 'I don't think so; it is too complicated for a woman.' Exemption was refused.

The Prudhoe tribunal also heard the case of a conscientious objector who said he had applied to join the Special Reserve Postal Service with the Royal Engineers, but was refused on the grounds his chest measurement was too small. He told the tribunal: 'I believe in the sacredness of life. No man has the power to recreate life after he has once destroyed it; therefore I cannot take life.' He was refused exemption but recommended for non-combatant services.

George Lamb (19) of Hexham, appealed to the local tribunal for exemption on the grounds he was a conscientious objector – even though he had worked for the War Office for three years. He said causing suffering to the innocent and taking life was against the principles of Christianity and civilisation. To attempt to kill militarism by militarism was akin to attempting to cast out Satan using Satan. He said: 'I am not particular whether I go to prison or not, but my parents and friends would be sorry to see me there.' The boy's mother argued that the

Pictured after receiving his DCM for his exploits at Armentières is Lance Corporal Richard Gilholme, of Prudhoe (seated, right) who received his award at a special ceremony at the Palace Theatre in Prudhoe where the legendary Piper of Loos, Douglas Laidlaw VC, played a selection of tunes on his famous bagpipes. His former headmaster at the West School in Prudhoe, Mr R. Brady, is seated opposite, and at the back are secretary of the Prudhoe Recognition Committee David Smart, treasurer A. Jordan and chairman G, Shotton.

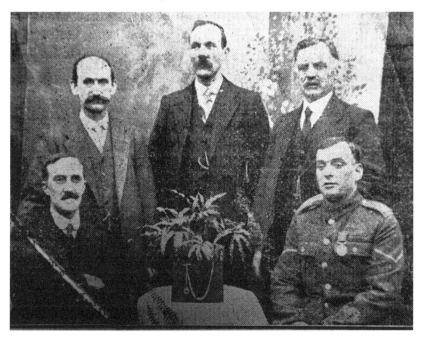

Military Services Act allowed some fragment of the British tradition of liberty of conscience. Mr Lamb said he would not undertake non-combat duties, and his appeal was dismissed.

Another conscientious objector was motor mechanic William Watson, who said warfare was against Christ's teaching, and was both wicked and foolish. He could not take up non-combatant service, because to assist militarism in any way was equally bad. The taking of human life could not in any way be justified. The boy's mother said she had three other sons who were at the front, and he was the only one left to look after her and make sure she was safe in air raids. The tribunal was split on the issue, with one member pointing out that some families had five or six sons fighting, and there were also plenty of married men doing their bit. Exemption was granted on the casting vote of the chairman, but the military representative intimated he would appeal against the decision.

A curate applied for exemption at Hexham, but was told that as this was a righteous and holy war, it would be better if some of the clergy would show more patriotism, exemption was however allowed.

The work of the tribunals was not easy, as was described by one member of the Bellingham panel in a letter to the *Courant*. He wrote:

'There were in the teens present on Saturday to make personal appeals, many of them accompanied by one or both of their parents. Doubtless the day would be for many of the parents the darkest in their memory. The weather conditions added to the despondency as the streets and roads were many inches deep in slush and a merciless sleet driven by a cruel north-east wind made the discomfiture as bad as it could be. Many of the tribunal members had come considerable distances and felt the uncanniness of their position. It was a moot point as to whether the position of the committee or the appellants was least desirable.

'It is a pity that more of the public do not take advantage of their privilege of attending the sittings as it would dispel the misconceptions that the tribunals set free too many men. What would they do in the same position, faced with the old bootmaker, stone blind and partially deaf, pleading for the release of his fine stalwart son, who managed the business? There was another son, but he was a cripple, and only able to do light work. The infirm parents and the daughter were dependant on the elder son and if he was taken, the bootmaker would probably have to give up a business he had operated for 60 years, with 150 customers. The

critics would say exempt him, but the tribunal hardened their hearts – for they are men of feeling – and dismissed the appeal.

'There is a elderly farmer, who is also a butcher with two sons, one exempted, the other his right hand man who can plough, slaughter, break horses and turn his hand to anything. The farmer has 200 customers for his meat, spread over a wide area, to be called on every week, and doesn't know where to turn. Result – appeal dismissed.

'The croakers don't see the tragedies behind every single case; the mother who hasn't slept for nights, not eaten for days; the young wives and sisters, with their pale faces waiting for the verdict, which could mean the disbanding of the home to subsist on a bare dependency or separation allowance. There are fresh tragedies at every deliberation.'

The whole of the Bellingham tribunal resigned in protest when Bellingham Rural District Council suggested the tribunal was not representative of the agricultural industry, and unilaterally appointed four farmer councillors to serve on the body.

The mass resignations were seen as without parallel in the country, and brought severe censure of the council from the *Courant*. The editor William Younger wrote:

'The assertion that the agricultural interest was not represented is entirely unwarranted. There were already four farmers and other agricultural experts on the tribunal. To add four more farmers on such a flimsy pretext is a vote of censure on the tribunal and one that any self-respecting man was sure to resent. Everybody recognises the difficulties of the farming community in the matter of obtaining labour, and tribunals may not always give the decisions the farmers want. However on the whole the industry has been fairly treated and the ill-advised and oft-times foolish advocacy of some of its supposed ornaments at this time of national crisis is very unedifying.'

The criticism was profoundly unjust, in that

Nurse Jennie Lee, of Haltwhistle, who had been nursing the wounded in France for six months, when she died in 1917 from complications after a bout of measles.

fully three quarters of appeals from farmers for their men were granted by the Bellingham body, with only thirteen appeals refused out of 331 applications.

As well as losing their farm hands, the district's farmers were being hit on another front, with the government announcing an embargo on wool sales. All wool was being commandeered for the war effort. The farmers protested vehemently at a series of meetings in Hexham and elsewhere, but their protests fell on deaf ears. They said they would be operating at a loss, as instead of being given the price which prevailed after the 1915 clip, they were offered the price which prevailed in 1914, when wool was much cheaper.

Hexham Farmers were given little sympathy, however, when they decided to raise the price of milk from 4d to 5d per quart. In the *Courant* columnist Ariel wrote:

> *'Dairy farmers must think that milk consumers are sadly lacking in intelligence. Three years ago they raised the price to fourpence per quart on a very flimsy pretext. The price has only just gone up to fourpence in Kirkby Stephen. Surely if it was possible to sell milk in Kirkby Stephen at threepence and make a profit, farmers in Hexham are not being badly paid at fourpence.'*

He suggested consumers should cut their milk orders by half and watch the price come down.

Farmers protested that the rise was necessary because of the steep increase in the price of cows, and noted that the price in Newcastle and elsewhere had been sixpence a quart for some time.

Farmers were struggling to hold onto their workers as they were called to France but the Guild of War Agricultural Workers was doing its

The Davidson brothers of Falstone. On the right is Private George Davidson of the Northumberland Fusiliers, killed on the Somme in September 1916 at the age of 20. His brother James (sitting) was twice wounded while serving with the Royal Naval Division in the Dardanelles, but was continuing to serve in France.

bit by organising teams of women to work the land. The local wardens of the scheme were Miss Daphne Straker of the Leazes, Hexham; Mrs Sample of Shildon Grange; Miss Taylor of Chipchase Castle; Mrs Clark of Bellister Castle and Miss Dickinson of Healey Hall. The Tynedale area was in the van nationally of having women working on the farm and Miss Straker had a capital list of those patriotic war helpers. A group of ten inexperienced women had cleared 18 acres of corn in the Hexham area, and the farmer was so impressed he had asked Miss Straker to supply women to gather the whole of his corn crop.

Prudhoe brothers John and Charles Thirtle both served with the Northumberland Fusiliers. Charles died of wounds in 1917 while brother John was awarded the Military Medal.

Ariel commented in the *Courant*: *'I know that women are working in the land in other ways, and while they cannot be expected to fully fill the places of experienced farm servants, they are not only doing extremely well, but also showing a desire to learn that is most commendable.'*

It was suggested at an appeals tribunal that a farmer from Allendale should have one farm hand exempted from war service because he milked twenty-six cows, and sent sixty gallons of milk away by train every day from the railway station. The tribunal dismissed the appeal on the grounds that a woman could drive the milk to the station. The farmer protested that a women could not lift the milk cans, which each weighed 15 stones, but the chairman said that was the job of the porters.

A grocer in Haltwhistle claimed exemption because he had to supply potatoes to miners. The Jersey Royals were just coming in, and the bags were too heavy for his wife to lift. He said potatoes were the first thing a miner looked for in his meal, but acting for the military, Mr Lightfoot said: 'They are better off than me; I have not had potatoes for some time.' The appeal was dismissed.

Also at Haltwhistle, the man who ran the cinema asked for exemption

on the grounds he was providing entertainment for the large population of miners in the South Tyne capital, but he had his appeal dismissed. The Haltwhistle tribunal also had to decide whether rabbit catching was a reserved occupation, when a man appealed on the grounds he had to keep down rabbits as well as pigeons and rooks following complaints of damage by neighbours, but he was refused exemption. A conscientious objector from Hexham was granted exemption but only on condition he joined the Mercantile Marine – or went to work in the woods.

As the carnage continued in Flanders, the military stepped up their pressure on tribunals to toughen the attitude to those requesting exemptions. That meant that staff at Settlingstones mine, the only barytes mine in the country, had their appeals turned down, and the operator of a one man business from Henshaw he had built up painstakingly over eight years had to go, even though it meant that business would collapse.

Another Zeppelin raid on Tyneside in February 1916 raised alarms about the possibility of one of the airships following the Tyne and releasing its deadly load on Hexham and other Tyne Valley communities. While the town had shown commendable alacrity in extinguishing all lights when news of the raid reached Hexham, it had been done on a voluntary basis, but Hexham Urban District Council decided to turn out all its street lights.

The holidays of many Hexham people to the north-east coast were ruined by the appearance in the summer of seven Zeppelins, which bombed coastal towns severely, despite the efforts of the coastal defences. Although no deaths were reported the towns were much disfigured and it was felt likely that Hexham people would not hurry back.

Assurances were given there were few occasions when Zeppelins could reach the North East. It was said they would not fly when the glass was below 30 degrees; when the wind was blowing over 15 mph; when it was foggy, thundery or there was the least prospect of rain or snow; when there was a moon and when it was not dark.

Soldiers with the Northumberland Yeomanry were dismayed when the Army took away their horses, and replaced them with bicycles, but as ever with the British Tommy, a sense of humour prevailed. They created a grave and surrounded it with wooden railings, each decorated with a discarded horseshoe and railings made of halter ropes. On the grave itself were more horseshoes, stirrups, brushes and combs and spurs and bits.

The set up was completed by a genuine tombstone, carved by a monumental mason which read:

> *Born 30/10/14 departed 4/7/16.*
> *Stranger pause and shed a tear,*
> *A regiment's heart lies buried here*
> *Sickened and died through no disorder*
> *But broken by a staggering order*
> *Our Hearts were warm, theirs cold as icicles*
> *to take our horses and give us bicycles*
> *For cavalry there was no room*
> *So we've buried our spurs in this blighted tomb.*

Although much has been written about the exploits of the Tynedale men serving with the 4th Battalion Northumberland Fusiliers, other local Territorials did their bit with the Northumberland Hussar Yeomanry, affectionately – or contemptuously – known as the Noodles.

They owed their origins to the spirit of unrest that ran through Britain in the wake of the French Revolution, when the local aristocracy and coal and shipping owners felt it wise to put together a force to help deal with any civil disturbances on this side of the Channel. The force was raised by the Duke of Northumberland as Lord Lieutenant, initially as the Northumberland and Newcastle Volunteer Corps of Cavalry, and was used to quell riots on Tyneside

Hussars Corporal Ernest Pigg, of West Woodburn (left) and Trooper R. Bowie of Hexham, both serving with the Northumberland Hussars in France. While on mounted patrol in October 1915, Bowie had a charmed life, with one bullet passing through his haversack another snapping the handle off his bayonet and a third shattering his sword case. His horse was then hit in the foreleg, but he rode the stricken animal back to British lines under heavy fire, and escaped unscathed. In the same action, Corporal Pigg had his horse shot from under him, and was wounded in the arm.

by keelmen and colliers.

The creation of a rifle volunteer company in 1850 led to friction between them and the cavalry, as the horsemen were paid, while the riflemen were not. It was this rivalry which led to the epithet 'the Noodles' being attached the Hussars, thanks to a song composed by the legendary Tyneside showman, Joe Wilson, 'The Noodle and Rifleman's Dispute'.

The nickname stuck, initially as an insult, with the working people still resenting the yeomanry's role in dealing ruthlessly with civil unrest, and a poem of the time entitled 'The Noodles' included the lines:

Blue bummed bumblers,
Cock-tail tumblers
Fireside sowjers
Divvent gan ti waar.

The differences were swept away by the Haldane Reforms of 1908, when the distinction between riflemen and yeomanry was abolished. They joined forces with the Territorials of Durham and North Yorkshire to form the Northumberland Division, under the command of General Robert Baden-Powell. The Noodles served with distinction throughout the war, where they were the first territorial regiment to be in action in the war, landing at Zeebrugge just two months after war was declared.

Four days after landing they were in contact with the enemy of the Ghent–Antwerp Road. They were reconnoitring for the 20th Division when they rode into an ambush, but very smartly extricated themselves, with the loss of two horses. The following days during the retreat from Ghent they acted as advanced rear and flank guards for the division. They helped check the German advance in the first battle of Ypres and after that they fought in almost every section of the Western Front.

Private Robert Renwick, of Great Whittington, winner of the Military Medal while serving with the King's Royal Rifle Corps.

The war brought the need for national economies, one of which was for the closure of workhouses. The closure of the Bellingham establishment was recommended by Mr J.W. Davison on the grounds there were only fourteen or fifteen inmates, of whom only one was a certified lunatic. There were two others who were feeble minded but they were not mad. Mr

Surveying damage to their trench caused by a German shell at Armentières moments before, are Sergeant T. Thompson, of Haydon Bridge, and Sergeant Forster, of Haltwhistle.

Davison argued at a meeting of the Bellingham Board of Guardians that it was not the responsibility of the people of Bellingham to provide accommodation for 'every Weary Willie or Tired Tim' who was passing through Bellingham and wanted a bed for the night. He felt the workhouse would be better put to use as a home for wounded soldiers, with the inmates removed to other institutions elsewhere in the county.

The motion was opposed by Mr J. Wilkie, who pointed out that many of the residents were old and infirm. They had lived in the workhouse for many years and regarded it as their home. They were very kindly treated by the master and matron, and their friends, relatives and associates were able to come to visit them. It would be 'inhuman and an outrage' to take them away from the environment they knew. There was more resistance

to the closure, as it was felt that the Bellingham workhouse embodied the ideals of the Poor Law reformers, who wanted to see this sort of establishment replace the traditional arbitrary and prison-like system. The motion was defeated by seven votes to six.

Despite the fact he had lived in Corbridge for many years, highly respected professor of geology at Newcastle University George Alexander Louis Labour fell foul of the law in the spring of 1916. Born in France in 1847, he went on to become a respected professor at the university and for twenty-two years took parties of students to explore the unique geology of the North Pennines. On one such trip, he was staying at a hotel at Appleby in Westmorland when the staff called police when he failed to reveal he was a Frenchman. Professor Labour told the court he had registered as an alien in Hexham, and did not think it necessary to do so again. He told the court he was not an enemy alien, not a neutral alien, but an Allied alien. His wife was British and his children were British and he had been educated at a British university. He added: 'All my desires are British and although I don't dislike or repudiate the French, I am sorry I am not an Englishman.' Despite his protestations, he was fined five shillings.

Attempts to demonise the Germans continued, with Mr Francis Gribble, who had long lived in Germany, describing the 'coarseness' of the enemy in their own land in a blatantly provocative propaganda article in the *Courant*. He claimed the Germans used wood shavings rather than wool in their mattresses, and people who could not afford shavings used old newspapers. Farm animals were fed dried leaves rather than hay. Because of a shortage of leather, they were soling their boots with wood, and because of a shortage of beef, mutton and pork, the flesh of cats, dogs and donkeys was not despised, and indeed butchers were advertising for them. Flour was being adulterated with potato meal, straw, and powdered chalk. Mr Gribble said he had tasted coffee made from roasted acorns, 'I do not recommend it,' he shuddered. He claimed Germans were encouraged to stop using soap – alkali powders were deemed enough to keep Germans clean, it seemed. Offal and bones, such as may be picked out of any dustbin, were recommended as the basis of a nourishing soup, and beetroot juice was being used instead of treacle. He also claimed that woodlice exuded a substance which would be used as butter, and Germans also believed that a palatable fat could be extracted from sewage.

There was censure for ten miners from Haltwhistle who were brought before the town's magistrates for playing pitch and toss in the street. As

well-being fined between £1 and five shillings each, the men were rebuked by chairman of the bench John Clark, who told them they were all men of military age, who had been left at home to dig coal not to waste their money on gambling. He said: 'Your brothers and companions are falling in France to save you at home. I appeal to you all as Englishmen to do your duty in the pits and not waste your time so frivolously.'

Children of Prudhoe West School sent out a parcel of cigarettes and tobacco to the front which was extremely warmly received, belying the rumour that the men were getting too much in the way of smoking materials. Private Ridley of the Machine Gun Corps wrote to the children of his home town:

> 'Nothing seems to steady the men when under heavy fire than a good smoke. All thirty of us Tommies participated in the contents of your parcel for which we were all deeply grateful.'

Sergeant R. Bolton of Wark and his son, Second Lieutenant R.F. Bolton, of the Northumberland Fusiliers. Lieutenant Bolton died from wounds sustained at the Battle of Messines in 1917.

Private J.W. Hope of the King's Own Yorkshire Light Infantry added: 'If you had seen our faces when the parcel was opened, you would have been well rewarded for your kindness.'

With the war deep into its third year, the list of casualties in the *Courant* grew ever longer – but there was the occasional piece of good news. A letter was received by friends in Hexham from Private Joseph Ridley of the East Yorks Regiment, based at Cannock Chase in Staffordshire, expressing his shock at reading in one local paper that he had been killed in action. He said: 'I received the cutting from my sister whom I have not seen for two years. I came home from France on 19 March with frostbitten feet, and was sent to Armstrong College in

Newcastle but discharged after ten days. I was classed as unfit for active service because of my injuries but fit for home service if excused marching. Now it's looking as though I might have to go out again, but I'm ready at any time – the sooner the better. I think I have as much right to be pushing up daisies as anyone else.'

Private J.E. Davison, of Holy Island, Hexham, serving with the Inniskilling Fusiliers, wrote to his wife that he was the luckiest man living, having been hit twice in the chest by German machine gun fire:

> 'I got a bullet right on the button of the left breast which flattened the button and broke my watch, and then got another on the top button. I thought my day had come, but the watch saved my life. I have been attending the doctor with a bruised breast but I am about all right again now.'

The Battle of Jutland, one of the greatest naval battles of the conflict, had its impact in Corbridge, because among the dead was former curate of St Andrew's Church, the Rev. G.S. Kewney, He was chaplain and naval instructor aboard the battlecruiser HMS *Queen Mary*. As well as being popular in the village as curate, he was a mainstay of Corbridge cricket club, with both bat and ball.

Not even the *Hexham Courant* was proof from the toll of the war, and announced it was putting up the cost of the paper from a penny to three ha'pence, the price of newsprint having increased by 300 per cent since the war broke out. The paper had already been greatly reduced in size and the editor promised every effort would be made to return it to its pre-war price once the emergency was over. Main rival the *Hexham Herald* announced a similar price increase, while the *Hexham Weekly News* was doubling its price from a halfpenny to a penny.

A great novelty made an appearance at The Riding Garden Fete at Acomb, with a great exhibition football match between rival teams of expert lady players who, as munitions workers, had done not a little to extract Prussian talons and to clip Hohenzollern wings, according to the pre-match publicity. The blurb said:

> 'This match, between crack teams of the North-Eastern Engineering Company and the Wallsend Slipway Company will cause great interest in circles along Tyneside and Tynedale. Without controversy, these ladies are fast, versatile, and clever as football players — true chips off the old Newcastle United – and they have already handed large sums to charity, and will likely, under the aegis of Mr Summers Hunter and their own captains, do

**Three brothers from the Northumberland Fusiliers all from Matfen.
They are Lance Sergeant L. Bell, Lance Corporal C. Bell and Lance
Corporal G. Bell. Lance Sergeant Bell was wounded for the second time,
in March 1915, and had to have a leg amputated in France, but was
making a good recovery in hospital in Leicester after being repatriated.**

not a little in promoting the utility of the YMCA and the Serbian
Red Cross.

'In addition to the ordinary entrance to the fete, the charge to
the football match will be 6d each. Kick off at 5.15. The lady
footballers have played some twenty matches, and have by their
efforts raised £1,500 for war charities.'

Women found themselves in the firing line, as well as providing entertainment and working on the land. Mary Dickinson of Fair Hill, Haltwhistle, was a nurse aboard the ship SS *Transylvania* which was torpedoed in the Mediterranean, and sank. The nurses, on their way to the front, were ordered to be first into the lifeboats and the men on board

the sinking ship sang and cheered as they pulled away. The sea became very rough and Miss Dickinson was washed out of the lifeboat on a number of occasions, but she was hanging onto a piece of rope and managed to drag herself back in again. After three and a half hours, feeling bitterly cold and worn out, she was picked up by a destroyer and taken to safety with the other nurses.

One of the tallest soldiers in the entire British Army at 6 foot 6 inches was Private William Dodd of the Northumberland Fusiliers, a native of Falstone. He too had cause to be grateful for actions above and beyond the call of duty by a woman. He was in the Red Cross Hospital at Barry Dock in South Wales, suffering from a bad shrapnel wound which refused to heal, so the chief surgeon decided to experiment with the new technique of skin grafts, covering the

The Kirton Brothers of Haydon Bridge, Corporal M. and Private Edgar, both killed on the Somme in October 1916 serving with the Canadians.

wound with healthy skin from elsewhere. While the surgeon mused as to where he might get such skin, the matron, one Nurse Tenniswood, told him to look no further and offered her own skin for the purpose. She told no one of her actions, and covered her wounds, and it was only when the experiment was a complete success that the surgeon announced what she had done, much to her embarrassment. It also transpired that earlier in her nursing career, she had given her own blood for transfusion to a patient.

The Northumberland Fusiliers were in the thick of the action on the Somme, and the toll was heavy. Among those killed in the same week were two brothers from Haydon Bridge, Corporal Matt Kirton and Private Edgar Kirton, while serving with the Canadians.

One Tynedale soldier signing himself simply as Joe was serving with

newly formed Tank Regiment, and wrote home:

'We appear to have created quite a sensation in the Old Country, and I can personally vouch for the look of utter dismay on the faces of our nice friends the enemy. It was very hot for an hour or two, but once we got over their lines, they soon did a disappearing trick. They absolutely poured shrapnel, machine gun bullets and hand bombs at us, but all to no purpose; apart from a scratch or two from bomb splinters, we got through with hardly a mark. The artillery fire from our side is wonderful, so much so that one almost feels sorry for Fritz. However, one's sympathy starts to cool down when he starts to send our rations across about supper time and keeps going till after midnight.'

Joe said the tanks had been withdrawn for a while and he was enjoying life in France, where champagne was the only thing worth drinking. He said: 'I really must make another attempt with French beer, but it is so very weak.'

Also from the Somme, Private Edward Thompson wrote:

'I got wounded last Friday in the first advance. We cleared the first line of German trenches, and were making for the second, when I got a piece of shrapnel through my left arm. They gave us hell until we got into their trenches. Then up went their hands and "mercy kamarad" was shouted on all sides. None of us, however, was in the humour to show much mercy and we let into them right and left. The first trench was heaped with dead.'

Private Thompson was awarded the Military Medal and his letters from the front also mentioned his first encounter with 'caterpillars' – Mark I tanks.

In order to comply with lighting restrictions, Hexham traders decided to close early in the interests of security, pulling down the shutters at 6pm on weekdays and 8pm on Saturdays. As well as lighting restrictions, traders were not allowed to waste water, and the licensee of the Garibaldi Inn at Haltwhistle was fined 10s for using 5,000 gallons of water from a standpipe in the cellar to cool his beer. A similar fine was imposed on the proprietor of the town's Gem Picture palace for using water to cool a gas boiler.

Hexham Urban District Council responded to the Government's call for land to be given up for allotments in 1917 by renting four and a half acres of land at Quatre Bras from Mr Kirsopp of the Spital. It was seen as purely a war measure, for this was prime building land. Under the

Defence of the Realm Act, 24 half-chains of land on building sites were taken rent free and used to increase the food supply, so that the following season potato queues were a thing of the past.

The demand was a never failing one and by the signing of the Armistice the council had as tenants 369 allotment holders, situated as follows: Round Close, 49; Prior Bank, 19; Quatre Bras, 96; Slaughter House, 39; Cuddy Lane, 19; Woodlands, 19; Park Avenue, 45; Shipfield 22; Priors Flat and Bank, 25; Alexandra Terrace, 34.

Looking after the allotments was not easy, because of the depredations of rooks and wood pigeons. Therefore, William Hedley, of Alwinton, Hexham, raised a party of friends and in two seasons, they put out of action over 5,000 of the feathered foes. Soon, the dedication of land for allotments for people to grow their own vegetables was being abused by allotment thieves, who were stealing whole rows of potatoes and stripping every pod from pea plants. Ariel in the *Courant* warned the pilferers that they were committing an offence under the Defence of the Realm Act, and faced a fine of £100 or six months in prison. He bemoaned the fact that the war had left the police ranks thinly stretched. He warned of possible vigilante action, with some of the gentry likely

The little Redewater village of Rochester sent the four Pringle brothers to fight, the sons of Mr and Mrs W. Pringle. From the left they are: Private James Pringle, of the Northumberland Fusiliers, who was wounded in France in 1915, but returned to the Front in May 1916; William Nixon Pringle, also Northumberland Fusiliers, serving in France; Sapper Thomas Thompson Pringle, Royal Engineers, stationed in Barnsley and Private Robert Pringle of the Yorkshire and Lancashire Regiment, stationed in Mansfield.

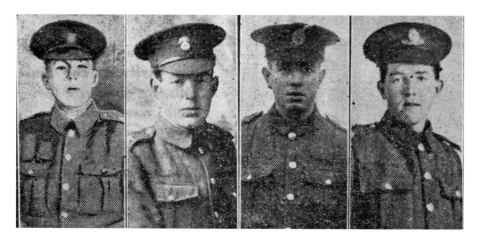

to be laid by the heels when they least expected it.

The zeal to find land to cultivate as allotments led to a suggestion that the cloister of Hexham Abbey be turned to a vegetable plot, but this was dismissed by local councillor Harold Ainsley as 'near sacrilege'. He said: 'It is not a very satisfactory thing to ask a man to feed potatoes with his own grandfather's bones. Some of my ancestors are buried there and when I eventually cross the Jordan, they might ask nasty questions. There is plenty of other land available in Hexham.' However it was pointed out that the cloister was not consecrated ground, and the application was agreed.

Despite the horrors of the trenches, the Northumberland Fusiliers could still enjoy themselves and frequently indulged in sporting contests, either among themselves or with other regiments. The Tynedale lads never lost their love of sport and in May 1917 held a sports day near a chateau occupied by the Northumbrian Field Ambulance. Blossom was bursting forth beneath a cloudless sky and the battalion band played throughout the afternoon. B Company was hardly able to take part as many of them had been inoculated the previous day and could only lie and watch.

The events were described in the *Hexham Courant* by a Northumberland Fusiliers officer signing himself only as Tock. The many contests included 100 yards handicap, bomb throwing, tug o' war, relay race, stretcher-bearers' race, boot race, wrestling on mules, mule races, plus a football match. He said the various mule races produced much hilarity, with Sonny, a little Indian mule with 1,000 tricks, depositing his rider Sergeant McCarten into the middle of the race track, where he was trampled by two other mules without apparent ill effect. The officers' race was won by Captain William Robb aboard Pimple, a fine mule. One of the six riders failed to finish, claiming he had been unseated by 'either a dog or a suffragette' running across the course. The stretcher-bearers' race was hard on the 'casualties', who were dumped unceremoniously on the ground at the finishing line, and if they were not really injured at the starting line, they often were at the finish.

In August though came the sad news that Pimple, the gallant mule which had borne Captain Robb to victory in the officers' race, was no more. Tock wrote: 'He was a bonny mule, who loved the regiment as much as we loved him. He died as he would like to have died – killed in action. He was taking rations up to the trenches when some nasty Boche put a bullet through him. He struggled back to the lines – he was a stout fellow – but died soon after. Dulce et decorum est.'

Cricket was very popular, using a rough bit of ground, with a stretched strip of canvas as the wicket. Tock wrote:

'The matches are great fun, and the crowds are increasing with every match. Our chief difficulty has been the provision of bats. We have one fairly good one, but the other had apparently been mistaken by some Fusilier as bully beef – he got well in at the bottom corner. Our interpreter took it up with the village shopkeeper, and had some great difficulty, as a cricket bat is not an entrenching tool, not a toothpick, not even a pair of silk pyjamas, However he returned with beaming visage having under his arm, bats, cricket, two. They will be used for the first time tonight, when I believe the brigadier is going to play against us, as well as the staff captain. We have had the opportunity to discover who are the

Matthew J. Thompson sent three sons to the front, all raised in Hexham and all officers with the Northumberland Fusiliers. The second son, Captain Arthur Thompson was killed in July 1916, on the second day of the Big Push. Brother Captain Edwin Thompson was wounded by shrapnel in the leg, but said he had suffered many a worse hack on the rugby field. The youngest brother Second Lieutenant Wilfrid Thompson was also wounded, but able to continue serving in France. Also doing her bit was sister Madge, who was a nurse in one of the London war hospitals.

Captain Arthur Thompson, Killed. Captain E. Thompson, Wounded. Lieutenant T. W. Thompson, Wounded.

stout lads to form a battalion XI. The adjutant (Captain Arkwright) is finding his form and we rely on him to put the wind up the opposition with both bat and ball. Sergeant Pagett, the orderly room sergeant, drags himself away from the world of chits and returns to prove himself a useful left hand bat and can bowl a straight ball – in fact several straight balls.

'The colonel gives us a lead in cricket as in everything else. He played one dashing innings, smiting one ball for six and generally treating the bowling as though it were the Boche. Private Cocker is useful behind the stumps, as well as being a sturdy bat, and among the officers we have some useful cricketers in Captain Herriott and lieutenants Gregory, Dobson, Hawkes and Smallwood.'

Games were held between Officers and Other Ranks, C Company v Battalion HQ, Battalion HQ v Rest of Battalion, and the intriguing Blinds v Battalion Fusiliers. The Blinds line-up included Brigadier General H.C. Rees, Second Lieutenant E.W. Styles, Captain J. Thomas, Lieutenant Braithwaite, and the Rev B. Kemer.

Later in the year, Tock wrote:

'The Glorious 12th was a lovely day, and some of us couldn't help thinking what a gorgeous day it would have been in the purple heather, waiting for the wily grouse. As it is, we have to content ourselves with shooting the Boche, which, being vermin, are never out of season. What we want is something to bolt them, so we can have a biff at the Boche in the open.'

Tock continued to write cheery notes from the front, saying:

'It must be awful not to see the humorous side of this war. I wonder if the Boches ever smile; their sense of humour seems to be seriously underdeveloped. I came across one of our men splashing about in a foot of liquid mud in a trench, and when I asked how he was, he just said "Champion sor". Put a Boche under these same conditions, and he would probably grunt gutturally and demand a sausage.'

A war shrine was unveiled on Gilesgate Bank to the soldiers and sailors of the town who had made the supreme sacrifice. It was the gift of Mrs C.W.C. Henderson, of the Riding, Acomb and was placed outside St Wilfrid's Institute. The work of Messrs Mowbray of London, it was made of darkened oak, and under a high canopy was the figure of Christ

on the Cross. Below were the names of the 105 Hexham men who had fallen between August 1914 and July 1917.

The Vicar of Haltwhistle, the Rev McClintock, announced his resignation, as he felt the Front was the place for all able-bodied men. He had decided to go at Easter, as a chaplain, and told the bishop so, but the bishop said he could only go if he found a replacement to serve at Haltwhistle. This he had failed to do, despite searching hard, so he had taken the decision to resign from the church to do his duty. He wrote in the parish magazine: 'I have taken this decision after much thought and prayer. It will be a great wrench to give up the work I have done for the past three years but it is what thousands of others have had to do, and why should I hold back?'

Another war shrine was dedicated at St Giles's Church, Chollerton, by Major Charles 'Butcha' Hornby, the officer who had drawn the first blood in the war three long years before.

Bellingham sent out eighty men with the first wave of volunteers and by 1917, the little village had picked up four Military Medals and a DCM, with 150 men in the field – about a tenth of the male population of the parish. Among the men who went out was Sergeant Wilfred H. Thompson, who won both the MM and the DCM, a feat which saw him honoured at a special ceremony at the town hall. The Bellingham Volunteers provided a guard of honour and 'Hail the Conquering Hero' was struck up on the piano.

In April he had led a night raid on the German trenches in which his officer was wounded in twenty places and left a prisoner in German hands. Sergeant Thompson took command, completed the raid and successfully extricated his men with their prisoners. For that he received the MM, but in June, under heavy rifle fire, he put an enemy machine gun out of action and killed the men operating it with rifle grenades, which he fired from no man's land. He afterwards assisted his platoon commander to bomb and clear an entire German trench. He then came home to Bellingham without saying a word of what he had done, but instead went round to the homes of colleagues who had been killed with some personal mementoes and comforting words to their grieving widows and families. He proved himself as kind hearted as he was modest and brave. He was presented with a five pound note, a wrist watch and a gold half hunter on behalf of the village.

Other Bellingham men recognised at the ceremony were Major J.S. Allen, twice wounded while leading an attack, but knocking out a machine-gun post, and continuing to lead his men. On the second

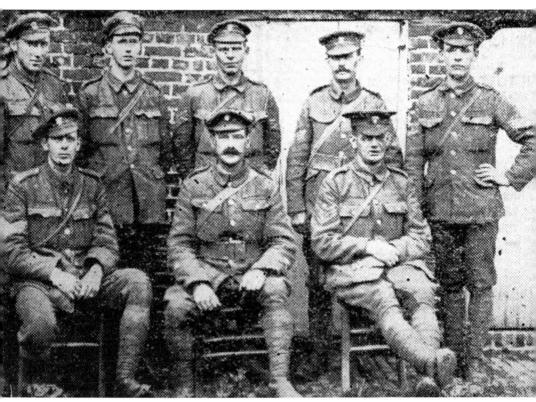

A group of local NCOs with the Northumberland Fusiliers. Back: Sergeant Brooks, Sergeant Forster, Sergeant G. Chadderton DCM, Sergeant T. Thornton, Sergeant Lambert. Front: Sergeant Shivers, Sergeant M. Smith and Quartermaster Sergeant Forster.

occasion, he was hard hit, but would not stand down until ordered by his colonel to have his wounds attended to, for which he was awarded the Military Cross. Private Robert Brown was awarded the Military Medal after digging out his machine gun which had been smothered under heavy shellfire and continuing to fight with it. Lieutenant T. Pearson of the Royal Flying Corps was ordered to locate a new German trench which had been dug overnight, from which the enemy had wiped out one of the British battalions. He dived twice to within 500 feet of the enemy and, although his machine was riddled with bullets, he gained the information and got the Military Cross.

At Wylam, Military Medallist Corporal Robinson was similarly feted when he was presented with his medal at the institute. A motor car, profusely bedecked with Union Jacks, was driven to Corporal

Robinson's home in Falcon Terrace to pick up the modest hero, with his mother, his little sister Molly, and his fiancée. The Emma Prize Colliery Band was also in attendance to play 'Loyal Hearts' as the procession wound its way to the institute. Marching at the rear was the Church Lads' Brigade of which he had been a member before the war. Corporal Robinson had been awarded the medal for conspicuous gallantry on the Somme under heavy shellfire.

Two or three hundred people gathered at the Market Cross in Corbridge to witness a public presentation to Lance Corporal Thomas Bell, on being awarded the Military Medal in the field. He had been in the Corbridge detachment of the Territorials since mobilisation in 1914 and distinguished himself by ignoring a hail of shot and shell on the Somme to carry many wounded comrades to the comparative safety of a wood.

He was presented with an inscribed gold hunter watch, ten war savings certificates and a purse of gold. He said any speechmaking he had to do was reserved for the Germans, and he was always prepared to give them a piece of his mind. He had never been frightened of any Germans and never would be.

Also honoured was Second Lieutenant Edward Giles Bates of the Northumberland Fusiliers Special Reserve. He received the Military Cross for his actions when in charge of a raiding party, when he directed their movements with great coolness and skill when they were threatened by their own barrage. The success of the raid was due to his careful reconnaissance.

Another Military Cross went to Captain (Acting Major) Everard Charles Broderick Dale, of Apperley Dene, Stocksfield, who displayed the greatest skill and courage, when commanding his battery under heavy fire and intense gas bombardment. By his fine judgement and leadership he was able to take up a forward position and carry out accurate registration, although he himself was badly wounded. He had been mentioned in Sir Douglas Haig's despatches on two previous occasions.

There was an interruption to the first house picture show at the Gem in Hexham, for a presentation to Private Edward Moulding of the Border Regiment, who won the Military Medal for gallantry in the field. He saw his officer wounded, along with four comrades, and without hesitation, jumped over the parapet of the trench, and dragged them in one by one. Although he had been injured on four previous occasions, this time he escaped without a scratch.

There was a similar ceremony at Prudhoe when three local lads were honoured by their townsfolk at the Palace Theatre, where the efforts of

the Mickley Band and the Newcastle Glee and Madrigal Society added to the festivities. Second Lieutenant Sidney Bates of the Rifle Brigade had won the Military Cross for gallantry when leading his men in a charge. He was wounded early on, but kept going and it wasn't until he was struck for a third time that he was forced to fall back. The crowd at the Palace were told they would not see the medal pinned on Lieutenant Bates's breast that night – he had been told he would be receiving it personally from the King. He was however presented with a silver cigar case, a silver cigarette case and a silver card case. Second Lieutenant Thomas Potts of the Scottish Rifles received the Military Medal for saving a quantity of ammunition while under heavy fire, as well as saving a number of wounded comrades. He had previously been mentioned in despatches. He had his medal pinned to his chest, as well as receiving a gold watch.

The third local hero, Private Jack Telford of the Northumberland Fusiliers, could not be present, as he had already returned overseas, but he had been awarded the Military Medal for maintaining fire with his Maxim machine gun when all others had been disabled. His brother-in-law Private Gray accepted on his behalf the town's gift of a gold wristwatch and a wallet containing five one pound notes.

There was a large turnout at Haltwhistle to see Private E. Craghill of the Northumberland Fusiliers presented with a gold watch and chain on behalf of the town after being awarded the Distinguished Conduct Medal for taking over his platoon after the officer and non-commissioned officers had become casualties. Though wounded himself, he remained

Red Cross workers honoured in October 1917 were Miss M. Henderson, commandant of the auxiliary hospital at Hexham; Miss G. Lambe, sister in charge of the auxiliary hospital at Dilston Hall, Corbridge; Miss I. Iveson, quartermaster of the Hexham auxiliary hospital and Miss Margaret Cranage, nurse at the Corbridge hospital.

at his post to encourage the men.

One of the most interesting functions ever seen in Mickley was held at the social club, where villagers gathered to pay tribute to Northumberland Fusiliers Corporal George Armstrong and Corporal G.W. Charlton, both of whom had earned the Military Medal. They were serenaded by the newly formed Mickley Male Voice Choir and a quartet party from the Mickley Institute Silver Model Band. Corporal Armstrong had received the award for a daring piece of work in no man's land, while Corporal Charlton won his for crossing the same piece of land twice under fire to bring food to his comrades. Both received a silver wrist watch, and a purse containing five half sovereign notes.

It wasn't only the men whose efforts were recognised, for four Red Cross workers from the district were also honoured by King George V. Red Cross decorations were awarded to the matron of the Hexham Convalescent Hospital, Emma Longden Coleman, and a nurse at the hospital at Dilston Hall, Corbridge, Margaret Cranage. There were also awards for Miss J.C. Atkinson from the Holeyn Hall Hospital at Wylam; Mrs L. Cranage from Dilston Hall; Holeyn Hall quartermaster, Miss M.E, Curley; Hexham commandant, Miss M. Henderson; Hexham quartermaster, Miss I. Iveson; sister in charge at Dilston Hall, Miss G. Lambe; Dilston Nurse, Mrs I Reed, and Holeyn Hall's, Miss C. Wilkinson.

Awarded the Military Medal was Lance Corporal John Campbell, of Falcon Terrace, Wylam, who was only 17 years old when he answered Kitchener's call, and joined the Tyneside Scottish, before volunteering for the Machine Gun Corps. He was involved in the Battle of Passchendaele in July 1916, before returning to action on the Somme on 26 October 1917. There his entire company was cut down by German fire, and his officer taken prisoner, so he was left alone to serve his machine gun in the face of continued withering fire. He fired it until he ran out of ammunition, and was finally forced to retreat – but took his machine gun, weighing a full 36lb, with him as German bullets sought him out. He eventually collapsed into the nearest trench – and found it was occupied by members of the Manchester Regiment, who restored him to his own regiment. The brigadier general received him by saying: 'Well done, my brave boy – Wylam shall hear of this!'

And indeed Wylam did hear of his deeds as he was guest of honour at one of the biggest gatherings ever seen at the village institute. He was greeted by a guard of honour of the Church Lads' Brigade, of which he was a member, as well as Boer War veterans, and there was a concert in his honour. He was presented with a solid silver cigarette case on behalf

Killed in action in November 1917 were Quartermaster Sergeant W. Allcroft of Corbridge; Private Walter Smith, of Hexham; Seaman James Robinson, of Hexham and Private R. Rutter, of Barrasford.

of the Wylam Welcome Home Fund, and a collection on the night raised a further £9 10s which was also handed to him.

There was real sadness in Barrasford where brothers Private John Bullock of the Coldstream Guards and William Bullock of the East Yorks Regiment died within a week of each other.

Residents of the North Tyne and Redesdale were warned to be on the look out for six German prisoners who had escaped from the prisoner of war camp at Stobs, near Hawick in September 1917. The runaways were Naval Chief Petty Officer Bernhard Haak, Petty Officer Paul Otto Buty, Naval Warrant Officer Walter Dusellmann, Zeppelin crew member Wilhelm Heinrich Jensen, Zeppelin Petty Officer Max Emmerlich and Military Intelligence Officer Emil Schulz. Between them, they held two Iron Crosses, and anyone seeing them was advised to speak to the nearest police constable.

The prisoners made good their escape, travelling across the moors and reaching the Northumberland coast just south of Amble. They managed to buy provisions, and moved on to the village of Cresswell, where they stole a boat, and put to sea. Sadly for them, their bid for freedom ended when their little craft was sighted by a trawler 170 miles from land, and a passing British destroyer took them prisoner again.

It wasn't the first escape from the camp, with a number of escaped

Germans captured at Rochester in the Rede Valley some months earlier, thanks to the alertness of a young postman. But it prompted a worried local to write to the *Courant*: 'Why are there so many escaping from this camp? Folks out here are scared as this is not the first visit we have had from stray German cut-throats. More attention by the guards seems desirable.'

Stobs was built specifically as a PoW camp, with 200 huts housing 6,000 prisoners, below Winnington Rig farm. The Geneva Convention allowed for non-commissioned prisoners of war to be employed in manual labour tasks. At Stobs, the prisoners were given building and labouring jobs which included the building of the sewerage works – said to have been a very well planned piece of plumbing, and one of the best examples in Scotland at the time. The men were also used on many farms, replacing the local men who had joined the army. The Germans did not grudge this work because it got them away from the camp and they were able to have contact with the outside world. For labouring, they were paid one penny per hour, the equivalent of four shillings per week.

Prisoners also baked bread for the entire camp, including the guards, who objected to the fact that the German bakers carved an Iron Cross onto each loaf. Most acknowledged, though, that the bread was very tasty. The camp had its own newspaper, *Stobsiade* with 4,000 copies of each issue, and they also set up a school with classes attended by up to seventy students There was also a library with 2,700 books, and a hospital with its own operating theatre. After being given instruments by the YMCA, the prisoners also formed their own thirteen-piece orchestra, which they claimed was the equal of the best Guards band in London. They also had their own brass band.

When the war was over, the camp was turned into a hospital for the treatment of venereal diseases, amongst other functions.

Attempts to raise money to help soldiers were strictly controlled, and the mother of two little girls from Wylam, aged 12 and 14, who had made flowers out of rushes to sell at a penny each, was fined 10s as they were not registered. Miner John Reay was summonsed for collecting money for the Prudhoe Welcome Home Fund. Collections had been taken at a Prudhoe Cycling Club sports day, during the visit of a professional ladies' football team, and collection tins had been placed in licensed premises. The committee behind the fund included a Mons VC, and they had raised a total of £30 10s, of which £30 had gone to returning soldiers. However, because the fund was not formally registered, Reay was fined five shillings.

An impromptu fancy dress party was held at the Hydropathic Establishment in Hexham, when the ladies' first prize was won by Miss Grace Grant who appeared as Charlie Chaplin. A progressive whist drive followed and the proceeds went to the Hexham War Depot.

John Thomas Young of Jacobs Ladder, Hexham, was taken to court for being a deserter. Police who visited his house spoke to his wife who said he had gone to East Boldon and had been there for several weeks. However they heard a noise from another room, and found Young hiding under the bed. He was remanded to await a military escort. At the same court, an 84-year-old man appeared accused of being so drunk at Hexham Railway Station he had to be transported to the police station in a handcart. He was fined 7s 6d.

The arrival of the Americans in the war in 1917 was duly celebrated on the front when the Northumberland Fusiliers held a special fraternal dinner, achieved by scouring the countryside for food and drink and such essentials as pianos, bands and pictures.

According to Tock, entertainment featured the Doc's priceless rendition of 'Jolly Jack the Sailor Home from Foreign Parts' while 'The Ginger Bean' recited 'The Thane of Fife', and someone called simply 'Erb' sang a Welsh song. 'Scots Grey' wrote to the *Courant*: 'It is nights such as these which strengthen our alliances, making the living and personal bonds, rather than cold political agreements. We feel a warmer kindliness to our Allies now that we have broken bread and drunk our wine together.'

An officer from West Woodburn, Second Lieutenant Ernest Pigg, wrote of being in charge of an attack on the Somme:

'We were waiting for time zero, when our attack was to start but the Germans fired on us at 5.30am with everything they had. The shells burst all round us and we were praying for zero. When it arrived, zero was the finest hour of my life, as thousands of guns spoke as one. I tried to give out an order but even the man next to me couldn't hear a word so I shut up and trusted to luck. When I got to the first objective, I had two platoons left out of four and while we were digging into shell holes I was greatly amused when about 300 Boche came running towards us with their hands up shouting "Mercy, kamarad". We could only see the grey forms advancing at first, and our Lewis gunners were giving them plenty of attention before I managed to stop them, as they were as keen as mustard. I can truly say I never wish for better fighting material that what I

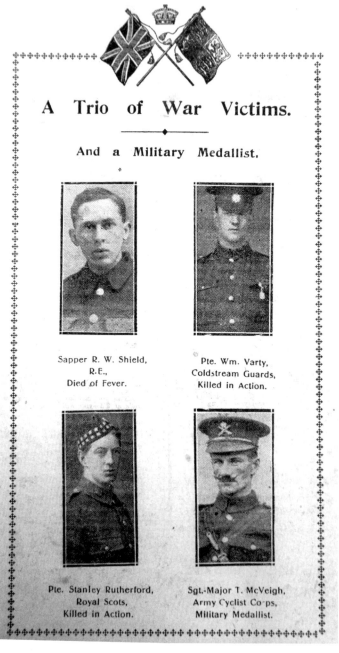

A Trio of War Victims.

And a Military Medallist.

Sapper R. W. Shield,
R.E.,
Died of Fever.

Pte. Wm. Varty,
Coldstream Guards,
Killed in Action.

Pte. Stanley Rutherford,
Royal Scots,
Killed in Action.

Sgt.-Major T. McVeigh,
Army Cyclist Co-ps,
Military Medallist.

These men lost their lives in March 1917: Sapper R.W. Shield of
Allendale, who died of typhoid contracted in Mesopotamia; Private
William Varty of Prudhoe, serving with the Coldstream Guards; and
Private Stanley Rutherford, of Hexham, serving with the Royal Scots .
Pictured with them is Sergeant Major Thomas McVeigh, of Stocksfield,
who received a Military Medal for his work with the Army Cyclists
Corps, having been at the front since war broke out.

had to lead into this show; it was just like a hunt, only they were the hounds.

'When the second objective was reached I set a pigeon loose with a message attached, but the poor bird was so frightened it flew round the basket several times before I got it to go away. I thought it would be killed any moment as the shells and bullets were so numerous.'

Lieutenant Pigg was eventually shot twice in the thigh, and was in hospital in France with several German prisoners, who were pretty badly knocked about. The French barber came round to ask each patient if they wanted a shave, but he refused to deal with the Germans, saying: 'Me not shave bloody Germans.'

As the summer of 1917 drew to a close, there was a significant increase in the number of holiday-makers coming to Hexham. In the *Courant* Ariel noted:

'It appears to be the general opinion, medical and otherwise, that all who can should try to snatch a brief interval from the all pervading sense of war weariness which is over the land. It is natural that Hexham gets its share of visitors, for it has many attractions to offer the toiler from down the Tyne, or the jaded city man whose daily occupation is the crowded commercial marts of our big Northern cities.'

Edward Little of Bardon Mill lost three sons to the war – two killed in action, and one dying of wounds – but he had the comfort of receiving a personal letter from the King and Queen expressing their sympathies via the keeper of the Privy Purse.

Cultural differences between the English and Belgian refugees were blamed for a major brawl in the North Eastern Hotel in Hexham when a party of Belgians attacked locals with billiard cues. François Dor was charged with committing grievous bodily harm after local man Charles Newton was stabbed in the neck. Evidence was given at Hexham Petty Sessions that a number of people had been in the billiard room at the North Eastern playing skittles. An argument developed between Dor and another man over the use of a billiard table and Dor was struck in the mouth by a third man so hard he lost three teeth.

Dor picked up his top coat and left the building, but returned with several of his countrymen, both civilians and soldiers, who started lashing out in all directions with billiard cues. During the general melee, it was alleged that Dor produced a knife, and stabbed Newton in the

neck, causing a wound which ran down to the bone.

Defending lawyer Mr Dixon said that the incident followed an assault on Dor by a third party while he was arguing with a man called Welch over use of a billiard table. He said:

'It was a dirty blow – an un-English blow which knocked out three of his teeth. Not being English, and therefore not acquainted with English law and custom, he went out to get some of his friends and countrymen for support before returning to the pub to seek retribution. Three were soldiers on leave from the Belgian Army.

'He should have gone to the police and reported the attack, but he was not accustomed to receive from the police of his own country the courtesy which distinguishes the police of this country; people from the Continent are more or less afraid of the police from their own country, and took matters in his own hand.'

He denied using a knife, even though as a shoemaker he possessed one as a tool of his trade. The charge was reduced from GBH to common assault, which Dor admitted, and he was fined £2 by chairman of the bench Lord Allendale.

Private John Stokoe, of Mount Pleasant, Mickley, was killed in October having spent two and half years in France, and being wounded twice. He was the third member of his family to die in the war, brother Robert having been killed in December 1917, also having been wounded twice before, and third brother Noble dying in September 1916.

Killed in action in France in June 1917 were Private William Lynch, who belonged to Hexham; Private H.N. Davison, of New Ridley, Stocksfield, and Private G.R. Maughan, of Allendale, all serving with the Northumberland Fusiliers.

Chapter Five

1918 – March to victory

THE YEAR 1918 dawned with heavy snow, and two boys were ordered by magistrates to pay 4s each for making a slide from the Shambles to the entrance of the Gem Picture Hall. Several people were observed by the police to have fallen on the ice. Two boys aged 9 and 11, who admitted stealing two towels and other items from a washing line, were each sentenced to four strokes of the birch. Seven boys from West Wylam each got six strokes of the birch for stealing a tin of corned beef from a shop at Halfway House. It wasn't just the children who felt the wrath of the law. Munitions workers Edward Salton and Edwin Pounder were each fined 5s for sledging at very great speed on the highway at Woodley Field.

The question of rationing also loomed and again the farmers came under fire for announcing a rise in the price of milk to 7d a quart. Ariel said it was difficult to see how Hexham should be put on the level of more urban areas when the milk in Hexham was sold and delivered by the producers in nearly every case, with no cost of freight or handling.

Tea was restricted to 1oz per head per week, butter or margarine 4oz per week and cheese and bacon 4oz. Meat was 1lb per head for adults and half a pound for children aged five – there was nothing for under fives.

A former soldier, Fred Jewett, who had twice been gassed was invalided out of the army and went to work on a farm at Healey. There he took solace with the 19-year-old daughter of a neighbouring farmer, who some months later informed her mother she was 'in a delicate condition'. The girl Isabella said Jewett was responsible for her plight and the services of a vicar were sought – but Jewett denied he was the father. The girl's father then sued Jewett at Hexham County Court for the seduction of his daughter, who had helped him on the farm and in delivering the post. He had lost her services for six months, as well as running up medical and nursing expenses, and reckoned he was £75 out of pocket through Jewett's actions.

Jewett said he had only seen Isabella once, and denied he had ever misconducted himself with her. However, the jury found against him and he was ordered to pay the £75 to the girl's father.

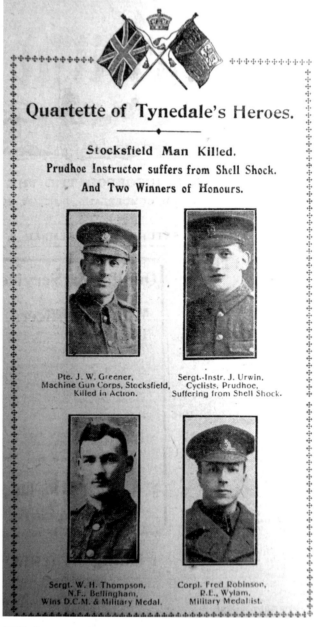

Quartette of Tynedale's Heroes.

Stocksfield Man Killed.
Prudhoe Instructor suffers from Shell Shock.
And Two Winners of Honours.

Pte. J. W. Greener,
Machine Gun Corps, Stocksfield,
Killed in Action.

Sergt.-Instr. J. Urwin,
Cyclists, Prudhoe,
Suffering from Shell Shock.

Sergt. W. H. Thompson,
N.F., Bellingham,
Wins D.C.M. & Military Medal.

Corpl. Fred Robinson,
R.E., Wylam,
Military Medallist.

Private J.W. Greener of the Machine Gun Corps who lived in Stocksfield lost his life in September 1917. Next to him is Prudhoe's Sergeant Instructor J. Urwin of the Cyclists Corps, taken out of action with shell shock. Below them are Bellingham's Sergeant Wilfrid Thompson of the Northumberland Fusiliers, who won both the Distinguished Conduct Medal and the Military Medal, and Corporal Fred Robinson, from Wylam, who won the Military Medal while serving with the Royal Engineers.

Just six weeks after being awarded the Belgian *Croix de Guerre* by the King of Belgians for conspicuous gallantry in the field after two and a half years at the front, Corporal John Nevin of Stocksfield, serving with the Motor Transport Corps, died from shrapnel wounds.

Four officers of the Northumberland Fusiliers wrote from the front with regard to various items of correspondence in the *Courant* about a war memorial for the town. Major J. Ridley Robb, and Lieutenants Ellis Pearson, Stephen Piek and A.A. Pickering felt that while there was merit in suggestions for a memorial in the town hall, or in the sacristy of the Abbey, it would be more appropriate to have a cottage hospital in the town to remember the fallen. This would have a double advantage of being practical, useful, and commending itself to people of all creeds and opinions.

However local councillor Tom Scott argued that as there was already one of the best hospitals in the country just a 45-minute motor run away at Newcastle, as well as an isolation hospital for the more infectious complaints in Hexham and even if there was a cottage hospital, the more serious cases would still have to go to Newcastle. He said: 'It would take at least £300 per year to run even a very small cottage hospital, and the public support would fall flat after a few years. No hospital that would be built could hope to compare as a monument with our finest modern building, the town hall. Although it has been let on a lease for the past few years as a warehouse, that would soon be overcome.'

Other suggestions were that the spire of the congregational church, never completed through lack of funds, would be a suitable memorial.

Allegations were made that the police in Hexham were being more zealous than anywhere else in the country for breaches of lighting restrictions, with an inordinate number of prosecutions. A woman at Prudhoe had been fined half a crown for showing the wrong sort of light on her baby's pram, with a red light at the front rather than white one. However, Ariel argued it was essential that lighting restrictions were strictly observed to continue to baffle '*the baby-killing Huns and their Zeppelins*', for despite improved defences the risk of raids was not yet over.

The volunteers continued to train well with a good muster for the three-hour daily drills. The exception was Sunday lunchtime, when only 60 men out of a roll of 180 turned out. The explanation was the time-honoured tradition of the Sunday dinner, and the rule that father must be there to carve the joint.

Not all the action took place in France. Private Thomas Bell, of

Honoured by the King in June 1917 were (left to right): Lieutenant Colonel Frank Robinson, of Hexham, serving with the Royal Inniskilling Fusiliers, who received the DSO; Major William Anderson, of Hexham, a partner in auctioneers Anderson and Garland, of Hexham, serving with the Northumberland Fusiliers, who added a DSO to his Military Cross; Captain Chris Stephenson, of Hexham, of the Northumberland Fusiliers, who was awarded the Military Cross; and Private Peter Clark, of Acomb, who won the Military Medal.

Haltwhistle, wrote to his wife from 'somewhere in Africa' that he was serving with the Motor Transport Corps, and said he and another soldier had been left in the bush with a car which had been put out of commission with a broken axle.

'We are living like Robinson Crusoe, with only wild animals for company. Last night we had to build a large fire to keep the lions away, and then we built a nest up a tree to get a bit of sleep. When we got up the tree we were faced with a snake, which I killed. When we need meat we have to go out and shoot springbok, pigs and guinea fowl. The hyenas make a hideous noise all night, and there are a lot of monkeys – what a squabbling they make.

'I am going to try to shoot an ostrich, and bring its feathers home to you. I am sitting in the shade but the sweat is rolling out of me, but I am in a better position than the men who are in hospital. Driving a motor here is a rough job which needs nerves of steel, and involves driving through river beds and grass which is 9 feet high. What they call towns here are just a few huts, built with clay and straw, where the natives dwell.'

Farmhands and other agricultural workers took a step closer to the front

FATHER'S TURN.

"HOLD THE LINE, LADDIE! I'M COMING!"

Recruitment was still a problem, with appeals to the family like this.

when the Government announced it was setting up a scheme whereby prisoners of war could be allocated to work on farms, releasing men to fight on the front. The men being provided were not Germans, but Austrians and Hungarians, who were, generally speaking, friendly to the Allies. Prisoners were to be lodged on the premises and not travel more than five miles from the farmhouse without permission; they had to be paid the same rate as English farmhands, less a deduction of 12s 3d per week for board and lodgings. The prisoner was required to conduct himself properly in every way and do nothing that would be harmful to the British Empire or its allies. Farmers wanting to take on a prisoner had to contact the War Office.

Women were also continuing to work on farms in the Hexham area, where the volunteers were praised for hoeing turnips quickly and well, as well as stacking hay.

Haughton Ferry, the little boat which had plied between Barrasford and Haughton Castle for hundreds of years, was grounded because the ferryman had joined the colours. The service had been provided by the

A Real Necessity for

WOMEN WAR-WORKERS.

WOMEN war-workers find that the grit and grime of the munition factories, exacting hospital work, and exposure to sudden weather changes are injurious to the skin.

Fortunately, they have in Ven-Yusa Cream a preparation which, by means of its special oxygen properties, revives the lustre of faded complexions and brings back the bloom of health and youth to pallid cheeks.

Thousands of women know from personal experience that no other toilet cream can be so invigorating, so agreeable, or so beneficial.

The regular use of Ven-Yusa will save you hours of discomfort, and banish for ever that tired, irritable feeling after a hard day's work.

1s. per jar of all Chemists, Stores, Hairdressers, &c., or obtainable by post at same price direct from the Proprietors, C. H. Fulford, Ltd., Leeds.

VEN-YUSA
The Oxygen Face Cream

Although they were doing their bit for the war effort on the land as well as in factories, women were still expected to look their best, as this advertisement for face cream shows.

Misses Cruddas of Haughton Castle, but they were unable to find a replacement and had decided to suspend the service for the duration of the war, even though there would be great inconvenience to travellers in the North Tyne. It was suggested that a woman be found to operate the ferry, as had been the case sixty years previously, but there were no takers.

In the closing days of the war, the village of Horsley was hard hit with the deaths of three of its sons in quick succession, two killed in action and other from the influenza bug which was sweeping the country.

Unusually, Private Joseph Boswell died in battle on 26 August 1918, in the closing weeks of the war – without ever setting foot in France. He saw action in Gallipoli, Egypt, Mesopotamia, and North Persia before being killed in action in South Russia. To put it in perspective, 150 British soldiers were killed in Russia during the war, as opposed to 416,617 in France.

Private Boswell was the son of Joseph and Janet Boswell, from Kingsgate Terrace, Hexham and was serving with the 7th Battalion, North Staffordshire Regiment, when he died aged just 25. He travelled all over the Middle East serving in areas where they had more deaths from disease and depravation than enemy action – although he was a battle casualty.

The signing of the Armistice came with the same suddenness which marked the start of the war four years earlier and there was triumphalism in the *Courant*. The editor wrote:

'The Armistice had brought down the most despotic autocracy that had ever existed in Christendom. The Kaiser proudly confessed himself military despot when he was not blasphemously asserting he was the vice-regent of the Almighty. He is now a fugitive from the empire he has brought to the edge of ruin and in his haste to

reach the safe shelter of Holland, he has deserted all those he should have been trying to protect. What a pitiful cowardly figure is presented by this uncrowned king.

'We shall never forget the sacrifice made by the youth of our land. Week by week, the columns of the Courant have afforded sad and silent testimony to the cost in human lives of the great struggle, and the casualty lists we have published have been but the bringing home to sad hearts besides the knowledge of their own losses, a fuller conception of the penalty that war was bringing to the whole of our country. In the midst of the victorious ending of the war, that naturally calls for jubilations, let's breathe a silent prayer for the gallant dead sleeping their last sleep far away from the old country for which they fought and fell.'

Demobilisation began, and soldiers started returning to Hexham, some gaunt and scarred for life, but others seemingly none the worse for their experience. There was also evidence of a new attitude to authority from those adjusting to civilian life which was demonstrated when the Comrades of the Great War from Hexham sought to take on the Comrades from Corbridge in a football match on the Sele to raise money for branch funds. Hexham Urban Council refused consent for the Sele

These formidable ladies provided comforts for the troops at Bellingham throughout the war.

Red Cross nurses who looked after convalescing soldiers at the VAD Hospital in Hexham reverse roles when they were entertained by the matron, and waited upon by the soldiers.

to be used, and suggested the match be held next to the rubbish tip on Tyne Green. In a letter to the *Courant*, Hexham Comrades chairman John Snowball wrote: 'I assume now the war is over, we are considered fitting material for filling holes in the tip, as many of our comrades are serving a like purpose by filling [the] shellholes of France. Apart from that Tyne Green is unsuitable from a financial point of view; people will not go there, as gas helmets are now being issued to the public, and at times it is a bit dangerous. Surely the lads who have done their best to keep the Sele from becoming a German military parade ground, where the goose step would have been taught, might have been granted the privilege of kicking a ball about, which is much more pleasant than dodging Jack Johnsons.' Permission was hastily granted.

Among those back in Hexham was Sergeant T. Blackburn, of the Northumberland Fusiliers who had special cause to celebrate. He had been reported missing, and then reported dead in November 1917. He was confirmed dead by his commanding officer who said he had been killed in action on 23 October – but it later transpired he had been taken

prisoner and held in a German prisoner of war camp for the duration of the war. He returned home in triumph looking fit and well and none the worse for his experience in German hands.

Also safely back home was Major J.F.K. Lockhart, of Summerrods, a career soldier who had been in India when war broke out. He began his service in 1902 with the Northumberland Artillery, but moved to the Royal Field Artillery. On his return from India he served with the historic 62nd Division and, although always in the thick of the fighting, he survived the war completely unscathed, although he had his horse shot out from beneath him. His second horse and groom were also killed. In recognition of his exemplary service he was awarded the DSO and was also mentioned in Sir Douglas Haig's final despatches.

Once back home, Allendale's Lance Corporal Tom Brown gave a graphic account of his life as a German prisoner of war, having been captured on the Champagne Front in France in May 1918:

'After I was taken I was searched by the Germans, who took everything I had, apart from two photographs which I hid down my puttees. I then had to carry the German wounded on stretchers, which was very hard work indeed especially as I had had nothing to eat since the morning before the night I was captured. We were then marched many miles over the battlefield, under heavy shellfire, until we were finally given something to eat – a small piece of bread and some barley water. We were then taken on another march of some 30 miles, marching all night, with nothing to eat. By this time we were footsore and very hungry, having not had our clothes off for many days. We finally reached an old peacetime prison at a place called Rethol, where we were still given nothing to eat, but were glad to lie on the stone floors and get some rest.

'The next day we had to go on parade at 6am, and at 10am, we were given one slice of bread, and something the squareheads called coffee. At noon, we were given some soup, but we could not take it, as it was not fit for pigs to eat. We were then sent on a six-hour train journey, which took us to a prison camp, where we had beds to lie on, but they were very uncomfortable as they were made of wrought iron braces.'

The next morning they were served 'coffee' at 6am and nothing else until 5pm, when they got more 'pigswill' soup. This was their diet for the next eight days, with one slice of black bread and a bowl of inedible soup. After another train ride, they were taken to a town called

Charleville, and after a 10-mile march were taken to a camp with proper beds, and given soup and half a loaf of bread – the best food they had had in months.

Lance Corporal Brown went on: 'The next day we were roused at 5am and sent to work in a German horse depot, with nothing to eat except a bowl of cabbage water, supposed to be soup. We worked through until 6.30pm, before being given more awful coffee and a single slice of black bread.'

After three weeks Thomas was taken ill, and was sent to hospital where he remained in bed for fourteen days. He said: 'I was reduced to 6 stones in weight whilst a prisoner and boiled potato peelings was quite a favourite meal.'

He was eventually moved to a camp in the heart of Germany as the Allies advanced and finished up in a prison hospital in Austria, where he remained until the Armistice was signed. He said: 'There was no work to be done in the camp after the Armistice and after a visit by some German officers and neutrals, the camp was condemned. Really it was not fit to live in; I am sure cattle in England live much better than we did.'

After his release he returned home via Copenhagen, where he remained for ten days having 'a ripping time'. He said: 'The Danish people think the world of British Tommies and gave us quite a time.'

There was an enthusiastic gathering at the Gem Picture Palace in Hexham when five local men decorated for gallantry in action were given gold watches by the Hexham Home on Leave Fund. The heroes were Lieutenant George Chadderton DCM, Lieutenant Matthew Burn MM and MC, Privates David Forster, and Thomas Pencott and Signaller Adrian Porteous, all of whom had been awarded the Military Medal. There was only one house for the proceedings, where the attractions included a 'picturisation' of the 4th Battalion Northumberland Fusiliers' triumphant route match from Newcastle to Hexham via Prudhoe as well as a series of animated pictures from the Riding Fayre of 1917.

After the euphoria that the war was over had sunk in, virtually every town and village in the district started to think about doing something tangible to mark the sacrifices their communities had made. At Hexham, public opinion was swinging firmly behind a cottage hospital – something that its neighbour Corbridge three miles down the road already had. Writing in the *Courant*, columnist Cardigan said:

Haydon Bridge war memorial was unveiled at the end of the war, one of the hundreds that went up in virtually every village in Tynedale.

'It is a serious reflection on the townspeople that such an institution was not provided many years ago. It would benefit all classes, particularly the poor and less well to do, and I know from fairly exhaustive inquiries that our returning soldier lads favour the project by a proportion of at least three to one. It should also be borne in mind that our local VAD hospital will soon be closing down, and there is a large amount of suitable hospital furniture, bedding etc which may be obtained cheaply if not as a gift.'

A town meeting on 4 February 1918 was chaired by Colonel Ridley Robb, who said the men of the 4th Northumberland Fusiliers had made an indelible mark on history with their efforts in the trenches in the dreadful winter and 1914, 15, 16 and 17, when they were forever fighting, with very short periods of rest, and notably at the Aisne, where they had sacrificed themselves so nobly to slow the German advance, and where they had lost their colonel in action.

The majority had fought in France, but others had seen action in Italy, Gallipoli, Salonica, Egypt, Palestine, Mesopotamia, Russia and East and West Africa, as well as being in the Navy, keeping ceaseless and vigilant watch on the German fleet. More than 250 had failed to return to the town, lying in nameless graves in all parts of the world.

Local GP Dr Stewart anticipated a hospital would cost £20,000, but patients would pay for their treatment at 5 or 10 guineas per week, and if they could not pay, their friends would have to.

Not everyone was in favour though; Councillor Rollingson felt that rather than saddling the ratepayers with the debt of a hospital for many years, the council should construct some cottages for the widows and orphans of those who had fallen in battle.

A public meeting at Haltwhistle also decided that the most appropriate war memorial for the town would be a cottage hospital. It had been proposed to buy Greencroft Park for public recreation purposes, but this was impractical as it was not for sale. It was therefore felt a hospital would be most fitting as more than £3,000 had already been promised for such a scheme and Colonel Joicey had made a very generous offer to provide a site at Moss Cottage Field. It was reported the scheme would cost around £7,000 to provide six adult male and six adult female wards, and a children's ward with four or five beds. There would be an administration block and accommodation for the nurses.

After opening on 5 October 1915, the war depot in Battle Hill, Hexham closed on 18 February 1919. During those three and a half

years, the volunteers at the depot sent 466,978 items to help with the war effort, including dressings, splints and even slippers. Of these items, 29,499 were sent to fighting troops, with 335,385 going to British sick and wounded in hospital. British prisoners of war, often languishing in conditions too dreadful to dwell upon, were sent 3,800 articles, while Allied troops were forwarded another 74,396 items. The total amount subscribed to the fund was £5,137 17s 7d and in her final report, the depot secretary Mrs Clarence Smith said: 'The committee can truthfully say they have never been in financial difficulty as the money, when wanted, was most liberally given.'

The Belgian refugees committee was wound up on 1 June when a letter of appreciation from the Prime Minister was received. During the war, the committee had looked after a total of thirty-five refugees in houses in Hexham, and £875 16 9d was received in donations from local people. One Belgian woman Mme Carlier had spent four years in Hexham, and said she had come to know the nobleness of the English character and would never forget how she and her children had been provided for, and lacked nothing. The committee treasurer, Mrs Clarence Smith, and secretary, Miss Mary Benson, were both awarded the Medal of Queen Elizabeth by the King of the Belgians.

Hexham UDC was approached by a deputation from the committee charged with organising the peace celebrations in the town, for a donation of £300 towards the festivities. Committee chairman the Rev. J.E. Pattinson said it was proposed to spend £100 on the dependants of those men who had been lost in the war. The fifty widows would be given £1, while nine orphans would also receive £1. There were around eighty fatherless children which the committee was aware of, although there could be more, and they would each receive five shillings. Another £100 would be required for the celebration itself, including games costing £10, £40 for mementoes of the occasion and £50 for food. As for the soldiers and youths of the town, there was £40 for games, £20 for a horse parade and £6 for fireworks

Supporting the appeal, Mr William Pattinson said if it had not been for the fighting men of Hexham the town could have suffered the vile depredations suffered by the towns of Belgium and northern France. He said: 'Rather than waiting for the decision of this council, we could have been waiting to hear from the German General Staff what indemnity they were going to demand from Hexham. An additional rate of three ha'pence or tuppence in the pound is the least we can do to show the gratitude to our brave lads who have freed us from the

tyranny of Germany. We have to think of those who have given their life blood, or have been maimed, or those who fought for the town, and what is being asked is infinitesimal.'

Most councillors were strongly behind the proposal, but Councillor James Forster was not altogether happy with spending ratepayers' money. He argued that many of the returning soldiers were also ratepayers and would therefore be contributing to their own celebrations. He felt the proposed horse parade could be done away with, and added: 'As for fireworks I am sure the men have seen all the fireworks they care to.' Councillor William Teasdale also had reservations, pointing out that the council was already in debt, and adding more to the rates was not fair on the poor people of the town.

Councillor C.F. Knight argued that rather than coming to the council, the committee should have carried out a door-to-door collection. He said: 'In a town like this, the money ought to roll in. The committee has three or four parsons on it who are well acquainted with the ways and means of raising subscriptions – I don't think the committee is really trying.' The council agreed to provide the £300 on a 5-4 vote.

The Ovingham Welcome Home Fund was the beneficiary of a display of war trophies in the schoolroom, opened by Viscountess Allendale. Pride of place went to the bagpipes played at the Battle of Loos in September 1915 by Piper Douglas Laidlaw VC. Laidlaw attended the ceremony in person, and was congratulated by both Lady Allendale and Sir Thomas Oliver. Laidlaw was a national hero following his exploits with the 7th Battalion, The King's Own Scottish Borderers, in September 1915 during the Battle of Loos. At Hill 70, prior to an assault on enemy trenches and during the worst of the bombardment, Piper Laidlaw, seeing that his company was shaken with the effects of gas, mounted the parapet and, marching up and down, played his company out of the trench. The effect of his splendid example was immediate and the company dashed to the assault. Piper Laidlaw continued playing his pipes even after he was wounded and until the position was won, for which he was awarded the Victoria Cross.

As well as Laidlaw's pipes, other exhibits at Ovingham were the steering wheel of a German seaplane brought down off Zeebrugge by HMS *Swift,* a piece of aluminium from a Zeppelin wrecked at Potters Bar, a piece of barbed wire from no man's land, pieces from the ruins of Peronne Cathedral, liqueur glasses found in Ypres, and a tobacco pouch presented by the ex-Kaiser to German troops at Christmas 1915. Of local

Peace celebrations in the South Tyne village of Haydon Bridge.

interest was the muffler worn by Private Norman Walker of Ovingham at Ypres, containing the German rifle bullet which hit him in the neck before he was captured. There was also a model aeroplane made from French bullet and shell cases, along with a vast collection of howitzer shells and other heavy artillery loaned by Mr Lancelot Smith CBE of Corbridge.

The Hexham War Hospital and Supply Depot was visited by the president of the Northumberland branch of the Red Cross, Countess Grey, to pay tribute to the wonderful work it had done over the past three years. In the last year alone, over 211,778 articles of medical equipment had been sent to thirty-four different hospitals. Dr Stewart reported that the Hexham depot was noted for the excellence of the equipment supplied. The antiseptic measures which were taken were helping surgeons to keep wounds clean at the front.

Mr James T. Robb, of the Hexham store Wm Robb and Son, announced he was donating to the town the splendid Georgian gate

which used to be the entrance to the White Hart coaching inn, before it was removed to accommodate his new store. He gave the gate to the town as a memorial to the 4th Battalion Northumberland Fusiliers, and for the safe return of his three sons from the fighting,

The name of Robb in Hexham is synonymous with the department store which dominated the town for more than two centuries. However, there was more to the Robb family than a wicked way with haberdashery and fashions for the country lady.

They were a family of sportsmen, soldiers and airmen of incredible distinction. The three sons of James T. Robb – William, Ridley and Milne – all distinguished themselves in different ways. All were born in Hexham between 1888 and 1895, and all went to George Watson's Boys' College in Edinburgh, where none showed a great deal of academic aptitude, with William's results in particular being deemed 'very poor'.

All three served in the school's officer training corps, and in 1907 William became associated with army life when he was gazetted as second lieutenant in the 1st Volunteer Battalion, Northumberland Fusiliers. Ridley joined him as a second lieutenant in March 1909 and both were gazetted lieutenants in June 1910 and captains in December 1912. As serving officers, they were mobilised at the very commencement of the war in August 1914 and served throughout the four years of the war to end all wars.

William was wounded in the second Battle of the Somme in 1918, and fighting in the same battle was his brother Ridley, who took over command following the death of Lieutenant Colonel Gibson and organised a fighting withdrawal.

Subsequently, Ridley became commanding officer and achieved the rank of lieutenant colonel, being awarded the *Croix de Chevalier* by the French Government in November 1918. He was commanding officer for four years, after which he re-entered civilian life.

The most spectacular career of the three brothers was that of Milne Robb who was granted a permanent commission in 1919 and enjoyed an eventful life.

In 1921 he was flying back from Paris when he crashed landed in the Channel, his plane sinking in twelve minutes, although he was rescued by a boat. Some time later he inadvertently killed three sheep when landing, explaining he couldn't see them because they were hiding in the long grass! He served in Iraq, helping put down a revolt by tribesmen, and was awarded the DSO in 1926 for outstanding co-

operation with ground forces over difficult terrain.

Milne Robb spent the following years successively as chief flying instructor at the Central Flying School, senior air force officer aboard the carrier HMS *Eagle*, and fleet aviation officer to the commander-in-chief of the Mediterranean Fleet. He returned to the UK in 1936 to become commandant of the Central Flying School. It was during this period at the school that he made two major contributions to the future success of the RAF.

First, as a highly skilled pilot, he played an important personal part in evaluating the flying characteristics of the new RAF monoplanes, such as Blenheims, Hurricanes and Spitfires and incorporating the results in notes for service pilots. Secondly, through his involvement in the establishment of the Commonwealth Air Training Plan in Canada, he underpinned a vital contribution to the war effort by providing Bomber Command with a steady stream of trained aircrew when it needed them most.

In January 1940, at the start of the Second World War, Robb was promoted to air commodore and commanded No.2 Group Bomber Command. He was sacked just over a year later by the head of Bomber Command, because of a bitter quarrel over the use of the Blenheim bomber as an attack plane in fine weather when it was clearly an inadequate plane for such conditions. History proved Robb correct.

His advancement seemed not to have been hindered and, after gaining experience of combined operations against enemy-held territory, he took part in the Allied landings in North Africa as air advisor to the supreme commander, General Dwight D. Eisenhower.

From then on he was at the centre of the Allied effort to defeat Hitler. Initially, he was heavily involved in the Allied operations in the Mediterranean. When Eisenhower was appointed to command all the Allied forces assigned for the liberation of German-occupied Europe, he was so impressed with Robb's abilities that he specifically asked for him to be deputy chief of staff (air) at the supreme headquarters in March 1944. In the October, he was promoted to air marshal, becoming chief of staff (air) under Eisenhower's deputy, Air Chief Marshal Sir Arthur Tedder.

Milne Robb was to be one of the witnesses to the signature of the Germans' unconditional surrender on 8 May 1945. He was knighted for his efforts, and in May 1945 was appointed to Fighter Command. When the High Speed Flight under his command was achieving the world's absolute speed record in 1946, he kept in touch, flying in a Meteor jet fighter to Tangmere where the flight was stationed.

Sir James, as he became known, was admired by even the liveliest

young pilots for his flying skills. He flew more than 150 types of aircraft during his career, without ever writing one off.

Whilst in charge of Fighter Command he received his own Mark XVI Spitfire, with its guns removed as well as the bulk of combat equipment and the bays modified to take luggage. The plane was painted light blue, with his initials JMR in large letters on each side of the fuselage. There were three stars and a pennant defining his rank below the windscreen. In July 1948, piloted by Air Vice-Marshal John Boothman, it crashed on landing when Boothman forgot to put the landing gear down!

The glittering career of Sir James Milne Robb GCB KBE DSO DFC AFC ended with his appointment as inspector general of the RAF, retiring in 1951. He died on 18 December 1968, in a nursing home at Bognor Regis, not far from his home in Felpham, West Sussex.

Chapter Six

1919 – Relief parties

IN 1919 WHEN the Treaty of Versailles was finally signed, 19 July was officially declared Peace Day, when communities across the land could finally see the blue sky after the dark clouds of war had dissipated. But in Tynedale celebrations were somewhat muted because the men of the North East Railway had decided to go out on strike, completely closing the Tyne Valley line between Carlisle and Newcastle. There was great irony in the fact that while Hexham was celebrating victory without, industrial strife was rampant within. The strike by train drivers and firemen was caused when a driver was sacked for refusing to take an eye test, and his workmates downed

A major celebration of peace took place at Gilesgate in Hexham, with fancy dress in abundance.

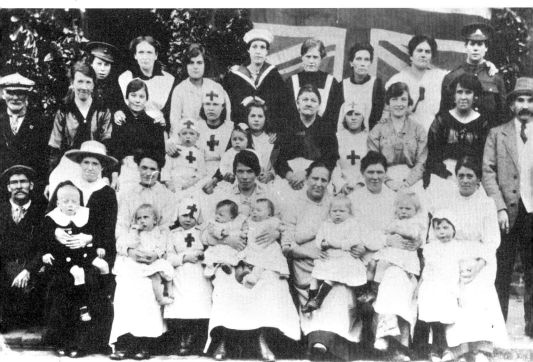

tools in a bid to have him reinstated. There was little public support for the strike, especially as it came on the eve of the national peace celebrations.

Cardigan commented in the *Courant*:

'This action caused great inconvenience and in many cases, extreme hardship. To strike without notice and in defiance of the agreement with the North Eastern Company is an act of despotism which will alienate all public sympathy.'

A planned fireworks display in Hexham had to be curtailed, because the rockets which were to be the centrepiece of the display were trapped in a railway depot by striking railway men. The organising committee compromised by letting off half a dozen Dover flares, used during the war for lighting up the English Channel, where they could illuminate a full three square miles each.

But the English are known to take their pleasures sadly, being less volatile in their temperament than their neighbours across the Channel. The railway strike was not allowed to dampen the joyousness of the Peace Day and Hexham was prettily decorated, although it has to be said, not on the scale of the golden or diamond jubilees of Queen Victoria, nor of the coronation of Edward VII or George V. The hoisting of the Union Jack at half-mast from public buildings was a reminder of the solemn side of the occasion.

There was a great parade through the town, headed by civic dignitaries and friendly societies, that was so long the tail of the procession was just entering the Market Place while the head was turning into Battle Hill from Beaumont Street. It was a colourful gathering of Sunday School children and decorated tableaux of folk in fancy dress, notably those of Gilesgate, which created much hilarity. It was preceded by a piper, Red Indians in full war paint, and a tableau which included Jane Charlton as a queen of dignified mien, Mrs Thomas Swinburne as a regal Britannia, and Mrs David Troupe as a boisterous John Bull. Others taking part were Red Cross Nurse (Mrs Lambert), Gipsy (Mrs T. Conkleton), dancing girl (Miss Scott), Indian Squaw (Mrs Gannan), negress (Mrs Riley); soldiers of the empire (Mrs James Charlton, Miss Newton, Miss Dodd, and Miss Elizabeth Harvey), and the driver of the royal coach who was Mr R. Moulding,

The piper carried an effigy of Kaiser Bill, which was subsequently burnt. The children were treated to tea while the nineteen horses and carts in the procession were judged, and there were also children's sports on the Sele including foot races, pillow fights, skipping and

hoop races for the girls, and an egg and spoon race – although the last three egg and spoon races had to be run without eggs because of a shortage. There were also competitions for kite flying and decorated hoops. The proceedings ended with a bonfire on the Sele, part of a national chain which echoed the chain lit to celebrate the defeat of the Spanish Armada in 1588. There was a united service for all faiths in the Abbey Grounds, and the following day, there was another sports day confined to men who had returned from active service, and youths. The numerous events included a mile race, sack races, tug o' war, seven-a-side football – and mop fighting.

During the proceedings there was a prophetic warning from Brigadier General Sir Loftus Bates, who said that while Germany may have been defeated and signed a humiliating surrender, Britain had to stay on alert. 'We must remember that the enemy was not killed,' he said. 'He was merely scotched, and already is starting to talk of regaining his lost power. Today we are sheathing the Empire's sword, which is being returned to the scabbard without the slightest stain of dishonour, but we must keep it well burnished and ready for action again. Let's keep it that way, and do away with this foolish fetish that being prepared for war is to encourage war. Nothing could be further from the truth.'

Elsewhere there were more sports at Humshaugh, including obstacle races, bicycle races and tug o' war for mixed teams of men and women which caused great hilarity. The children were given a bag of sweets each and treated to tea. Medals and prizes were presented by the Misses Cruddas, of Haughton Castle and Mrs Clayton of the Chesters. There was also a bonfire which burned brightly for upwards of an hour.

Each child in the parish of Tarset was presented with a peace commemoration mug and two free meals before the great bonfire was lit. There were sports and dancing at Ovingham, where peace mugs were also distributed before a fireworks display preceded the lighting of the bonfire. At West Woodburn all the school children were marched from the railway station to take part in sports and celebrations, as well as enjoying team games and being presented with a souvenir beaker. The adult sports included a 120 yards handicap race won by 'old' Jack Quinn, off a 21-yard start, which was considered a marvellous achievement by a man of 47.

At Falstone, the accommodation at St Peter's Church was severely taxed, as an ecumenical service was held to accommodate a large contingent who had come down from Kielder. Extra chairs had to be

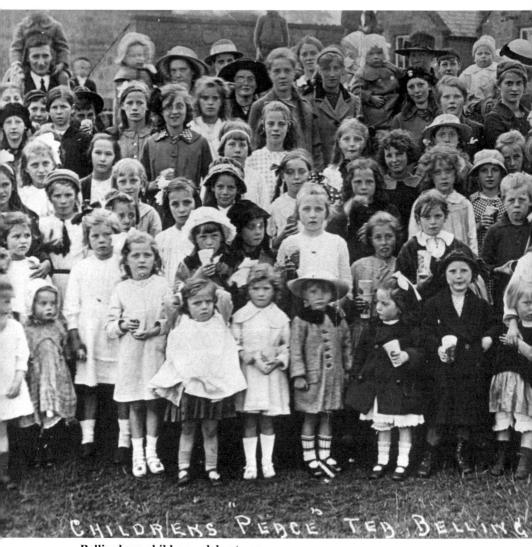

Bellingham children celebrate peace.

brought in, but everyone was seated. During the service, the bells tolled as the names of those from the parish who had been killed were read out, before a more joyous peal to mark the end of the war was rung. All the children from the village were taken to Hawkhope Hill to see one of the village's oldest residents, Matthew Ridley, some in fancy dress and all carrying flags in a colourful pageant of Britannia and her Allies. They sang Rule Britannia, the Marseillaise and God Save the King. A procession was then formed, with the Britannia group on a

decorated lorry, to march to Mr Weatherson's field, where a long programme of sports for young and old took place. Having deposited Britannia and her Allies, the lorry returned with a piano which was soon augmented by a cornet and a violin, and local talent entertained throughout the afternoon to the enjoyment of all. The sports went on until close to 10pm, after which all the servicemen from the village who had survived the war were presented with mementoes by the Falstone Welcome Home Fund. Afterwards the village basked in the glow from the Plashetts bonfire on the skyline, which could be seen for miles around.

At Bellingham there was a procession of local schoolchildren along with the headmasters and staff, headed by the Heworth Colliery Prize Silver Band, to the Fairstead, where sports took place, Afterwards most of the young people indulged in dancing on the green. All inhabitants of the parish – more than 1,000 – were regaled with an excellent tea prepared by indefatigable local ladies. At 11pm, the bonfire, bearing its effigy of the Kaiser, was lit by two of the oldest men in the village, James Aynsley and Joseph Breckons.

The children from Plashetts School had marched to the station waving flags and singing patriotic songs, raising great cheers en route. They were each presented with a peace mug by Mrs Jobling, who had lived in Plashetts longer than anyone else, and one of whose sons had made the supreme sacrifice. A judicious application of liquid fuel supplied by the Plashetts Coal Company ensured the bonfire burned well, and in lighting it with a torch, Mrs Smith from the village store said: 'May all the wickedness that the name Hun stands for perish as this will do, and all that stands for righteousness and justice burn

brightly in our national life, onward and upward and weld together and hold our British Empire.'

Commemorative mugs were also handed out to children at Hedley, where there was also a free tea for children, and sports – including women's tug o' war – which created much hilarity – and dancing on the village green. Handsome gold medals were presented to the twenty-eight servicemen from Hedley who had returned from the war, with a magnificent gold watch being presented to R. Craigie for his gallantry in being awarded the Military Medal in the conflict. Gifts of money were also made to widows whose husbands had not returned from the war. A bonfire with an effigy of the ex-Kaiser on top was then lit by the village's oldest resident, Joseph Moore, in his ninetieth year.

The Kaiser also topped the bonfire at Wark, where sports and dancing went on all day. Although a band could not be found, music was provided by a piano, fiddles and the bagpipes. There was a massive parade through the streets of Wylam, where the sports and dancing continued for much of the day, and 320 children were give souvenir mugs, deliberately chosen to match those distributed to mark the coronation of George V, to make heirlooms of worth.

A procession wound through Haydon Bridge led by Haydon Bridge Brass Band and the parish council, featuring numerous decorated lorries, horses, floats and tableaux. No fewer than sixty prizes were offered for the various classes, ranging in value from £3 to half a crown. A 4-mile running race was won in twenty-two minutes by local Military Medal winner Sergeant Leslie Bell and the numerous other sports were much enjoyed. A total of 570 commemorative medals were given out to all children under 15, and the ladies of the village served tea for 1,300 people.

Sports at Sandhoe included an old man's race and threading the needle race, but plans to give out peace trophies for the children, kindly donated by Mrs Cuthbert of Beaufront Castle, were thwarted by the railway strike, the presentations being delayed until a later date. The Bardon Mill prize band led the parade at Corbridge where the church bells rang out merry peals. Tea was provided for 400 children and £150 having been raised by public subscription, the adults of the village were given a free tea too.

There was a magnificent pageant at Wall, where John Bull (T. Mitchell) headed the procession which included a wonderful Victory Car containing Britannia (Miss E. Robson), Victory (Miss R. Davidson) and Peace (Miss A. Proudlock), complete with shield,

trident, trumpet and dove. Also in the parade were young ladies dressed in the colours of the Allies from France, Belgium, Italy, America, Serbia, Romania and Japan. There was a village party which went on all afternoon and evening, with the more unusual categories in the sports being a matrons' race, a Gretna Green race, a centipede race and a cigarette race won by Miss Margaret Scott and T. Mitchell. At 11pm, the wife of the chairman of the parish council, Mrs Waddilove, surprised and delighted everyone by walking over rough fields, heath and crags at great personal inconvenience to light the bonfire.

Langley was also on parade, where the men who had returned from the war were treated to tea, along with their wives, and each was given five guineas from the Langley Soldiers Comforts Fund. All children under 17 received a commemorative mug, as well as a packet of chocolates.

One of the biggest bonfires in the district was at Blanchland, where it was said to be the equal of the monster blaze at Cow Hill in Newcastle. Earlier there had been a colourful *tableau vivant*, where the children wore wonderful costumes depicting the Allied forces.

More than 1,000 children from Prudhoe gathered in the town and when their young voices rose together in renditions of the National Anthem and Rule Britannia, the effect was most impressive. The formidable task of feeding the multitude fell to the Prudhoe and West Wylam Co-operative Society, who rose to the challenge admirably.

However, the event was only arranged at the last minute, with the Prudhoe Urban Council criticised for its 'monkish' attitude towards its returning servicemen. A group of demobbed soldiers wrote to the *Courant*:

'Why is everything so dead in Prudhoe for demobbed soldiers? There is no one to lead us in the social life of the town; the people who really ought to do this live apparently for themselves only. They probably have no sons in the army, and if they have they have probably never seen France, or taken any share in the real fighting and probably don't realise what coming back to the pre-war monotony means to the men who have fought and suffered for them. A small instance of this selfish existence being that there were no arrangements made to celebrate peace on July 19 until a week or so previously, by which time everything ought to have been in place. Almost every village in the country has given its returning soldiers a hearty public welcome home with the addition of a small sum of money, while those who have returned

with any permanent injuries are receiving aid from the people. Nothing like this is being done in Prudhoe. We returned soldiers don't require charity – we just want what is due to us – a small appreciation of what we have done for them. We have fought in France and elsewhere to allow you to live in comparative comfort – don't you appreciate this work?'

In Hexhamshire the children from Ordley School sang patriotic songs at Newbiggin Hall, where Major Atkinson threw out sweets and coppers for them to scramble for. They carried on to Slaley, where sports were held until proceedings were hilariously interrupted by the arrival of the Crown Prince (Little Willie) riding on a donkey. The impersonation of such a notorious character was so good, and the roar of laughter occasioned by his majesty (William Robson of Windy Hill) that it caused the cessation of the sports for quite some time. A quoits competition and dancing began on the field, and later adjourned to the granary at Dotland, where it continued until 11.45. While there was no Shire bonfire, more than a score of blazes could be seen from the lofty vantage point.

A service was held at St Giles Church, Birtley followed by keenly contested sports while Mr, Mrs and Miss Taylor from Chipchase Castle stayed at the event all day, donating £5 towards the costs, as well as an ample supply of fireworks.

Early in the war Hexham Urban Council had decided to approach Lord Allendale to ask him to use his influence in London to procure for Hexham some of the captured German guns recently landed at Woolwich Arsenal. The Chairman, Councillor E.S. Lee JP, said the town would benefit from a war trophy. He felt it would be appropriate because of the number of young men who had already gone to the front, and the others that would follow, that the town should be rewarded in this way.

He thought Hexham should have a share of the spoils, and a gun on the Sele pleasure ground would be very nice. Other councillors agreed, pointing out that Hexham had long since earned its title as the 'Heart of All England' by the number of volunteers it had sent in the front. The notion was welcomed by the *Courant*, as:

'the claiming of war trophies is evidence of the spirit which emanates the sturdy sons of the Borderland, for while they are quite willing to take hard knocks there is an underlying strata of Scotch shrewdness which demands they are not forgotten when the spoils of war are distributed.

Violet Loraine the First World War template for World War Two's Vera Lynn as the Forces' Sweetheart. She is seen here with her stage partner 'Prime Minister of Mirth' George Robey, but after the war she became a much loved lady of the manor at Blenkinsopp Hall, Haltwhistle.

'It may seen a little early in this elemental European upheaval to ask for trophies of war, for the end is not yet here, for although it may seem certain our enemies must go under there is always the risk of unpleasant surprises; for what may not happen in a war of this immense character?'

However, the notion was not universally popular, for in the letters column when the news broke, John Wilson of Allendale wrote: 'To my

mind to have such a memorial, which may have slain thousands of our comrades and perhaps dear relatives, is quite ridiculous and an extreme reminder to us all of the ghastly horrors of war, bringing with it grief and sorrow of a magnitude unknown in the history of man.

He was supported by John Margaret of Whitley Bay, who wrote: 'I really do not see how any Englishman could wish for one single article that once belonged to the murderous Huns. Any Belgian would advise on this.'

The council renewed its desire for a war trophy in its first meeting of 1918, with Councillor John Civil suggesting the council should ask for one of the German guns seized by the Northumberland Yeomanry at the Battle of Cambrai. He said an admirable site could be found for it, either on top of the Sele or in the Abbey Grounds. The *Courant* agreed, with Ariel suggesting that a war trophy would be a fitting tribute in the 'Heart of All England' to the gallant men from the west and north Tynes who made up such a sizeable proportion of the yeomanry.

However, readers were not so enamoured of the suggestion, with John Wilson again retorting it was 'lamentable' that the council should even be thinking of such a thing when the war was not yet won. He said: 'It is appalling this is being done to remind us of the slaughter of so many of our dear ones and thousands of comrades. We have reminders in every homestead in the form of empty chairs, and in the press, of the atrocities of war without gazing on any item of German origin.'

The War Office finally offered the town one small damaged German machine gun along with an ammunition box and ammunition belt. A disgusted Councillor William Teasdale said: 'There is no town in England which has sent more men into active service according to their population than Hexham has done, and towns out of that number have been given some big guns. I move that they keep their damaged machine gun.' The motion was agreed.

As well as having the dubious honour of drawing the first blood in the war via 'Butcha' Hornby, Tynedale would also lay claim to one of the conflict's great superstars in Violet Loraine, the girl who was the template for the Second World War's Forces' Sweetheart Vera Lynn.

Her glittering career began at the age of 16, when London-born Violet made her stage debut as a chorus girl, learning her trade treading the boards in the capital, eventually reaching top billing as leading lady in a string of musical revues. By the time war broke out she was

already a well-known performer, and was in a series of revues at the London Hippodrome. Her big chance for super-stardom came in 1916, when she topped the bill alongside the most famous musical hall star of the time – George Robey, the 'Prime Minister of Mirth'. For the final two years of the war, firstly in *The Bing Boys are Here*, and subsequently *The Bing Girls are There* and *The Bing Boys on Broadway*, Violet and Robey played to sell-out audiences at the Alhambra Theatre night after night.

Together, they made the Alhambra the magnet for the men of the forces on their break from the battlefront. Violet and Robey, in duet, had the hit song of the war with *'If You Were The Only Girl in the World'*; closely followed by *'Let The Great Big World Keep Turning'*.

After the war, she cashed in on her sweetheart appeal, as the star of a string of West End revues, as well as tours to Paris and Broadway. It was at this time that she met Captain Edward Joicey, head of the South Tyne land-owning and mining dynasty, who had earned the Military Cross during the war. Romance blossomed and in September 1921, at the age of 35, she announced on stage her retirement from show business to marry Captain Joicey. She told the stunned audience she 'simply had to have babies.' And true to her words on her farewell from the stage at the height of her fame, she went on to give birth to two sons. She was, on occasions, tempted back to the limelight. In 1928 she took part in a charity performance of *The Scarlet Pimpernel* at the Palace Theatre. Later she was lured by the pull of the new-fangled talking films, appearing in the big screen musicals *Britannia of Billingsgate* in 1933 and *Roadhouse* in 1934.

Their box office appeal was muted. And in truth, Violet's appeal lay in the sentimentality of the music hall of the Great War, rather than the mass audiences of the cinema.

Content that a show business comeback was not on the cards, Violet settled down to life on the Blenkinsopp and Hunstanworth estates near Blanchland, where she was hugely popular with tenants and workers. She did, however, accept an invitation in 1939 to be part of variety shows to entertain the troops throughout the Second World War. Her last appearance was at a concert for the RAF in London's Royal Albert Hall in 1945.

She was widowed in May 1955 when Captain Joicey died after a long illness at the age of 64. She soon became ill herself. She died the following year, a week before her 70th birthday, after two months in the Royal Victoria Infirmary, Newcastle.

At the time of her death, there remained a great deal of affection for Violet among the surviving veterans of the Great War. And this was reflected in the host of glowing tributes which were prompted by her passing. In its obituary, *The Times* said:

'To the soldiers in the muddy trenches, Vi stood for dear old Blighty, smoky London, the leafy lanes of England, home sweet home. To us, now left behind, she stands for our lost youth.'

Bibliography

The primary sources of information for this book were the 1914-19 files of the *Hexham Courant* newspaper, of Beaumont Street, Hexham, Northumberland.

Further information came from:

Teenage Tommy – Memories of a Cavalryman in the First World War by Richard van Emden. Pen & Sword Military 2013

The personal diary of Captain Charles Beck Hornby, 4th Dragoon Guards, August–December 1914.

Happy Odyssey by Sir Adrian Paul Ghislain Carton de Wiart VC KBE CB CMG DSO. Pen & Sword Military 2007

Alston Moor and the Great War by Alastair F. Robertson. Hundy Publications 2014

A diary of an officer: with the 4th Northumberland Fusiliers, in France and Flanders, from April 20th to May 24th 1914 by Lieutenant Wilfrid Joseph Bunbury. J. Catherall & Co 1918.

Weekend Warriors: From Tyne to Tweed by T.L. Lewiston. The History Press 2006

Index